THE PILOT HILL COLLECTION OF CONTEMPORARY ART

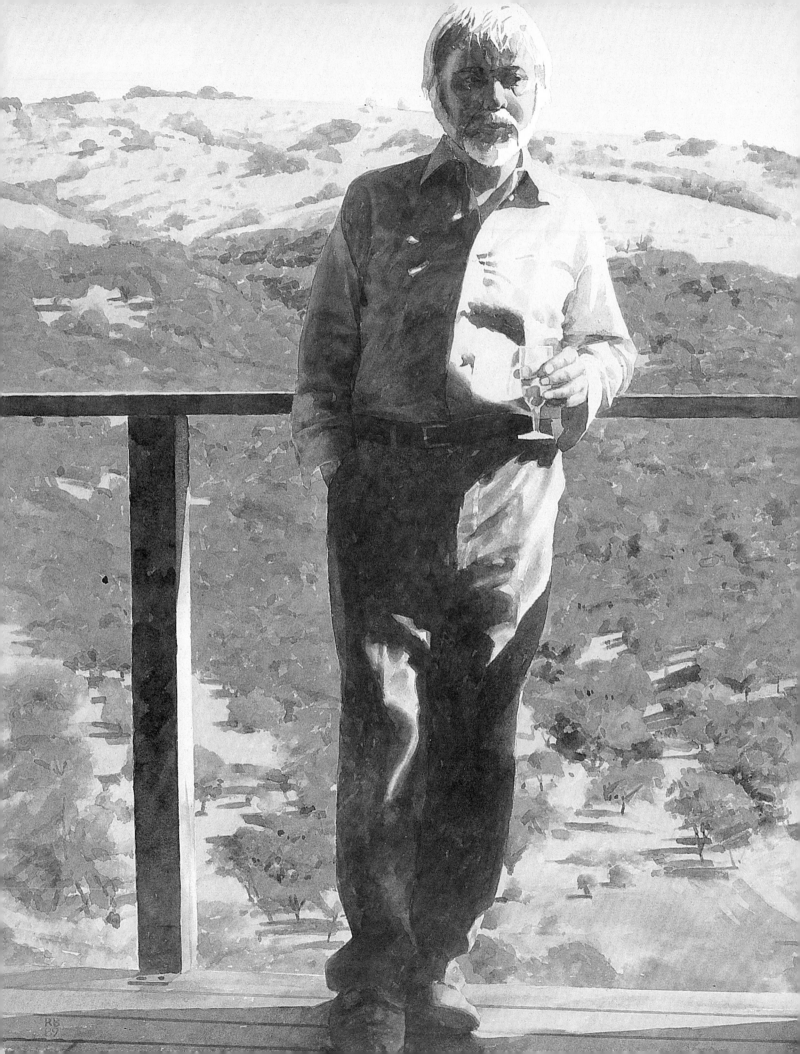

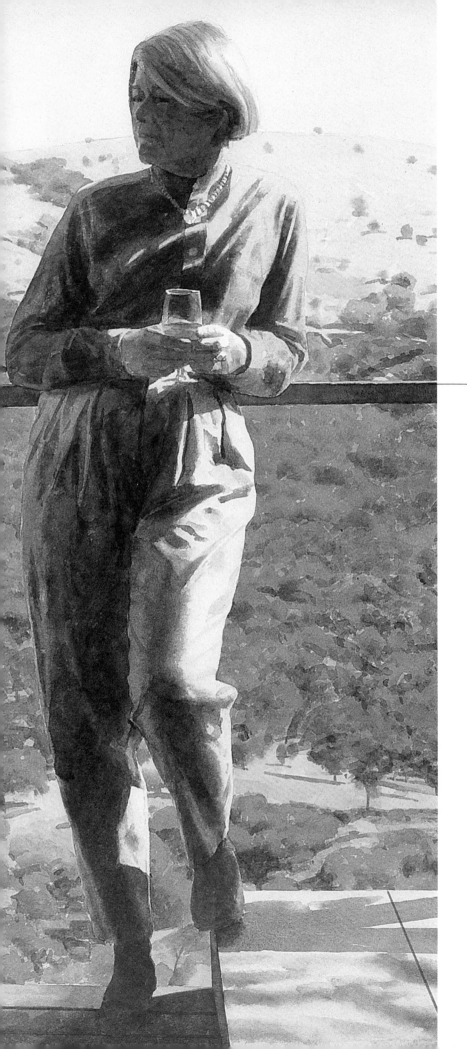

THE PILOT HILL

COLLECTION OF

CONTEMPORARY ART

JOHN FITZ GIBBON

CROCKER
Art Museum

THE PILOT HILL COLLECTION OF CONTEMPORARY ART

Organized by Crocker Art Museum
216 O Street, Sacramento, CA 95814

CROCKER
Art Museum

Chief Curator: *Scott A. Shields*

Curatorial Coordinator: *Diana Daniels*

Registrar: *John Caswell*

Exhibition Coordinators: *Patrick Minor, Steve Wilson*

Library of Congress Cataloging-in-Publication Data
Fitz Gibbon, John.
 The Pilot Hill collection of contemporary art /
John Fitz Gibbon.
 p. cm.
 ISBN 1-884038-06-9 (alk. paper) —
ISBN 1-884038-07-7 (pbk. : alk. paper)
 1. Art, American—California, Northern—20th
century—Catalogs. 2. Fitz Gibbon, John—Art
collections—Catalogs. 3. Fitz Gibbon, Jane—Art
collections—Catalogs. 4. Art—Private collections—
California—Catalogs. I. Crocker Art Museum. II. Title.
N6530.C22 N674 2003
709′.73′07479454—dc21
 2002015585

Printed in Canada
9 8 7 6 5 4 3 2 1

The Crocker Art Museum's programs and publications
are funded in part by the Sacramento Cultural Arts
Awards Program of the Sacramento Metropolitan Arts
Commission with support from the City of Sacramento.
Additional funding is provided in part by the California
Arts Council, a state agency. Any findings, opinions, or
conclusions contained therein are not necessarily those
of the California Arts Council.

Sacramento Metropolitan
Arts Commission
A Public Agency
Funded with support from the City and County of Sacramento

California
Arts Council

for John Fitz Gibbon

At night, on the walls of a house, its paintings dream,
or, say, play in the dreams of those who dwell
among them: on the walls of their minds they hang
or swim in the dark, but then, as a new day dawns,
coming up for air, they surface again to light
and settle into the frames where we think them fixed.

Domestic wildlife, they frisk, while those in museums,
caged, like Schopenhauer's ape or Rilke's
panther, stare down at blank and stupid guards
in whose stolen naps there is no room for greatness
to move in, never mind romp as they also do
in churches, where in parishioners' prayers, those directed

dreams, the shimmering marches of consciousness
offer that unconstrained attention they thrive in.
A glimpse is never enough, as the steady gaze
of scholars, too eager and earnest, is too much.
From a canvas, stretched over time, each stroke of the brush
must make its mark in the slowly roused neuron.

Each daybreak, and every passage along that wall,
indicts, corrects your memory, trains your eye
with tints, textures, and shapes that are not even better
but different, surely, from what you believed with surprises,
ever smaller but nonetheless precious for that,
like a many-years-married couple's allusive banter.

—David Slavitt

CONTENTS

ILLUSTRATIONS

PHOTOS OF EVENTS

ACKNOWLEDGMENTS

THE FOOTHILL SETTING of Pilot Hill is quiet, even pastoral, with cattle dotting the open range on nearby hills. Deer, hawks, and an occasional bear pay visit to the house described by one artist as John's aerie. Perched on its hill, the Fitz Gibbon home commands a dramatic gaze out over a vista that on a clear day reaches to Folsom Lake. Pilot Hill, however inspiring in its natural setting, is best known for the art collection there. Clearly realized by the collectors is the cohesion of personal taste with a profound thoughtfulness of selection. Many works are monumental; others are poignant and personal emblems.

The Fitz Gibbons display their collection floor to ceiling—even on the ceiling—at Pilot Hill. Here, there is barely a square inch of interior room available. John believes that art should breathe, and by breathing, he means that art should not be kept in storage. He commands everyone to hang art up the walls and to "pitch their tent on the ceiling." John has moved his larger and less fragile pieces to the deck, the lawn, and even the surrounding hillsides. Some of the collection, for sheer want of space, has been dispersed to John's children and their spouses, while still other pieces have been placed in museums. Once art chances to be removed from the house, the vacated spaces are immediately refilled, allowing more art to be brought out into the air. His joy is in his daily immersion into this, his most ardent subject.

The goal of this exhibition is to share with a wider audience outstanding contemporary California art and to spotlight an eclectic, intimate and highly personal approach to collecting. Many supporters came together to form this extraordinary collection into an exhibition. Julia Couzens introduced the idea of approaching the Fitz Gibbons and arranged for a positive reception. John Fitz

Gibbon warmly and eagerly took up the idea of organizing his collection into *The Pilot Hill Collection of Contemporary Art*. John and Jane opened their home to us, fed us, facilitated our explorations, and met our many demands with admirable dispatch. It was no small amount of time required on their part in providing information about and access to the collection.

The patience and generosity that the Fitz Gibbon family has extended to Crocker staff earns our most heartfelt thanks. We thank Dr. John Fitz Gibbon Jr. and Linda S. Fitz Gibbon and Erle and Pinkerton F. G. Flad for their hospitality and for their cooperation in sharing important works from their collections.

The contributions of Jock Reynolds and William Allan meaningfully elaborate on John's role as friend and professional colleague. We thank both Dr. Lou Zona, Director of the Butler Institute of American Art, and Dr. Bill Otton, Director of the South Texas Institute for the Arts, for their support of the exhibition.

Others have touched this project with their enthusiasm, championing the exhibition to their friends and colleagues. William C. and Teresa Bourke, Peter and Elaine Bull, Alison Carrillo, James T. and Kathy Fitz Gibbon, the Milton Gaines family, Elizabeth Grace, Roger W. Hollander, Chris Olson and Mark Fowle, Jack and Jane Stuppin, and Bill and JoAnne Rees are among these and we thank them.

The contributions of the artist Stuart Allen as our photographer assured that the catalog would be beautifully illustrated. We appreciate his tremendous professionalism and grace under pressure, photographing art on location, often under the most challenging of circumstances.

Every member of the Crocker was committed to the project. The contributions of the curatorial department in particular are recognized. Scott A. Shields, Curator of Art, provided curatorial leadership to the project. John Caswell, Registrar, Diana Daniels, Curatorial Coordinator, and Patrick Minor and Steve Wilson, Exhibition Coordinators, all contributed their experience and a great spirit of collaboration to the endeavor. Finally, it is the continuing commitment of the City of Sacramento and the Co-Trustees of the Crocker Art Museum that makes projects like this possible.

—*Lial A. Jones*
Director, Crocker Art Museum

FOREWORD

■

IN WRITING FOR John Fitz Gibbon, who's been compelled to collect California art from "A to Z" and likes to have artists at his side, covering both his rear flank and fronting his and Jane's continuing advances into rugged cultural terrain, it's my job to offer a foreword to this catalog. So let me begin by simply offering the four words that seem most appropriate to this task: "Art is a gift."

I began to learn the verity of this phrase back in 1970 when I discovered that "you can go home again." The occasion to do so arose when I was admitted to the graduate program in U.C. Davis's art department and returned to the campus town where I'd been raised as the son of a microbiologist and a botanist. I'd been steered homeward by Gurdon Woods, the sculptor and a past director of the San Francisco Art Institute, who was then my undergraduate mentor at U.C. Santa Cruz. He told me that a man he greatly admired, Richard Nelson, had earlier been given a free hand to assemble a talented faculty of young artists at U.C. Davis, one that now had its art department "really hopping." He claimed that any number of these creative figures might well help me continue the process of becoming an artist myself. I took the bait.

Having secured and outfitted a studio on the outskirts of town, I remember attending my first graduate seminar with Wayne Thiebaud, who looked out at his new crop of students and rather quickly explained to us that he and his peers couldn't teach any of us to become artists, that we simply had to assume that identity for ourselves and get on with making our work. He assured us that this was what he and the rest of the U.C. Davis faculty were doing, day in and day out, and that we should just join in with them, asking for criticism when we felt we needed it, and sustain as best we could a quest to find and grow our own

creative voices. Thiebaud then added, almost cryptically, that there were some very practical things he could teach us that might be useful during our years at Davis. He then requested that we produce pencil and paper. What followed was a remarkably lucid lecture on where we were to buy the best and cheapest salami, cheese, fruit, bread, cakes, wine, and more in the region, things our professor insisted would significantly enrich the quality of our lives. As Thiebaud's extremely detailed talk continued (including addresses and phone numbers), I not only recognized from my youth many of the Sacramento-area delis and bakeries my new teacher was describing, but soon came to realize that he was sharing something more than a remarkable and very helpful shopping list with us. He was also giving us direct insights into the very subject matter that was inspiring his own art; the frosted cakes, the cream pies, and the trays of herring and sardines he was transforming, through the skilled application of paint onto canvas, into the most tactile and sensuous visual compositions imaginable (we all know someone who's been tempted to gnaw on a Thiebaud painting over the years). I took this first lesson at U.C. Davis to heart as a genuine gift, a true sharing of what pleasured and inspired my professor, and proceeded later in the week to pursue a share of his suggested homework. This entailed me driving my pickup truck up Highway 101 to the Fetzer Winery, where I followed Wayne's detailed instructions on which warehouseman to contact in order to buy multiple five-gallon glass containers of freshly decanted Zinfandel and Premium Red wine, which man to see in order to receive the free cases of empty fifths I would require for my "rebottling" project, and where I was to go to purchase the fresh corks and corking device needed to prepare and store a sufficient supply of good wine for my graduate years. Mission accomplished, I remember calculating my wine costs at 87 cents a fifth, clear evidence that my teacher was correct in insisting to his new students that "you needn't be starving artists."

My other initial graduate seminar at U.C. Davis

was led by William T. Wiley, who regaled his first gathering of students with an unexpected recital of blues and folk songs that he accompanied with guitar and harmonica. He then proceeded to demonstrate a simple folk toy he had fashioned of whittled wood and string, one that when swung around overhead as a lariat made us all think a large wasp was loose in the room. In advance of his students' arrival, Wiley had tacked a canvas to the classroom wall, a large piece of raw cloth on which he had inked a simple grid, framed by an active field of marks and brief phrases, rendered in his telltale style of drawing. He invited all of us in the seminar to help him complete this artwork over the next week, encouraging each of us to select a sectioned portion of the canvas and to work on it in any way we saw fit. We did so and, although I didn't realize it right away, this man would soon come to exert a profound influence on my creative development for he knew well how to infuse play, improvisation, and collaboration into art-making in ways that continuously stimulated his own curiosity and imagination, as well as those of others. Wiley was also quick to discern what made his students tick, and would then individually suggest artworks and films one might benefit from seeing, books that could be read, people you might want to meet, and much more. He and Jim Melchert (another remarkably inventive artist then teaching at U.C. Berkeley) even took the initiative of regularly inviting their graduate students to attend one another's seminars as intercampus guests, thus helping to form a larger community of young Bay Area artists before some of us were even out of school (this is how I met my eventual San Francisco studio mate, Jim Pomeroy).

Partnering closely on the Davis campus with Dan Snyder (another dynamic artist and professor of scenic design in the nearby drama department), Wiley also gave of his time to work in theater facilities with students from both the art and drama programs, helping Snyder launch a whole series of experimental performances that continued for years as rich interdisciplinary collaborations (among them

the renowned *Out Our Way* main season theater productions, the first two of which I had the good fortune to help create with Wiley, Snyder, Bill Morrison, and many others). Within all that Wiley taught and gave his students, nothing mattered more to me than his willingness to take risks and sometimes falter a bit as he worked and taught before us.

Few artist/teachers I know possess the quiet self-confidence it takes to reveal aspects of their own creative awkwardness for others to see, which seems unfortunate given the fact that all artists must grapple, one way or another, with aspects of their own creative clumsiness as they proceed to find their way through their work. The duncelike "Mr. Unnatural" character Wiley created to perform in the *Out Our Way* productions (which also contained a good dose of Merlin the Magician) personified his unabashed willingness to bring both utter foolishness and deep knowledge to bear in any and all artistic endeavors; "wizdumb," as Wiley was wont to pun on the subject. And what else would you expect from an artist who staked out his own home with a hand-painted sign announcing that one was approaching "Stupid Manor." Wiley was the closest thing the U.C. Davis art faculty had to the venerated Coyote who appears in many Native American stories and myths, always operating as the playful and wise trickster who somehow carries the day.

Let me mention Manuel Neri, too, another member of the U.C. Davis art faculty with whom I studied and served as a teaching assistant in sculpture. Neri, too, was a memorably generous and gifted teacher, one deeply knowledgeable about art of the past and much of the art then being created by artists working in the Americas, Japan, and Europe. He was also someone I enjoyed simply observing for he would regularly go on working jags as long and hard as a major-league drunk's best binge. These intense periods of creative work were usually undertaken with a live model in the artist's studio (an old "converted" church in the town of Benicia). There, and later at 80 Langton Street in San Francisco, I saw full human figures, partial figures, and sometimes simply heads come to life in the very immediate medium of plaster, of which Neri is a true master. While constantly surveying his subject, he would deftly apply wet plaster to a basic armature fashioned of wood, wire and burlap. Once underway on a piece, Neri would work at a feverish pace to maximize the "open time" in which the plaster allowed itself to be easily formed and carved. He used all manner of hand tools and methods to craft the dynamic human forms and gestures he sought to infuse with highly expressive visual powers and emotions. When his spatulas, chisels, rasps, knives, and even hatchets finally came to rest, Neri would sometimes leave his figures just as they were. At other times, his sculptures might receive a second round or more of his attentions, incurring additional regimens of "hard carving," filing, and sanding, interspersed with active bouts of drawing and painting directly on the plaster figures. He freely used whatever expressive means and materials he needed to employ to achieve the visual and emotional essences he was seeking in the human form. Watching him at work was utterly enthralling and greatly extended my knowledge of classical modeling and carving. Most impressive to me, however, was Neri's sheer ability to improvise wildly and freely in very short periods of time. I used to love watching him while I was assisting in his undergraduate sculpture class, where it was my job to help prepare and deliver wet plaster and clay to and fro for his students as they first attempted to create the human figure from a live model. Neri, when not making rounds of the classroom to encourage his charges with helpful observations and pointers, would often perch upon a stool in the back of the classroom with a cup of strong black coffee in hand. While drinking some of the beverage, he more often consumed most of the cup with a small brush, exercising his eye and hand by producing a torrent of small espresso-strength figure studies of the class model on sheets of scrap paper. He'd turn them out one by one in seconds, float them off to the floor,

and start another. By the end of a class, a beautiful visual accumulation of the man's keen eye and quick hand was to be swept up by me and discarded along with the other debris resulting from the day's lesson. Through Neri, I was given important lessons about the value of careful and constant visual observation, the practical value of daily disciplining one's hands and eyes, and something special about the sheer joy one could experience in making art. Neri also taught me the value of letting some things go, urging that every work need not be physically saved if it had served its intended purpose in one's creative life.

Now before you begin to think I am going to go on forever like this, let me say that I want to mention just one more of my U.C. Davis teachers before giving John Fitz Gibbon his chance to weigh in for the main event as this catalog's chief essayist. I'd be really remiss in this foreword, one seeking to illuminate and exemplify something about the extraordinary quality of art instruction so many young people of my generation received in the bay area, were I not to say something about Robert Arneson. Now deceased and sorely missed by many friends and associates, Bob was a creative force who loomed large in my education and those of so many others who studied with him. And since I never aspired to be a ceramic sculptor and thus never took any of Arneson's famous clay classes, nor labored beside him and other fellow students who loved working in the art department's TB 9 studio building and its constantly-fired kilns, you might wonder why I wish to bring him forward from memory. The answer is easy. Bob was the needed "in your face" challenger on the U.C. Davis art faculty, an extremely rigorous artist and dedicated teacher who knew how important it was for his students to learn to articulate their values and ideas as fully as possible, doing so not only through regular studio practice but also through careful critical viewing and well-honed verbal debate. Arneson loved to probe and press his graduate students so vigorously that we could sometimes hardly bear it, but most of us soon came to

realize he was doing this to see how well we were thinking and not simply to torture us. The graduate seminar I had with him took the form of what you might characterize as Cedar Bar-style arguments. But instead of gathering on New York's Bowery, Bob and students, and frequently a guest visitor or two, usually drifted together for weekly meetings at "The Club," an old beer joint in downtown Davis. There, voices could be raised as loud as they needed to be and a game of pool could be had if the usual ruckus ever got dull, which it seldom did. This fine man tested us one and all, but once you passed muster with Bob, you were accepted as a professional peer and forever after that treated as such. I remember, to this day, the courage with which he battled cancer for many long years while still teaching full time and producing art at a staggering pace. A mere two weeks before his death in 1992, I came across him and his wife Sandy Shannonhouse in San Francisco, visiting a show of my and Suzanne Hellmuth's work. I was deeply touched that my old teacher was still paying attention to one of his former students.

Why do I mention these few memories of just some of the very fine artist/teachers who so profoundly shaped the trajectory of my adult life? I do so because I will warrant that these few personal anecdotes are merely typical of myriad others that could have been told to you by many other artists of my generation and beyond who have received their art education in the public universities and other independent colleges that have so importantly inspired visual creativity within northern California. Whether it be at U.C. Davis, U.C. Berkeley, U.C. Santa Cruz, the California State Universities at Sacramento, San Francisco, San Jose, and Hayward, or other venerable institutions such as the San Francisco Art Institute, the Oakland College of Arts and Crafts, Mills College, and Stanford University, there is a very long list of distinguished artists who have done wonders in vitalizing this region of America and its culture through their art-making and teaching during the latter half of the 20th century.

John and Jane Fitz Gibbon's collecting interests and personal friendship have long intersected with many of the strongest contributors to this enduring cultural and educational legacy, one that has been steadily accruing in northern California, one I am delighted is being celebrated through this exhibition and catalogue organized by the Crocker Art Museum.

—Jock Reynolds
The Henry J. Heinz II Director,
Yale University Art Gallery

DOWNHILL FROM HERE: BEYOND REGIONALISM IN NORTHERN CALIFORNIA ART

California art, from its very beginnings, has been removed from the mainstream. Separated historically by distance and mountains, and now by psychology, artists here have responded to trends in the East, Europe, and Asia, but have pursued their own paths. This path, for all its meandering trails, has been and continues to be distinctly Californian. The psychological sense of separation and apartness of California art is all the more curious in that historically a vast number of the Golden State's artists have not been native, but were transplants from other parts of the country or world. Many too have perfected their craft by training in other locations, bringing their skills west to use in the forging of a new identity. California has shaped identities that in turn have contributed to the collective whole. This whole has, in the last half-century, extended well beyond the boundaries of the Golden State to sway a national consciousness that it may well be *the* American art.[1]

By definition, California art is regional, and regionalism at its most basic expresses a spirit of place. Regionalism can be pursued collectively as part of a movement or colony or it can be explored solitarily, between the artist and the subject; it is not limited to medium or genre. Although the concept of regionalism can be debated, the tendency among artists is not new. Its basic assumption that individuals, and indeed entire communities can and do have strong associations with a particular locale and that these associations are manifest in their lives and the art that they produce, has been present in various forms throughout art history. This is especially true in American art, the best of which most critics, historians, and artists have felt to be founded on genuineness and sincerity derived from a close communion between the artist and the land. D. H. Lawrence understood it well. "Every continent has its own spirit of place. Every people is polarized in some particular locality, which is home, the homeland. Different places on the face

of the earth have different vital effluence, different vibration, different chemical exhalation, different polarity with different stars: call it what you like. But the spirit of place is a great reality."[2]

Not all have shared Lawrence's assessment. E. P. Richardson, the art historian, defiantly stated that "the place where a man lives may determine what crops he can grow, or what he does for a living. But there is no automatic connection between the rivers, mountains, or plains of man's habitat and the imaginative life of man's mind."[3] The question is a basic one—nature versus nurture—whether artistic inspiration resides in the imagination or responds to environmental forces. While Richardson rightly stresses the imaginative forces behind artistic creation, he discounts the profound influence that a place, particularly one as rich and persuasive as California, can have on its artists.

This spirit of place, "call it what you like," is manifestation of regionalism. Such a definition is one that can apply to the art of diverse styles and periods. It is a concept broader than Regionalism with a capital "R," a period of painting in the 1930s defined by rural Midwestern subject matter and a representational style. It assumes a long-standing tradition of the power of the home, which aptly applies to California.

Historically, the degree of involvement with one's own heritage and landscape has waxed and waned. It has also been perceived cyclically. Grant Wood cites Carl Van Doren: "America rediscovers herself every thirty years or so. About once in each generation, directed by political or economic or artistic impulses, we have reevaluated or reinterpreted ourselves." Van Doren went on to note that this happened first, for obvious reasons, around 1776, and then subsequently during the time of the Louisiana Purchase, the Jacksonian era of the 1830s, the period immediately after the Civil War, the expansionist period at the turn of the century, and finally during the 1930s, the period when Wood was writing.[4] According to this model, regionalism would seem to have existed in some form in nearly every movement and "ism" of

American painting. Even Wood himself conceded that regionalism could develop anywhere, and presumably in any period. "I shall not quarrel with the painter from New Mexico, from further West, or from quaint New England, if he differs with me," he said, "for if he does so honestly, he doubtless has the same basic feeling for his material that I have for mine—he believes in its genuineness."[5]

While it has long been held that the postwar New York School was the next, and some might say final step in the modernist progression, the next cyclical stop on Wood's regionalist trajectory might well be northern California art of the late 1950s and early 1960s, a period when local artists produced paintings that were nationally significant, but also specifically local in feeling and inspiration. Through a new style uniquely Californian, artists produced work that, like the state itself, manifested a profound sense of self-confidence, which had either never existed or had somehow been lost over time. California had certainly come into its own during the period, assuming a central place on the national stage in terms of economics, politics, and entertainment; and art of the period not only seemed to find itself, but also assumed a leadership role in what has since become the art-historical canon.

This change in California artists' perceptions of themselves, and in the way they have been perceived by outsiders, had been a long time coming. Since the late nineteenth century, California's artists harbored insecurities about the provincialism of their art, fearing that it did not measure up to Europe and the East. Public opinion also conspired against them, and most wealthy patrons preferred second-rate European paintings to California work.[6] After the sensation of the gold rush had subsided and the rest of the world became bored with the newness of California, the state's artists hardly found themselves in a position to raise a national consciousness of California as the new symbol of national identity. They did, however, begin to view their art as a separate regional entity. The vast majority of California painters went

about painting the state's landscape, proclaiming and glorifying their own unique place in America, distinct from the rest of the nation. They also felt that California was the new symbol of America as natural paradise, a place where one could experience the divine untrammeled wilderness of the Sierra, the state's ancient live oaks and redwoods, its vast golden hillsides, and miles of uninterrupted coast. These landscapes were not overtly nationalistic, but they did aim to illustrate California's glories to the rest of the nation.

These California landscapes evolved between the 1860s and the 1920s from highly detailed images of California's majestic scenery to more intimate, Barbizon-inspired views of tranquil pools and meadows to brightly colored impressionist scenes of California desert and sea. Although these paintings often included signs of human presence, humanity was inconsequential to nature. In most cases, paintings showed people living or working in harmony with the land, and buildings co-existed within the natural setting. Adobe buildings, farmhouses, and wagons were considered appropriate subject matter for early California paintings; factories, modern buildings, and mechanical methods of transportation were not.

This avoidance of modern life began to change in the late 1920s as artists increasingly turned to their urban surroundings as subject. Instead of taking extended sketching trips to California's wilderness areas, these artists began simply to step outside their urban studios and look at the city around them. In this period after World War I, artists nationally were turning away from foreign artistic influences, striving to discover what was American about their work. California artists participated in this trend, making local activities and commonplace scenes their preferred subject matter.

European-inspired modernism found few adherents in California in the first decades of the twentieth century. Those artists who did experiment with avant-garde styles were largely centered in Los Angeles and were galvanized by the presence of notable artists and advocates includ-

ing the painter Stanton Macdonald-Wright and the collectors Louise and Walter Arensberg. In the north, most artists failed to progress much beyond Post-Impressionism. The University of California at Berkeley became the first institution to adopt a more progressive art program, enlisting the German artist Hans Hofmann to teach a series of courses beginning in 1930. Hofmann's "push-pull" theories of color and composition were revolutionary at the time and through them he taught Californians an important lesson: that painting existed in two dimensions, rather than as an illusionistic window onto a three-dimensional world. Clement Greenberg, the New York critic, would later describe the change: "From Giotto to Courbet, the painter's first task had been to hollow out an illusion of three-dimensional space on a flat surface. One looked through this surface as through a proscenium into a stage. Modernism rendered this stage shallower and shallower until now its backdrop has become the same as its curtain, which has now become all that the painter has left to work on."[7]

Hofmann's paintings seemed to bridge the gap between European modernism at the beginning of the century and Abstract Expressionism a generation later. His views provided a decided departure from the way California artists, particularly northern California artists, were accustomed to thinking and seeing. Thomas Hill's gigantic hole, *Great Canyon of the Sierra* (fig. 1) literally set the stage for generations of artists to think about painting as a deep window onto California's vast landscape, and most were unready or unwilling to relinquish their hard-won technical skills in favor of a new set of aesthetic principles.

It was not until after World War II that Bay Area artists were willing to abandon adherence to subject and focus solely on the formal properties of their art. Working concurrently with better-known Abstract Expressionists in New York, San Francisco's artists offered an important western counterpart. For the first time, San Francisco was truly positioned to give America's primary art center a

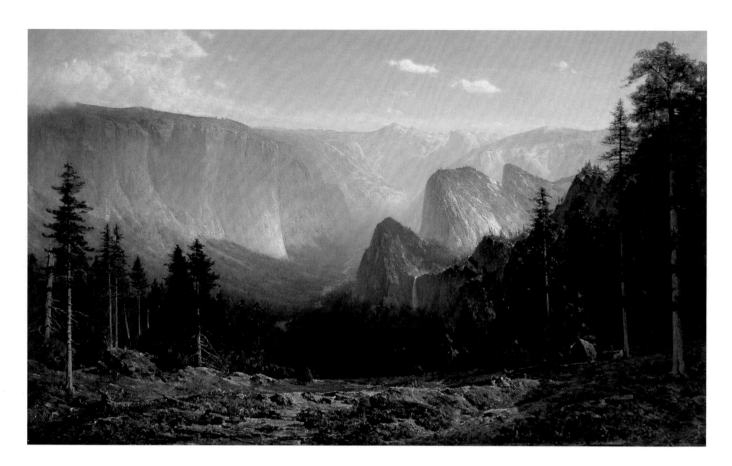

Thomas Hill (1829–1908), *Great Canyon of the Sierra, Yosemite*, 1871. Oil on canvas, 72 × 120 in. E. B. Crocker Collection, Crocker Art Museum.

run for its money, and San Francisco's role as America's other artistic leader was made possible by the appointment of Douglas MacAgy to the directorship of the California School of Fine Arts in 1945. MacAgy, aiming to update the school curriculum and make it nationally significant, put together what many have described as the finest art faculty in the United States. He brought together the artists Hassel Smith, David Park, Elmer Bischoff, Clyfford Still, and Richard Diebenkorn, a former CSFA student, among others, and hired the notable Easterners Mark Rothko and Ad Reinhardt to teach summer sessions. Of the Abstract Expressionists, Still, who came to San Francisco from New York, was the most influential, producing large dark, non-

objective canvases that inspired and liberated a generation of students.

Although in the late 1940s these artists were producing nonobjective paintings, many were not completely comfortable about giving up subject matter entirely. California's open spaces and climate were perhaps less conducive to Abstract Expressionism than were New York's immense structures and oppressive, brooding atmosphere. The style's obliteration of the subject had left artists nationally with a sense of "Where do we go from here?" It was up to Californians to provide the answer, and David Park was the first to venture a riposte. After disposing of his own Abstract Expressionist paintings, he put forth *Kids on Bikes* (1950), which restored the

primacy of the subject. He exhibited the painting at the 1951 annual juried exhibition of the San Francisco Art Association, and although it won an award, its radical reversal toward representation confused his colleagues. Soon, however, other artists, including Elmer Bischoff and Richard Diebenkorn began to return to representational motifs, adapting the gestural brushwork of Abstract Expressionism to human figures and other subjects including landscape, which seemed to offer an expressive and succinct summation of California's light and color. These paintings earned them the appellation "Bay Area Figurative," which in 1957 was officially sanctioned in a landmark exhibition, *Contemporary Bay Area Figurative Painting,* at the Oakland Art Museum.[8] The exhibition garnered national and international attention, helping to thrust local art into the vanguard of American painting.

This interest in representation came once again to characterize northern California art in its various forms, which included not only Bay Area Figuration but also other major movements and styles such as Pop, Photorealism, and Funk. More than ever before, work produced in California led national trends, and regional styles achieved universal significance. Not since the 1870s, when self-confident masters such as the highly skilled German immigrant Charles Nahl and Yosemite painter Thomas Hill created monumental paintings of California life and landscape, had California's artists been so sure of their abilities and pursuit. This self-confidence helped make them key players on the national stage. Self-confidence also meant that artists suddenly were in a position to take themselves and their art a little less seriously, and humor with a spirit of good-natured subversiveness began to creep in. While early in California's history, artists like Nahl had lampooned the California experience (fig. 2) and capitalized on its citizenry's ability to deprecate itself, somewhere along the way, driven by their need to be taken seriously in the eyes of the art world, California artists had lost their sense of humor. Now they were beginning to reclaim it.

Concurrent with Bay Area Figuration, northern California in the 1950s became the locus of other movements with equally far-reaching implications. San Francisco's North Beach area was a hotbed of art, poetry, music, and performance that comprised the counterculture known as "Beat." Artists living and working in close cooperation with writers, poets, and philosophers mutually influenced one another. Beat artists rejected convention and flaunted mainstream and bourgeois norms. A pervasive, seemingly relaxed attitude and casual acceptance of diversity made San Francisco just the place for such experimentation. Considered outcasts themselves, Beat artists in turn made art from refuse, recycling the discarded materials of consumer culture. In doing so they not only rejected California's materialism, but also created within their own limited budgets. Although artists of this generation could be profoundly serious, they frequently imbued their art with humor, spawning progenitors such as Funk, which had its beginnings during the Beat generation. Exhibitions of Funk art in San Francisco in the early 1950s included a diversity of artistic styles that shared a subversive and irreverent spirit with the tendency to make art out of found materials.

In the early 1960s, Pop Art became an international phenomenon to which Californians made uniquely western contributions. Pop appropriated mundane consumer objects and icons as subject matter, serially repeating or heroicizing products and celebrities. Whereas in New York, Andy Warhol's images of Campbell's Soup cans, Marilyn Monroe, or American currency sought to critique our image-clogged culture and point out society's consumptive nature, California's Pop was more playful, accepting, and even campy. It too drew upon the products of consumer culture—food, roadside architecture, cartoons, and pornography—but its impression of these products was more positive, even celebratory. Brash, vulgar, and rich in excess, California Pop seemed to match the state's newfound sense of self. Mel Ramos relished the comic imagery and California pinups he painted;

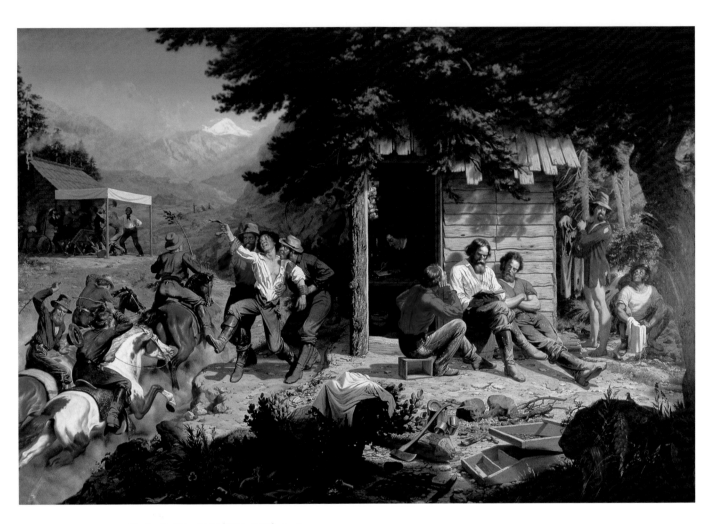

Charles Christian Nahl (1818–1878), *Sunday
Morning in the Mines*, 1872. Oil on canvas,
72 × 108 in. E. B. Crocker Collection,
Crocker Art Museum.

Ed Ruscha celebrated Los Angeles car culture and Hollywood; and Wayne Thiebaud delighted in the creamy lusciousness of his pies and cakes. Andy Warhol, it seems, hated soup.

Concurrently with Pop, Funk once again became the label for the style of art that developed in the 1960s around Robert Arneson and William Wiley at the University of California at Davis.[9] Representational, witty, irreverent, and even kitsch, its playfulness masked an underlying concern for more serious issues. An antithesis to New York minimalism, it was perfectly suited to, and representative of, California in the era. Like Pop, Funk used banal, everyday objects—but with less detachment. Arneson incorporated into his early work gross humor, scatological and sexual references, and blatant, in-your-face amateurishness of technique. He appropriated the Funk label as his own when he submitted *Funk John* to an exhibition of California sculptors in 1963 held on the rooftop of the Kaiser Center in Oakland. A toilet with excrement, *Funk John* paid homage to Marcel Duchamp's famous urinal signed "R. Mutt" and entitled *Fountain*. Arneson, who taught at Davis for thirty years, was in a strategic position to disseminate his ideas, and many of his students—both Funk and not-so-Funk—went on to become important artists in their own right.[10]

Arneson's colleague at Davis, William Wiley, initially worked in an Abstract Expressionist style, but soon began producing work that shared Funk's wit, impertinence, and penchant for found objects. Primarily a two-dimensional artist, Wiley was a pivotal figure in the transition of California Funk into an art of self-conscious humor and social criticism. In 1971, because of Wiley's interest in common imagery rendered in a style akin to comic book illustration and his own self-conscious promotion of himself as the epitome of the relaxed Californian, the New York art critic Hilton Kramer dubbed Wiley's style "Dude Ranch Dada."[11] Beyond humorous, Wiley's paintings were also visionary, critical, and combined an expansive knowledge of art history with highly personal autobiography, a tendency he shared with others including his friend Bill Allan at California State University, Sacramento, and colleague Roy De Forest at Davis.

ART ON THE HILL

Enter at this moment into the northern California art scene the collectors John and Jane Fitz Gibbon, whose home on Pilot Hill has served as a retreat, salon, and setting for happenings. From the moment that California art "arrived," the Fitz Gibbons have been there, participating in the next movement or "ism" while amassing a renowned collection of hundreds of works along the way. Representing nearly a half-century of production, these works are primarily by California artists and those who, at least for a time, have called the Golden State home. The distinct West Coast sensibility that runs through the collection is distinguished by its humor, irreverence, and its adherence to the physical object—whether as still life, landscape, or especially the human figure. Abstraction is represented in the collection, but there is a prevailing sense that even in those works the artist has not moved too far afield of physical reality.

Many works in the collection are monumental, powerful in their execution and size; others are intimately scaled works of technical refinement. There is also an abundance of ceramics, a recognition of the importance of this medium in the Davis and Sacramento region. The collection includes the work of many of the "legends" of contemporary California art—Robert Arneson, Richard Diebenkorn, Elmer Bischoff, Joan Brown, Roy De Forest, David Park and Mel Ramos—as well as an abundance of exceptional and unique figures who ought to be better known—James Albertson, Eduardo Carrillo, Judith Linhares, and Don Hazlitt. Among several in-depth concentrations around a single artist is Fitz Gibbon's collection of seventeen Robert Colescotts, constituting a primary repository of the artist's work.

Driven by an inexhaustible fervor for his subject, John Fitz Gibbon himself is an eccentric,

intensely passionate man and an extraordinary art critic. For over forty years he has not only collected and lived with art, but also studied and written about it. He taught its history—from caves to de Kooning—for twenty years at California State University, Sacramento. In the course of his career he has penned dozens of articles, gallery guides, and catalogue essays about the artists he collects.

Fitz Gibbon does have one axe to grind—about New York—and his writings and tastes are distinctly different from those celebrated in the East. Feeling that artists working beyond New York City have had an inequitable struggle for equal recognition against their eastern competitors, Fitz Gibbon has aimed to sway bias toward the unique contributions that Californians (mostly northern) and an occasional Chicagoan have made. His views are the polar opposite of Clement Greenberg's, New York's infamous critic, and he has, on numerous occasions, assumed the stance of "Anti-Greenberg." Whereas Greenberg generally felt that narrative and content-driven paintings pandered to middlebrow taste, Fitz Gibbon delights in content, narrative, and even a good dirty joke.[12] In his eyes, less is definitely not more. Greenberg shared T. S. Eliot's belief that "the emotion of art is impersonal"; for Fitz Gibbon the opposite is true—it is deeply personal.[13] Much of his collection came directly from the artists—either as gifts from friends or through Fitz Gibbon's system of barter and trade. When

viewed in its entirety, the collection itself can be read as an extended narrative about his experiences with these friends, revealing his prolonged interaction with California's avant-garde.

The personal, humorous, and idiosyncratic nature of his collection and criticism does not imply that Fitz Gibbon is not concerned with formal issues. Even for him, a champion of "Bad" paintings, the physical object is paramount.[14] He has always been pro-object, even if this means anti-progress, and long before he pursues discovery of iconography, narrative, or conception in a work, he simply looks. His sharp eye and sureness of taste allow him to know what he likes instantly, and his opinions follow rapid fire. Only then does Fitz Gibbon further inform his instinctual response through closer examination and study, uncovering classical and popular art-historical sources, archetypal and personal fantasies, and the inside joke.

For John and Jane Fitz Gibbon, art has always been about friendship, love, humor, storytelling, and the western ethos. Never satisfied with their current holdings, the Fitz Gibbons continue to visit galleries and acquire work, but most still comes from friends. They have learned that they enjoy most what they know best, and what they know best is California, especially northern California, and the artists who have made this miraculous region their home.

—*Scott A. Shields*
Chief Curator, Crocker Art Museum

1. "I am becoming increasingly convinced," wrote Henry Hopkins, a former director of the San Francisco Museum of Modern Art, "that art currently being produced in California more clearly reflects the American mainstream than does art being produced in New York." In Henry Hopkins, *50 West Coast Artists,* edited by Douglas Bullis (San Francisco: Chronicle Books, n.d.), 9.

2. D. H. Lawrence, "The Spirit of Place," in *Studies in Classic American Literature* (New York: Viking, 1964), 16.

3. E. P. Richardson, "Regionalism in American Painting," in *Regionalism in America,* ed. Merrill Jensen (Madison: University of Wisconsin Press, 1952), 261.

4. Grant Wood, *Revolt Against the City* (Iowa City: Clio Press, 1935), 10–11.

5. Ibid., 29.

6. Judge E. B. and Margaret Crocker were among the few nineteenth-century collectors in California who made a concerted effort to collect the work of California's best contemporary artists.

7. Clement Greenberg, "Abstract and Representational," 1954, quoted in Karen Wilkin and Bruce Guenther, *Clement Greenberg: A Critic's Collection* (Portland and Princeton: Portland Art Museum in association with Princeton University Press, 2001), 20.

8. Now Oakland Museum of California.

9. The name stuck after being used in an exhibition curated by Peter Selz, *Funk Art* (Berkeley, Calif.: University of California, 1967).

10. A partial list of Arneson's students includes Clayton Bailey, Robert Brady, Deborah Butterfield, David Gilhooly, Bruce Nauman, Steve Kaltenbach, and Peter VandenBerge.

11. Hilton Kramer, "Dude Ranch Dada," *New York Times,* 16 May 1971.

12. Wilkin and Guenther, *Clement Greenberg,* 19.

13. Ibid.

14. Fitz Gibbon frequently references an important exhibition curated by Marcia Tucker at the New Museum of Contemporary Art in New York entitled *"Bad" Painting* (14 January 1978 to 28 February 1978). The show included many of the artists in Fitz Gibbon's collection, notably James Albertson, Joan Brown, Eduardo Carrillo, Charles Garabedian, and Judith Linhares.

FAMOUS JANE'S ARCADIA

Good Spelling, 1972: Dorothy Wiley and Jane Fitz Gibbon

■ FRIENDS, HERE'S A COLLECTION OF FRIENDS by friends for friends. According to me, a major content of Art is Friendship. I first breathed this idea into the invisible airwaves of KPFA-Pacifica around 1961, and this medium returned an invisible message. So (Nov. 1971), I incorporated my thesis into an *Art in America* article on the artscene here at Sacto/Davis and received a resounding No Thank You!!! from an artworld still mired in Modernist formalism. Ten years and more of catalog polemics on my part led to a no response from semioticians (or any other category of art-theorectic), yet I tried again in 1990 with my *California A–Z,* but the artworld was still honing itself to unmask (thru Deconstruction) the operative mechanism by which the work of art sneaks across its hidden agendum. This approach meant almost nothing to me—which is more than it meant to our Northern California artists. They had no patronage to speak of; critical awareness was nauseatingly off-base (Al Frankenstein) or merely hapless (Alexander Fried); the curatorial realm was fresh out of crystal balls; the academic establishment was grudging (if you can even *grudge* with your head screwed on backwards). Then there was the Public . . . WHAT PUBLIC⸘!⸘

In this atmosphere they banded together as friends. And did their work for each other's pleasure and approval. The story of those friendships, seasoned by the odd word or two about Jane and me, will be pretty much the story of these pages and, altho' it's more than a little overwhelming to contemplate, I will try to explain how art can throw some light on the ever-murky arena of gender relations or on how far to take the obligation to honor one's parents or on the prospects for Peace with Justice as well as on questions less fraught, such as how to identify good teaching in time to avoid it or how to prevent collective hysteria in docents or how to find a parking spot within a mile of the SFMOMA (includes a 1-unit course in how to reset your car clock to Pacific Standard Time). Then, I don't absolutely promise, there may be some artist-specific solutions on ■

Good Spelling, 1972

offer here—for instance how to trick Peter Van-
denBerge into coming on the day you invite him,
how to be funnier'n Bob Colescott and Clayton
Bailey *combined,* how to be more generous than
Wm. T. Wiley, etc., etc. Then too—should interest
flag—I may go ahead and name names: such as
who is playing Jimmie Chan to Bruce Nauman's
Charlie. Finally, in all conscience I cannot pledge to
abstain, should I begin to feel the reader's attention
slipping, from dropping in this or that essentially
name-dropping incident, anecdote or episode such
as, "What John Cage thought of Tchaikowsky,"
"Why Mark Rothko had such an affinity for
salmon/yellow canvases," "How I came to change
my mind about Dale Chihuly's work"; if pressed,
moreover, I might even supply the reason I shall
always pity and admire the British artist Damien
Hirst (whom I've never met). And, should I choose
to divulge it, the reader will discover that this rea-
son involves a Finland woman (the which can
prove, for more men than Mr. Hirst, a . . .).

Before I go any further, I think I'd best get myself
born, a phenomenon that overtook my mom and
me one July midnight in the deep of the Depression
in Los Angeles CA, where my father was a $9-a-
month intern. My parents had a nice house in Bev-
erly Hills. My 2-year-old memories give back a dog,

the huge (as it seemed to me) silhouette of our Ply-
mouth coupe parked in the driveway, some flower
beds and the injunction not to play in the street. I
remember my mom talking to neighbors, possibly
telling them what a hard, prolonged labor she had
travailed with me, or perhaps how I *never* slept
through my middle-of-the-nite bobbie but would
cry & wail until she rose and came to feed me.
There is a charming photo-snapshot of me at 5 on
the running board-fender of the giant 12-cylinder
6-mpg Packard touring car, the first of my father's
commitments to beauty over utility, at least where
cars are concerned. Growing up, I was always able
to borrow that little Thunderbird with the function-
less porthole, or the black Mercedes when that mar-
que was a novelty in America. My favorite? The
Chevy '55 convertible Bel Air, blue with a white
top. And how 'bout yours?

When I was 4 we moved to Pasadena. I organ-
ized a strike against nap time at Broad Oaks, a
Quaker nursery school. In 1st grade I won the
countywide American Legion essay contest on
"Why I wanted to be an American." Thru-out the
school years, I won so many competitions, bees,
prizes that today I cringe whenever I'm obligated to
look at one of those student résumés that list every
little thing. I was student body president, valedicto-
rian, chairman, captain. When I was small I talked
like one of those kids in Shakespeare—who sound
like they're around 40. Indeed my folks would drag
me out to recite Shakespeare at a party. "Who is
Sylvia, what is she, that all our swains commend
her?" And: "Tell me where is fancy bred, or in the
heart or in the head." The idea I formed then: that
this fancy bread was some sort of sugary panettone,
with gem-like currants and translucent candied
fruits has been hard to shake, and would I dare say
have pleased Wm. Shakespeare. My friend (holy,
fair & wise is she) Alison Carrillo, Ed's widow, says
it's a mixed blessing to be too precocious a kid.

The Mexican girl who took charge of me when-
ever my mother needed to get away, *se llama*
Dolores. She used to take me down to the arroyo,
where her boyfriend would be waiting. They'd

play and laugh, whilst I would wander over to my ducks. Dolores was a fan of mine & my parents would occasionally smile on her proposal to take me home to the barrio for the weekend. I retain the deepest most satisfying memories of the cooking smells; the presence of people of all ages; the warmth of all the human (& animal!) relations; the guitar playing, the mandolin; the atmosphere of "room-for-one-more." And, yes! the dirt floor.

Where was this, do you suppose? That's right: Chavez Ravine.

The War loomed, stuttered, caught Fire. We had just bought a villa in the south reaches of Laguna Beach (pop. 4,000). Victoria Drive, this was. The shelved-stepped house was laid back on the sea-cliff, so positioned that from any deck at sunset you could walk a red-gold path, the wake of the sun itself, so seem'd it, straight West to Catalina. A Hollywood producer, ——— (not a universally recognized name, to be sure), owns the place now. He did win the Preakness in 19— with ———. Go and figure. Next our house the Chinese ladies lived. The Chinese ladies were Presbyterian WASPs who occupied a manor *à la chinois,* a sort of pagoda-folly replete with irrational curves every-where designed to fox the evil spirits. To help them center their Buick when parking it, the mid-dle-aging spinsters had concrete groins built out from the garage to the sidewalk, and on these were inscribed in blue script with red rubric famil-iar counsel for the edification of pedestrian passersby: "Laying aside all malice and all guile," begins one epistle of St Peter's, "and hypocrisies, and envies, and all evil speakings, as newborn babes desire the sincere milk of the word that ye may grow thereby."

The text on the other wall might be drawn from the psalmist or one of the evangelists, in this case Mark: "Behold I send my messenger before thy face, which shall prepare thy way before thee. The voice of one crying in the Wilderness. Prepare ye the way of the Lord, make his paths straight."

If you passed this info at least 4 times a day en route to & fro "your" beach, these texts tended to stick in your head. I was ever alert to sacred texts that dealt with "John," whether as Baptist and har-binger of coming events or as the agonist in the number-one pop tune: "O Johnny O Johnny, how you can love!" In the school yard I heard that one often enough. The Chinese ladies liked me & per-mitted visits to the back of their twisty house (which of course faced the sea). The table was set with paper napkins, sandwiches & milk. Instead of an observation deck the Chinese ladies had two tall stanchions. A sizeable rowboat was stretched between them. At 106 ft. above sea level I slowly chewed my peanut butter & jelly; it offered little resistance, tho' the peanut butter was none too fresh. The Chinese ladies watched their small guest eat. Basking in the aura of their Sino-Xtian *feng shui,* and cloaked in the benignity that covers the doers of every good deed, they were spell-bound with self-satisfaction. The big question was, did this business of treating your neighbor as yourself extend to inviting me to share their boat when the Time Came??? For the present they would defer the issue, they decided. Deal with the question when the Time Came. Because the Time *was* Coming. The Second Flood. My mother was sometimes right. On our street everybody but us was a trifle on the loony side. The Chinese ladies, tho', the Chinese ladies bore it away.

■

I hurried past Mr. Kendrick's house next door and on past the people nobody knew; the Samuel F. B. Morses' house—their Laguna house—was next, then Mr. & Mrs. Bamberger, whose estate was bordered on the far side by the public access steps down to the immensely popular swimmable beach. I was just on time to meet my best friend Byron Isaacs for the swimming lesson we received each day that summer and fall from Lt. Isaacs, Byron's father, who was on 3 mos. leave between his European theatre assignment and new duties, presumably in the Pacific. My own father, with the rank of major, was set to running a small hospital next to an airfield in Northern Ireland. The idea was to accommodate wounded bombers returning

■

1

William Geis,
Untitled (Kill),
ca. 1969

from raids over Germany or France. He was gone for the duration.

Byron & I built some excellent forts in the bamboo brake that covered the rivulet that trickled down to the rocky part of the beach where the Headland began. We would leave my little brother standing guard over a fort while we went adventuring for hours. I still feel a sharp remorse.

Before we could have our lesson, Byron & I had to lie prone for about 45 minutes while the senior Isaacs had his swim. We inched forward on our stomachs, hunching new, sunheated sand to our chests and carefully watching the swim exercises being demonstrated for our benefit. Finally Lt. Isaacs would come dripping out of the sea and run

up to us, and it would be our turn. Under these conditions I learned to use face-plate, trident, fins & a kind of lugwrench/crowbar (for abalone). I could float out behind the breakers for an hour at a time, I could dive thru any wave the Ocean chose to challenge me, and I could ride the biggest comber. To bodysurf the day away, that was pure 10-year-old satisfaction.

We were back in school when the telegram came ". . . killed in the 2nd wave at Iwo Jima." Mrs. Isaacs, 29 & lissome, took Byron & his baby brother back to Alabama where her folks lived.

Good reader, take a minute now to look at Bill Geis's big untitled drawing (fig. 1), which actually does have a title—or at least it spells out a word.

A 4-letter word. This piece hung above my desk in the chairman's office at Sack State for 6 mos. before it hit me: this drawing is trying to say something. Reader, can you read it? Now as a boy I buried the episode of Byron's father's death. I had not learned yet how to be sorry for another person's grief; that's something that takes time, and it's an area where art can help. Friends, don't muscle your kids into those museum trips. They are not ready for R-rated Love and they are not ready for Death. Anyway, I didn't think a single thought about my friend's father for ten years, growing up, and then it all rushed back at me, one La Guardia-to-S.F. December all-nite flight crossing a darkened America sea to sea on an old DC-6. This American Airlines "red eye" was called the Christmas Plane because all the Ivy League boys and girls en route home to Northern California did their best to book it. It was a good time. I was seated next to a red-headed Wellesley girl, listening to her story & trying to get over a little personality. Then I told my side, and out tumbled the death of my friend's dad. The view of Lt. Isaacs afforded the Japanese machine gun nest, I realized, was just the one shared by Byron & me as we lay in wait for our swimming lesson. I can point to that exact moment of deadly irony, somewhere above the Great Plains, as the instant when I recognized that each person bears responsibility for the killing and that it would be up to me, someday, to do something. Real middle of the night Big Talk, huh? But there it was.

Has the kind reader puzzled out the Geis yet? Geis with his leaps of wit, his taste for paradox, his visual grammar of bleached seawrack, of flotsam & jetsam, was a mighty influence on Hudson, particularly, but also Wiley in the early days, and Bill Allan, even. Without Geis the early Wiley masterwork *Columbus Rerouted* #3 (1962) belonging to the Crocker is hard to conceive. But Geis could be difficult personally. Very difficult. You had to confront him early, the only way. I remember the first social encounter I had with him, lunch at Bill & Suzy's Mt. Tam cabin in the trees. The event went off cordially, but as we got ready to go, headed for dinner

at the Raffaels' (then stepping on eggshells as renter occupants of the white Venetian palazzo that David Simpson plastered onto a formerly charming neighborhood in Pt. Richmond), I announced that we were completely broke, and could we have 50¢ for bridgefare? Bill looked at me. My eyes held firm. Bill Geis went & fetched from a drawer a Kennedy half-dollar. I have it still. After that, matters went well between Geis and me, but he continued to put me in mind of Peter Beagle's observation that when you see a harpy smile you'll wish you were looking in another place. One night, however (this was at our houseboat under the Elkhorn Bridge over the Sacramento), Geis was in high dudgeon, tossing things about, pissing in the river and acting menacingly toward our six-year-old. Jane drew the line at this. She tossed him out. The next week Bill apologized. And he told me the following: Bill's father was a Top Sergeant serving in the island-hopping war in the Pacific. One day, when Bill was about 5½ his father took his hand and led the boy down the steps to the basement. He pulled on the light bulb, and drew down a long leather case. Unlatching the narrow box he withdrew a steel bayonet, holding it to the light. "Do you see this Knife? With this knife I KILLED 5 men. And I want you to grow strong and KILL!!!!!"

Geis grew big alright—he's a huge fellow who carries himself even huger, but he hasn't killed a lot of people that one knows of (unless it turns out that Geis is the Docent-Murder killer, and I don't know anybody who believes that). Stomp on a few horrible student sculptures—that could be Geis (or Dave Gilhooly). Murder, no.

But I should not make light of a situation where the forces warring in an artist's psyche resulted in such brilliant work, work that was pathfinding then and always, work that was of benefit to so many of the friends gathered here. What Geis wanted me to know is that in the basement of every man's brain is the ex cathedra injunction to KILL, a "gift" from father to son. "I want you to take this knife and KILL!" And that this lamentable truth

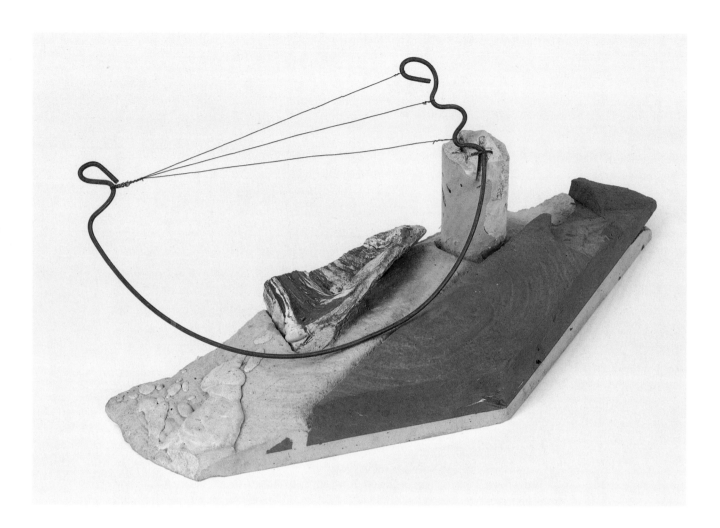

2

William Geis,

Plato's Harp,

1969

must be understood, resisted, and compensated for. We are a weapons-carrying animal. And what you carry it will always make a certain sense to use.

What a wonderful drawing, though. The setting is a tropical island complete with palm trees, sand & camouflage. A partially outlined dead man slumps against a tree, returning to dust. We are looking at the sole of his shoe. Above him the foliage spells a word. Of course, KILL. Notice how the bottom of the "I" drops open on a hinge and out of the black case falls the devastated little boy, his "ego" blasted forever. The pulverized body of the dead man breaks down further into geometric segments, as we move Big Bang-like from the center outward, and these geometries vector, separate, and vector onward toward the corners of the page, where they disperse finally as molecular energy.

Bill Geis excels at setting up unresolved formal tensions in such a way that the play of forms comes off as dynamically charged—instead of "wrong." Commonly a sculpture will rise up out of a horizontal plane and bifurcate, with the two pieces "talking" to each other, call & response, catercorner across the field plane. Geis knows how to ring the changes on the familiar organic/geometric split, and he is good at exploiting conventional sculptural antinomies that have a sexual echo: hard/soft, melted/solid, wet/dry. At the same time he is capable of the quiet neoclassical harmony of the pellucid little *Plato's Harp* (fig. 2), where a bow of steel mediates between the horizontal/vertical thrusts, and all is calm resolution. How one would like to see such a piece executed at public scale.

For many years now Bill Geis has done no art—at least for outside consumption. Bill and his wife Tibi, a painter, live in the artists' haven established in the Old Creamery in Bodega by the late Bill Morehouse. We used to get them to come for visits here but that broke down and after a cancellation & rescheduling Tibi wrote to say, "Father t-rex just isn't up to it." I always liked Bill Geis, and I miss his scary smile. Bill showed the same face to all comers. Unless there is some octogenarian still serving the Emperor from an island cave, I think it could be maintained that Bill Geis is the last casualty of WW II.

In early days of the California School of Fine Arts/S.F. Art Institute, Geis clearly influenced Wiley's use of whaleroad imagery, as in the Crocker's masterful diptych. But Wiley wasn't interested in Leviathan thrashing and splashing and crashing and smashing in the best Bill Geis Destroy & Create manner. Bill Wiley was interested in *flukes*. We all live in pretty much a consensus reality where we manage to fit everything in. We are delivered from this prison of self-fabrication only by keeping aware of flukes, enigmas, paradoxes and other spoilers of the orthodox consensus view of reality. Through these holes, as it were, the spiritual realm can manifest itself. Without the spiritual realm, dear reader, paintings are just decorated textiles. The pun may be the lowest form of humor, but in Wiley's hands the pun becomes an awl to puncture the All.

(Sorry.)

Of a philosophical turn of mind, Wiley is well suited for the role of Teacher, or indeed of legislator. Tall, handsome, down to earth, and the inventor of a unique visual realm that can be drawn under no New York umbrella, William Wiley is that city's greatest fears incarnate. Attempts have been made to derail him. One Whitney Biennial the curator put up two facing interior walls. A Jasper Johns Map painting looked at one of Wiley's. This proved that Jasper was serious and an all-around champ of a painter, while Wiley was a cornball doodler of no real significance. At least

Good Spelling, 1972: William Wiley

it proved this if you already felt that way before you went in the museum. To me it showed that while Jasper Johns, like WTW, had understood the Issue—America—from the beginning, Jasper lacked any sympathy for paint as paint and his drawing skills are for the *pájaros*. Both these artists have Duchamp as principal antecedent, Duchamp rather than Picasso or Matisse—the way it is with most artists contemporary with Jasper & Bill. One time when I was teaching over at Davis I ran into Wiley who said he was just back from Philadelphia. "Oh, you lucky!!" I gushed and Wiley had to listen to me chirp away about Duchamp for 5 minutes, how Wiley must've enjoyed seeing all that work of his mentor's gathered in the museum, and on & on, as ingratiating as I can be when I want to. Wiley cut me short. "Yes," he said, "I saw he couldn't draw."

Wiley intended no diminution of Marcel Duchamp. He was merely warning me against the stock response to the stock assumption. The true teacher teaches all the time. One day, looking for an eraser, I wandered into Wiley's drawing class. The students were working, the classroom was quiet as the still-life setup. In the center of the room sitting atop the high stool he sometimes incorporated into his Mr. Unnatural graphics,

Wiley had his head tilted way back. I followed his gaze in order to see what was fascinating Wiley. Nothing. Wiley was simply bored to the 33rd power. Ten days later I heard he had quit. From close to the beginning Wiley arrived at the place where Nothing is interesting. Jasper Johns has an early "sculpture" that is just a white painted, sort of phallic, standing *Numeral 1*. Around the same time the young Philip Pearlstein did his *Superman* paintings. William Wiley, though, was focused on Zero. "Don't try to change the world," John Cage admonishes, "you will only make it worse." Wiley as a matter of fact has done as much as anyone I can think of to work against War and to forward wise policies. But Eastern critics persisted and persist still in typing Wiley as "laid back," a typical California dopey lounger. With no excuse at all, and good reason to know better, Tom Albright out here took a similar tack of willful misunderstanding. The charge against Wiley was that he was (well, what else!) guilty of being a California artist. Bob Arneson (in *California Artist* [1982], coll. SFMOMA) bothered to answer the indictment. Wiley didn't bother. I'll admit it right here: on one occasion I DID see Wiley laid back. This was in the lobby at MOMA, hard by the bookstore. They used to have those long wooden benches there, you could wait for your friends to show up. Wiley & I happened to be in New York at the same time and there he was, stretched out on one of those benches before the turnstile, sound asleep. What if Hilton Kramer or somebody had chanced by instead of the present writer? They'd have had the goods on Wiley, for certain. I didn't wake Wiley. It's not a felony, reader, to fall asleep on a museum bench. It did hit me as uncharacteristically discourteous on Wiley's part. He is after all quite tall and 7 or 8 pregnant women or guys with Parkinson's disease could have taken a load off their toes were it not for this laid-back Westcoaster.

Wm. T. Wiley got right to work on the "America" topic, turning out 3 series of emblematic American icon paintings by the time the Whitney saw fit to purchase *Time Table* (1959), a good-sized semi-AbEx jumble of flag, stars, clocks on a semi-discernible tabletop, and (typically of Wiley) raising more questions than it answered. This painting was included in Lloyd Goodrich's exhibition *40 Artists under Forty* a year or so later. Wiley was the youngest artist in the show. In his statement Bill claims he just "started with the obvious [i.e., the flags], which I hope evolve into the more subtle language of the things I see and love. . . . [The flags] came about through a sudden interest in the country I was living in but was not seeing or painting. Until this time contemporary Eastern [i.e., N.Y.] and European art had been a main interest." Was Wiley at all involved in the Jasper Johns issue: how to paint an intrinsically flat object—a flag—on a ditto surface—a canvas? Not at all. Wiley felt that all formal considerations would take care of themselves (as indeed they usually do). What WTW cared about (and let's not take anything from Johns; he cared too; both men were pointing at the Flag) was whether the Flag still stood for the same things we grew up believing: Justice, Peace, fair play; right relations between rulers and ruled in this our Time and Age. Right relations are what abstract geometric painting, like Leo Valledor's, like Hassel Smith's, are all about. A harmonious order, a signal to the State. Right relations are what conceptual art's about. Take Steve Kaltenbach, Wiley-friend and quondam student. Steve's *P E A C E* piece. Here's a work (fig. 3) that factors William Wiley's art all the way down to the bone. Yet a constellation of questions persists. Should the piece be larger? Smaller? Another color? Must it be hung right side up? (Yes!) What about the degree of relief? Will it "read" in the mirror? (No.) Would "PAX" or "PAIX" work just as well? (Maybe.) Can it be made of a different material from concrete? (I think so.) Can it exist in a larger edition? (Why not?) Does it belong in regular face, or would script serve as well? (?) Would a circular, trapezoidal, or square format suit better than the lateral rectangle Steve chose? (NO.)

All of these doubts can be used to interrogate Kaltenbach's conceptual P E A C E, but what is beyond question is the fact that the content of

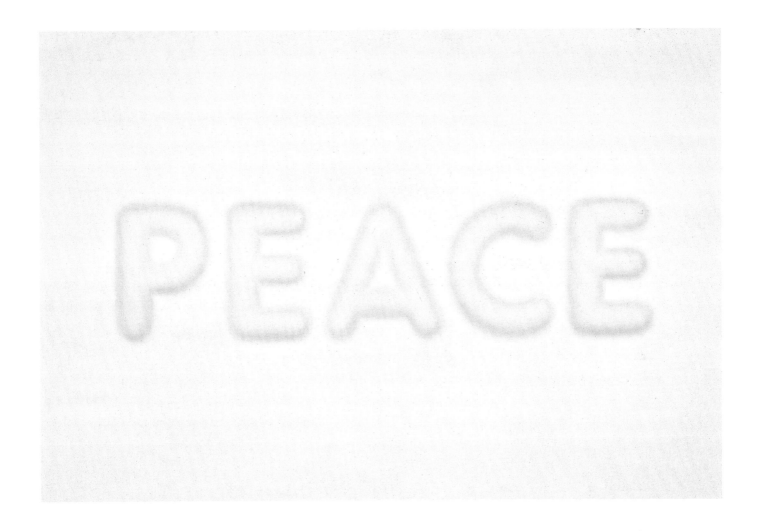

Steve's work is the same as an early Wiley *Peaceable Kingdom*, or as a late Robert Arneson from *that* Kaltenbach friend & teacher's "Col. Nuke" series against militarism. The 50 or so Edward Hicks's *Peaceable Kingdom*s that remain to us have the same message: the lion shall lie down with the lamb. In the background of each version Hicks quotes the Quaker painter Benjamin West's *Penn's Treaty with the Indians*, the one & only diplomatic agreement with Native Americans never abrogated the moment Profit knocked. I did a *Peaceable Kingdom* performance-event myself (about which a little more later) in order to celebrate the bicentennial, Pilot Hill-style. Those Quaker nursery schools know how to getcha early. I wouldn't be too surprised to find that my vision of artists as a Society of Friends was nurtured in the selfsame source.

At any rate, readers, the main issues for WTW, early, middle, and as late as yesterday, have been issues of content: how to achieve Justice, Peace, a non-violent society. Formal issues, no. How to prevent Saturn from devouring his children, yes. It would be a mistake to suppose that artists as a class are unpatriotic subversive malingerers. As a group they tend to support Democracy and honor the Flag for what it means—or should mean. Good Government vs. Bad Gov't has been the thesis of a lot of art between Ambrogio Lorenzetti and Wm. T. Wiley and the topic is fully alive in Northern California in our day, with Bob Arneson hiking the ball to Wiley and Jim Pomeroy & Jock Reynolds going out for a pass.

These last two—Pomeroy and Reynolds—I had already planned to treat here in tandem when by

3

Stephen Kaltenbach, *Model for a Blastproof Peace Monument,* 1992

■

accident I learned that they shared a studio-loft space in San Francisco for quite a little time. It sure does figure. They recorded, separately, the two best politically motivated installations ever seen around here. Jock Reynolds's and Suzanne Hellmuth's target was malfeasant congressmen. Their bad votes & general wrongdoings under color of authority were fact-sheeted & posted around a large room generously decked with flags, red-white-and-blue swags and all manner of bunting and crepe. There was a fund-raising quotient to this election spoof—you threw dimes at cups—and a lot of citizens not just from the artworld openings crowd came, laughed, read the sober research on which legislators got what from whom, laughed again & went home wiser than they started. Over this pseudo-patriotic hustings Uncle Sam himself (well-portrayed by the tall stringy artist) cast a glittering eye.

Pomeroy's baby was Mt. Rushmore, that most elephantine of white pachyderms, that lodestone of kitsch, that bathetic and crypto-facist monument to the mediocrity of the little man's taste. In the high exhibition hall at SFAI Pomeroy evoked not just the mountain itself but every toy, booklet, gameboard, thriftstore collectible, every pillow, scarf, tee-shirt, cap, knife, Injun doodad, 3-D postcard, bumpersticker, every radio aerial finial, pennant, huggy-bear, ranger figurine, burl carving and license plate mount. Every last item was there, from pillar to poster. It was wonderfully horrible. Jim made no comment. Indeed, the stuff spoke for itself. Maybe the best, I liked the canned ranger speech. And the photo of the RVs leaking away in the jammed parking area. Oh, and the Rushmore deck of cards. Somehow all these pop-fetishes hung together, clung together is better; there was a certain organicity. Pomeroy brought it off. It was a lot of work, just to show that the Presidency in our day is a kitsch Presidency. Roy Lichtenstein made the point that the Presidency has declined, gone down in quality, with a single painting—his Jefferson 3¢ stamp, quality-less, crude & flat ugly. Compared with the work of Gilbert Stuart's circle,

Lichtenstein's Jefferson is a shoddy business. I have on my desk Pomeroy's transparent plastic relief portrait of President Lincoln. Old Abe appears cuckoo. But if you hold the piece up, between a lamp and a white wall, the familiar dignified Lincoln is shadowed forth. Present and Past meet. And the "past" President looks mighty grim at what he sees.

■

Jim Pomeroy was fond of introducing old, dated obsolescent technologies of seeing into his work. This made you pay attention. His overall message was about taking the time & the effort to see well. Using, say, a stereopticon slowed you down but it was worth it. And those dissolving views. Remember them! Everyone's all-time favorite Pomeroy is the rotating drum wheel with photographs of a lizard and of Fred Astaire. You turn the crank, peep thru the hole, and you see A Newt Ascending Astaire's Face. Jim was missed by me & by many when he slipped away at 49. Brain hemorrhage. From Texas, Pomeroy came under Melchert's tutelage at Cal, on to Davis and unofficial mentoring by WTW. Behind them, Marcel Duchamp.

Wiley, asked how he bore so many imitators of his idiosyncratic drawing manor, replied that *he* stole from everybody, and Welcome. He drew my manor one time, and the cussed hillclimbing road that winds up to it (fig. 4). This is in ballpoint pen in one corner of those chamois-like "hides." Beneath the house he wrote *Delta Ledge End*, which was kind of him & pleased Jane & me. He also handpainted the word *Singe* across the litho. I thot to myself, Wiley can't know that this word cuts 3 ways! Then I thot, He can! I thot back a little. Impressed by Wiley's Goodspelling (i.e., Gospel-ing) I had invited WTW, Elmer Bischoff & more wise men to come up & ride with me thru untouched countryside a couple of miles, ending up at a stable where they were awaited by a young couple & their infant son on hay bales, she all in blue, he in carpenter's togs. Along their way Wiley & others would encounter not shepherds but cowboys to the number of 100, plus the same

4

William Wiley,

Delta Ledge End,

1972

Good Spelling, 1972: Elmer Bischoff and William Wiley

Good Spelling, 1972: Manuel Neri

number of angels ("long skirts, please, no jeans"), all these trailside well-wishers urging & pointing the riders toward the stable where presently all gathered, looked at the imagery and passed into the corral for the picnic.

But a couple weeks before the *Good Spelling* Event Bill Allan came up to me: "Wiley isn't keen on doing this, John." My heart sank. I looked up at the Sack State art building, which looks like a motel. It isn't made of plastic but it looks like it is. The art building maintained a plastic silence. Finally, and for probably the first time in my life, I thot of the right thing to say. "Please tell Bill that somebody has to go first."

So Wiley went first, as indeed he is destined to do; and Jane gave opinion that he hadn't had that bad of a time with it. The party after had its moments. I had brought Lance Richbourg in to be a sort of Master of Equine Safety and Lance (in orange chaps) *walked his horse up the stone steps* to the wooden deck where the band was playing and couples dancing. For reasons unknowable to mere earth minds, the redwood deck held and we weren't sued for $100 million, or whatever they get for angels, going rate.

The Wileys, Bill and Dorothy, seemed . . . *laid back* at the post-event party/dance. A bit before dark, they left in Wiley's sporty swept-back-from-the-cab American truck without any overtly hostile act, such as stealing the silver or sump'n, and with, in fact, a friendly wave. So I was relieved about having put Wiley on the spot, asking him to go first, as it were. Not long after came the hand-painted lithograph. Singe. Plus the delta legend drawing. Primo, Wiley had been chary of a scenario that called on him to escort other wise men into the Space/Time of those museum paintings that record the visit of Kings, cowboys & angels to a stable where a baby lay in a manger. Might he be burned by this enterprise? It was only a singe. Secondo, the reference goes to me (John)—or at least to the myth fastened on me—*sub specie* John Millington Synge (*Playboy of the Western World*). Terzo, the word *singe* means *en français* monkey.

Thus I, John Fitz Gibbon, am John Monkeyson, "Fitz" being an early corruption of the Norman *fils*. Fitz Gerald = Son of Gerald. Fitz Alan = Son of Alan. Fitz-Frankenstein = Son of Frankenstein. Etc.

Wiley is really fond of these tri-level, cross-lingual flights? Since the period of his Bordeaux visitation, yes. Also, *cf.* the old Salt Cellar (or rather Salt Seller, the Marchand du Sel). Duchamp's most notorious cross-lingual play on words (as I have pointed out so many times) is (or would be if anyone is listening this time) the true title of his Large Glass: *The Bride Stripped Bare by Her Bachelor Seven*.

As a young artist Wiley was almost completely transparent. Another way to put it is that Wiley was extremely Hot. The story is told that John Coplans, out here on a visit, made an appointment to see the work of a girl student who came to his lecture. This person had a share in WTW's living arrangement. When Coplans showed up, he passed WTW in the foyer. Wiley was seated on a tatami mat, leaning forward, drawing. He did not look up. When Coplans departed Wiley was still seated cross-legged on the tatami, bent over his drawing board. He did not look up. Coplans had no luck whatever with the star artists hereabouts. I was in Richard Diebenkorn's studio a few years earlier when Coplans arrived with one of his putrid little violet & green hard-edge abstractions. This was for trade, an idea so grounded in self-deception that I could almost feel empathy for the poor hack. Dick went ahead & made a drawing of John but ended by writing "with reservations" on Coplans's shifty likeness. The only comparable instance I recall was when Diebenkorn tried to draw Kenneth Rexroth and Ken had too many conflicting personalities for Dick to fix him on the page. But we all liked Rexroth. (I knew him from the station KPFA, and visited him in S.F. on occasion. Kenneth did something nice: for the benefit of his toddler children he hung his small Tobeyesque vermicular paintings on paper just above the baseboard of his apartment.) But I was starting to say how transparent Wiley was as a neophyte. Similar thing

happened to Jim Nutt in Chicago a little later. Someone organized a show of artists who employed language in their paintings & Nutt was roped into a show that featured Fluxus artists, Allan Kaprow, and other curious cellmates. Same kinda thing occurs with Bruce Nauman, year in year out; Bruce just seems to fit.

When Bay Area Figuration gained momentum it was decided to stage a survey. It's clear from our perspective that WTW didn't belong. But he was too hot to leave out. Evidently figuring wot-the-hell, Wiley submitted a large *Plane Crash!* I fine-tuned my sense of the absurd on that painting. Baffled in the Oakland Museum, that was this unfledged art critic.

Wiley now faced the task of positioning himself. He didn't want to belong. Not to the Bay Area figurative movement, even if like Manuel Neri he could match them at their own game. Nor did he want to follow along in the SFAI tradition, like Carlos Villa, then making heroic AbEx paintings the equal of his mentors. Wiley wanted something a little more . . . Wiley. Others, then, could follow *him*, tho' he probably didn't put it to himself in those terms.

The basis for Bill Wiley's self-invention was line (figs. 5, 6). Line at the service of Imagination more than of observation. In his eye, shoulder, elbow, good left arm, wrist, hand and fingers Wiley happened to have the Rolls Royce of linear vehicles. That's what he relied on, and virtually nothing else. I've always wondered at just how idiomatic, how "far out" (a locution fully recovered from cliché by now) WTW's achievement is. How idiotic—*idios* being a Greek word for "off by yourself." Of course, there's Roy De Forest. Roy's realm, however magical, is indebted to Child Art (fig. 7). Miro? Looks back nearly to infancy. Picasso is no doubt the innovator of his century; cubism, though, owes African art, owes Oceanic. Wiley on the other hand is without creditors. His Map paintings are in debt to no art convention. Fairly amazing, no?

Wiley invented himself out of whole Wiley cloth. Amazement sits on this poor writer's quizzical brow. You cannot doubt a FeeNom. ■

5

William Wiley, Study
for *Sacramento*
2000 (recto), 1997

6

William Wiley, Study
for *Sacramento*
2000 (verso), 1997

7

Roy De Forest,
*Bigfoot Series (Dog
in the Woods),* 1988

The big Map paintings are not about the inherent flatness of maps; that issue's there but it's incidental to Wiley—as it is *not* to Johns. True, Wiley indicates the shallowest of spaces. The marks do not go into depth but race across the canvas horizontally and up & down; there are very few stressed diagonals to lead the eye into naturalistic space. In *Diamonds in the Rough* (fig. 8) what confident, various, non-repetitive marks they are! I've looked at this painting for 30 years without coming close to exhausting the pleasure of keeping company with a master draftsman. The work is rich in informations. At the center of a large approximate map of the United States is a dark-pupiled bloodshot eye, which is of course also an "I" and perhaps also a starsun image of some sort, or a kind of initial cell, then, a zygotic image implying birth-of-universe or cosmic yolk could do, or—better mention—cosmic joke. Certainly the painting deals with the Birth of William T. Wiley, which took place in Columbus, Indiana, where that yellow umbilical cord emerges from that dark egg and begins its spiral loop (indicating Time) from this omphalos or World-Navel. We follow the yellow (brick?) line across the "American" South & Southwest, where it turns blue & veers upward toward the Pacific Northwest, where young Wiley apparently ran into a little blood & tears—it can happen to a teenager. That's the personal story behind this epic painting: an ordinary ■

William Wiley,
Diamonds
in the Rough, 1972

American family bounced Westward in the lingering Depression and then north to Eastern Washington, looking the whole way for luck and work in a Raymond Carver world full of sadness and light. And by a quirky quirk the path dead ends at the plutonium plant; a situation that brought the young Wiley face-to-face aware of the Damoclean sword hanging above the neck of an America that continues right on stuffing itself. The young artist musta thot (& may think still) along the lines of: O cursed spite / That ever I was born to set it right.

Connections that might seem forced or merely arbitrary impositions, coming from someone else, flow naturally and convincingly from Wiley. *Diamonds* (they are those little cameos of gemmy color scattered) *in the Rough* is, for my money, the flagship painting of the Map series based on the notion of Columbus Re-routed. For damned sure, it was the painting that cured me of the gingerly scruple I'd for some years developed against BUYING ART. Wasn't it a tad non-ethical, I'd asked myself, to be

TALKING ART on the electric radio (KPFA-FM) when I personally owned some of the artists' work I was analyzing on the air? And had said work hanging right there in our living room, tacked high enough up so's the kids' sticky fingers couldn't reach? Was that fair play? These doubts crept in after an initial period of buying pictures from the Bay Area figurative school and just as I was beginning to acquaint myself with transitional artists like Manuel Neri & Joan Brown, transitional, that is, to Funk and to the increasingly heir-apparent group of Friends around William Wiley. My misgivings over whether you could own art and write/talk about it with any semblance of impartiality simply pulled up stakes & doused the campfire when *Diamonds in the Rough* came on my horizon. It is one of those works that offer just about all an artist has to say. A? r? k? Spells ark. *Diamonds* is a painting about starting out and starting over. And God looked at the world, and saw that it was bad. So God had Noah build an ark. And He whelmed the world with flood.

Wiley's Map series suggests that America itself can embody that Ark, that America can offer the world, steeped though it be in the iniquities of yesterday, today and tomorrow, a real second chance, an opportunity to start over, for Mankind to try again. So the "ark" is the Mayflower revisited and all the other ships launched in our direction in pursuit of communities of freedom.

It goeth similarly with the notion of *Columbus Rerouted.* By an accident of birth Wiley could legitimately access the Columbus-discovery trope of a New World turning away from an Old World sunk in sin & oppression. Bill Wiley's idea is that a new start can be made, Columbus's failed and compromised endeavor can be re-rooted in the expectation and hope of a better result. WTW took his cue from the serendipitous street-repair project that caused Columbus Ave. just below the S.F. Art Institute to be re-routed for a couple of months while this principal North Beach thoroughfare was dug up and trenched. What was for everyone else merely an irksome delay, Wiley turned into one more opportunity to play onwards.

Wiley's "ark" is also (and this is of perhaps equal importance) the Ark of the Covenant between God and his Chosen People. In the Old Testament, God's Chosen are the Jews; in WTW'S formulation Americans are the chosen of God; and the Chosen of the chosen are . . . the artists! And what is it the artists seek? (Here I avail myself of the professional right to sermocination & just cross my fingers in hope that Bill Allan will not be felled by this obsolete word, which deserves to be brought back into usage as I do here for its beauty and accuracy, crossing my fingers as I said, in the honest hope that this lovely word, "sermocination" will not stroke Bill Allan—at least on the side of the brain that governs the intake of wry whiskey; be assured, dear readers, the present writer wishes a stroke on nobody, artist or otherwise.) I only started out to say what it is the artists seek. They seek the Promised Land.

So then, that about says as much as *can* be said about *Diamonds in the Rough* (1972)? No, not quite

I'm afraid. Indeed perhaps the best gloss to the painting has come from the 5-year-old daughter of my longtime friend, Denise, who had in mind to show off bright little Heather. "Tell Mommie what that is, Heth." The "right" answer to the question was, "It's a map." We all waited. Heather eyeballed the giant canvas much like the little kid before the easel in Courbet's big *Studio* painting. I continued to wait, impatient. Finally, the very pretty little child turned to face her mother. "It's a Ewafump," Heather announced.

I had not seen it!!

Not only are we dealing with a regulation elephant with gray hide & trunk, it's a very particular pachyderm, familiar to the reader from childhood tales by . . . Kipling? Nope. Jean de Brunhoff? Yes, but not Babar himself. The wise old Cornelius, then? Yes. Given the weight Wiley was placing in that era on what he termed "Wizdumb," a wise old elephant should have been spotted right away. I took the painting on a State Department-authorized tour of Brazil (the gallery made this a condition of my being allowed to buy the piece), and it soon after traveled to Wiley's show at Eindhoven; no one saw the elephant, drunk or sober. It took an innocent eye to see the wise elephant. How cautionary.

Can the good reader believe it? There is more to come. Moreover more is more. A while back I claimed that Wiley had no art antecedents. He does of course make use of Sioux & Kiowa painted buffalo hides—but that is a rescue on Wiley's part, not a dependence; Scott Shields hazards that the caves may lie behind the markmaking—and this is much in keeping with the Wiley outlook. What is certain is this: when *Diamonds* first came to Pilot Hill, after the South American show, Jane & I decided we could spend a few hours *counting* the number of "abstract" faces we could see in Wiley's painting. Our tallies widely diverged, but both of us were well up in the hundreds. The reader wants to play this game? All you need for a "face" is an eye, nose, mouth, chin & perhaps a sprout or two of hair. Most of your faces will be profiles. Do whales, pooches, etc., count? I count 'em, animals ∎

have faces. Leonardo was the first to observe that an old cracked wall will yield warring armies, while in Hamlet we learn that a cloud may be "very like a camel," so it isn't just cave people or tribal seers who perceive faces in rock formations or picture clouds backed like a whale; it's all of us. The Imagination is what made us human in the first place, it's what keeps us human now. Just as Wiley reduced the operations of the verbal imagination down as far as the pun, so he factors the visual imagination all the way down to those "accidental" recognitions of "spirit-faces" he or you or I might notice while staring, like the Indians who lived here before us, at the pebbled race of Paper Mill Creek. "Man's Nature" (the title of an early Wiley film) incorporates this very image—of running water over creekstones. And WTW not infrequently employs a skeleton stick figure as protagonist; here he marches West under the aegis of WTW's familiar equilateral triangle, an essay in three-person'd metaphysics I for one find more compelling than Father, Son & Holy Ghost; in Wiley's version of Man's Nature Man's Supernatural Mind is in perfect balance with Man's Natural Mind is in perfect poise with Man's Unnatural Mind. Where most of us come a cropper is in our failure to acknowledge, even to ourselves this 3rd unnatural leg of our experience. That 3rd leg always giveth trouble. It's ever amazed me that Wiley, the most natural, the most natively gracious of men, should be willing to take on, for all our sakes, the flasher robe of "Mr. Unnatural."

Jane poked her head in as I sat bemused and musing, and asked if I were done with *Diamonds?* "Never done, I spoze. But for now, finished."

"Well, don't you think you should qualify your admiration for *Diamonds*, just a little? I mean, why can't he bring over that radiant color from the watercolors? And put it into the acrylics, I mean?"

"Well, he seems to be doing just that," I said. "Nowadays. In the new Brueghelesque replays. But I don't see that *Diamonds* could be any improved at all, Jane." And I looked over at the 11-ft.-long "map" of the United States of America for the thousandth time. "You don't feel," I ventured, "that it's too autobiographical?"

Now Jane can scorn with the Scorners. The reader will appreciate. The flip side of domestic bliss is domestic scorn. Jane gave me her look. It has 50 years of practice behind it. "Do you really think," she asked, softening it a bit with an interrogative, "that a work of art can be *too* autobiographical?"

America the beautiful. A major topic for the friends gathered between these boards. Especially for (as I, their Arthur & Author, dubbed them) the Sonoma Four. Bill Wheeler, Tony King, Jack Stuppin, Bill Morehouse. It all started as a sort of tease, really. These guys had been out doing *plein-air* painting in the Sonoma countryside and at the ocean. Stuppin got them together for a September Fence Show—painted outadoors, hung outadoors—at the Coffee Grounds, the old Charles Schulz estate on Coffee Lane in Sebastopol. They had come together for comradeship and (they were each in a different stage of career uncertainty) for mutual moral support. They were out there trying something new that was also something old. This put them at some personal & professional risk—for good ole peersneer (which is more deadly than you'd think). My dear friend Brian O'Doherty likes to make the point that it's peer-fear that keeps artists or generals or organ-transplant doctors from innovation. Thus if some idjit were to try to slip across (may God prevent) a novel form of art criticism there'd be voices on the sidelines crying "Who said ya could do it thattaway?!?'*%#??!!" Anyway, if the Sonoma Four wanted to get their shirt stuck on barbed wire or their cotton duck hailed on or come down with pleurisy for the Winter, I figgered: Let'm. The Sonoma hinterland is not Provence, true; neither is it the Yukon. Stuppin, an investment banker, had made 3 bags full of gold thru risk-taking. I was to find out that hanging paintings on a fence in the sunlight instead of in a cream-white box under tracklites was the sort of fresh approach to be expected from Jack. Before breakfast, one of the seven sacred meals in the day, Jack has likely figured out some previously unimag-

9

Jack Stuppin,
*Farallon Islands,
September 25,
1995*, 1995

ined way to merchandise his art to the unwary rich (who are everywhere). It is wery, wery hard in this weary world to run across a decent primitive, much less one who can pick up the check. From just about the beginning I was carried along by Jack's lap-lap chk-chk crisscross strictly from the knuckles brushstroking; if viewers let themselves listen to the metronomic handbeat of a true primitive all hearts will soon be lulled. Is Jack Stuppin, with his unnaturally bright fairytale color, the pulse/impulse/pulse/impulse of his small brush, truly an "outsider"? Have a look (fig. 9). Unconvinced? Try faking one. You can fake a Picasso easier than you can produce a mock Jack Stuppin. I don't want to make a big fuss here. I like Jack &

Jack's work. Charmed me. From the beginning, just about.

The Sonoma Four episode started as a casual joke, then it turned serious. And back to joke again, this time leaving me with egg on my face. Only it was worse'n that. More like what we useta do to high school rivals: break an egg on their m/c engine while it was running. Virtually impossible to remove.

What I'd seen at the first Fence Show were 4 artists in pursuit of an identity. By the simple expedient of Naming them—I was the Adam in their Garden—I had provided cover for their operation. Whole echelons of Sonoma landscape painters now sprang up (the North Coast 4, the Donkeybarn

10

Tony King,
Cape Arago,
Oregon Coast, 2001

■

Group, etc.) as tho' Deucalion & Pyrrha were still around tossing stones over the shoulder. I had allowed myself the Monstrous (this is unpardonable but here goes) and fundamentally creepy thought that I might have *my own* art movement with which to test my thesis that Friendship is a major content of art. I know, horrible; please to forgive, if the reader can. I was seeking a situation where artists might work under the same umbrella, all the while directing their work at each other in friendly challenge. And for a time this seemed actually to be working. Then Bill Morehouse died, the group elder. And with him the

moral authority to carry on, subordinating self to whole. Immediately, two turned against the third guy. Usually it was Tony & Bill vs. Jack. There was competition; jealousies of various sorts; money matters surfaced; there was lack of respect and "room" for the other chap. I was forever on the telephone reconciling, smoothing over, quieting. But I lacked enough Arthur in me to keep these Sonoma knights at the peaceable Table Round. My thesis lay ruined on top of my phone bill. Whether ruined for good, we'll see. Friends or no, at least "our" larger topic survived & proved to have a sustaining life of its own: "America the Beautiful."

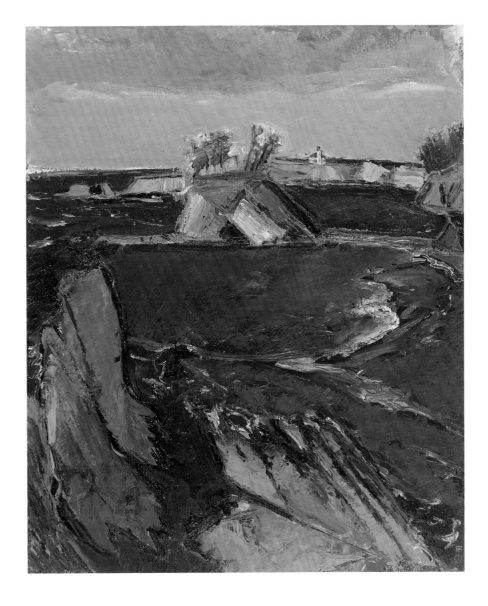

11

William Wheeler,
*Cape Arago,
Oregon Coast,* 2001

Thus it is that I am able to share with the long-suffering reader these Thoughts Composed above the Ocean at Cape Arago.

The Maine littoral aside, America doesn't boast greater beauties than supplied by the Oregon coast. Last year a nice paradox was shaping itself up in Coos Bay just above the California line where two friends, King & Wheeler, were pulling off *plein-air* paintings from roughly the same searock & shoreline motifs (figs. 10, 11). They're painting away at the very same scene; and the outcomes are radically different! This raises intriguing & fantastical & fundamentally subversive ques-

tions about the contingent nature of Reality. A point to point inspection of the two landscapes can be endlessly satisfying. And the plangent Music set up by this clash of conflicting sensibilities is clangorous but, like the roar of the surf itself, not without its brazen harmonies.

That's not the paradox.

What's puzzling, and not a little curious, is that what begins for both artists as an exercise in outdoors on-the-spot seeing & recording ends, for both artists, in a sort of paean to Memory. The unmistakably eidetic paintings of King are in effect seen by Tony before he even looks at the landscape

motif in front of him. There is a Platonism involved here. It's as if King opens a door in his mind and calmly, slowly draws the painting forth, "trailing clouds of glory" as it comes. With their measured, plane behind plane recession into space, their nearly mathematical sense of order, their Apollonian lucid light, these pictures bask in a full-palette glow of Emotion recollected in tranquility.

Where Tony King's brush seems to "think" its way across the canvas, Wheeler's hand is instinct with feeling. Bill's visionary paintings look not to Wordsworth but to Blake's transfigured rapture for nourishment. An imaginative colorist, Wheeler is not reticent about playing fast & loose with local hues; his brush too he dips in freedoms, allowing him to carve paste & scumble in often wild irregular, virtually dithyrambic strokes of opulent graded color. The resultant paintings are strictly in fealty to Dionysus, and the Memories that go with them are excited, untranquil, passionate, and redolent of an appetite unslaked & ready to swallow the world. Wheeler leaves the methodology to patient, step-by-step, accumulate-the visual-evidence, impossible-to-fluster Tony King. It was the old boxer/puncher encounter, the match-up at Coos Bay.

Paintings are rich in layered meanings. They are NEVER fully elucidated. King is a painstaking Realist. Conceals himself behind the painting; examines his fingernails for a spot of paint. He is not there. Wheeler is a classic Expressionist. Paints his *feelings* before the motif, not really the motif itself. Bill is there, all right. But something more than Friendship brings them back together. Namely, a lurking Patriotism. The paintings are about America the Beautiful! These landscapes say, NOWHERE ELSE!! King has from the outset staked his interest in the National Fate. Think of his nod toward Jasper Johns's American Flag paintings—the way Tony incorporated the flagstars into his imagery in the early iconic works. His Plant-Myself-Spang-in-the-Tradition Hudson River landscapes (they emerge from bands of old newsprint—another wink at Johns). His Currency Series: "celebrations" of the

confluence of Big Money and the Bad Presidency (i.e., McKinley). His genuine celebration of this land, our land, the West (and this, too, a political ploy insofar as it represents a knowing repudiation of New York artworld orthodoxies & imperatives & thou-shalt-nots). Then there is Wheeler. Back in the Days, back in the Daze, he gave his fortune his land his Youth and some of his sanity to back a novel vision of an America compact of Peace, Brotherhood, Sexual Freedom, Psychedelics, Redwood Zen, and many another Lifestyle Alternative to RATScramble U.S.A. All Bill Wheeler's paintings of American Beauties can be read as a continuation by other means of his quixotic struggle to renew America, and to build the New Jerusalem in California's green then golden land.

Whither the Sonoma Four? Bill & Tony's Coos Bay expedition found Jack Stuppin taking a 180° turn in order to paint the selfsame American shoreline Beauties in riparian Maine. Bill Morehouse? Gone these 10 years, nearly. How Bill would have loved to deliver in his best foggy *chinois* marine-layer manner those marvelous Han Dynasty rock formations visible from the Cape Arago Park, the ones that, having had their shots snapped by a dilemma of tourists, now graduate to having their portraits rendered faithfully by King, and, with many a Liberty, at the hand of Tony's friend, colleague & fellow undercover patriot, William Wheeler.

As the cinematic sun falls westward off Cape Arago, my thoughts tend again to Wheeler who back in that remarkable moment in the '60s wagered all in defense of his probably silly Utopian community. Who cares now what Suzy Creamcheese said to Janis Joplin? Yet thanks—my thanks, anyway are due Wheeler for in that brief episode of Hope having tried to crack open the door to American enlightenment.

THE OCEAN BILL SAW . . .

My friend
Wheeler went
To Kent.
Next was Yale.
That's the End!
To this clipped Tale
 (for
I'm not prolific).

I lied.
Wheeler tried
Leaving East
 (broke)
Coming West.
In Sonoma he,
Silent, eyed
A Shining Sea.

The Wheeler Ranch
Was Root, Bole
Budding Branch
Of that Whole
Era's Ecstatic
Problematic.
 Yes!
Remember how Terrific?

Wheeler condoned
Getting stoned
Issued permissions
(Some held vicious,
Others said: Visions)
 &
Smiled at Public Ban on
Seckshuel Emissioooons

Bill's Loose Canon
Left Authorities alarmed
 & armed
With Tractors and Writ
"They" did their Shit
(Pardon my Anglo-Saxon)
This Envious Action,
Cowardly, Unjust,
Hypocritical,
Raised the Level of Disgust
In Sonoma; finally Turned
Wheeler finely political.
Outgunned, Outspent he learned
From uncompensated losses:
A Bureaucracy is hard to Fight
 —faceless,
Amorphous, a Paper Mountain

Concealing a 'Dozer.
Let the years pass,
 Bill!
Play the Pariah, Play the Loser.
But ask for no Ruth,
Except from Maria (or do I Confuse her . . . ¿)
It's only the Truth:
EveryWoman's a Fountain.

Wheeler didn't change.
He still stood
For a free Mind in a free
Flesh and the Right to be
 Strange
(He set his own Good
Example.) Meanwhile he
Chopped Wood

Counted every Mouse and Frog
Rented the Attic
To Owls; held a Dialogue
With the Deer (Quite
 Quiet)
Ate out each Night
At the Dream Café, on a Diet
Of Mindhealing Shooting Stars

And Buttercups and Fog;
From on High, Vulture and Hawk
Counted Bill. Not
One Given to Mock
 GOD
(Despite a Temptation
To Self-Dramatization
And Sad Guitars)

 Bill
Timely arrived at the Thought
"The Best Revenge is Painting Right!"
For Paintings DO take Sides,
Point to What Oughtn't/Ought
Be Done. A Wheeler hides
Man, Man's Works, Man's MalaFides
He Paints the Land for Which he Fought.

The Sonoma Landscapes Say
Peace! Don't Build on Me!
Peace! Cast no Shadows!
sobre mis rios y mis prados
Hallow this Place. Let it Stay
 This Way
Awaiting a saner Polity.
Sonoma! No olvide los lugares consagrados

The Work of the Four Painter Friends
Differs Somewhat as to Ends.
For Morehouse Landscape's a Body and
The Body's a Land-
 scape
Jack Stuppin prepares a Table
Bright with Viands
While Tony King is Able

To find Architectonic
Puzzles already laid out (in his Head)
Bird's-Eye Fashion.
In Wheeler what's Chronic
 Are
Ruder Geometries of underlying Forms
The Landscape Elements grasped in Terms
Of a Rough-Colored-Boulder-Tumble

 Or
Of Giant Ragged Jewels in Chains
Or even Huge Hunks of Frenchbread
Piled in a Broken Jumble
As though Heaped on a Crude Altar.
Something Awkward, Something Humble
Gives to Images a Moral Conviction.
We feel that Awe that Wheeler kenned

In front of Nature. The Specific
 Quality
Of his Glance comes through. And when he Rains
Fervid Brushwork to Obscure Structure,
We have to Acknowledge the Passion.
Over the entire Surface sustained Pressure
Never lets his Identification falter
With Sonoma and America the Beautiful,

A Promised Land
My Friend Bill
 (Dutiful)
Promised to Honor,
Beyooond Meeere Depiction (!)
Brushes in Hand.
A Blessing upon Her!
Wheeler's Radical Still:

THE OCEAN HE SAW IS CALLED THE PACIFIC

John Fitz Gibbon
Pilot Hill,
April 1994

■ BEFORE DINNER, in halfway decent weather, our family used to take a stroll in order "to develop an appetite." We'd either walk in the direction of the Claremont Hotel & Berkeley Tennis Club about as far as Mrs. Marx's brown shinglestyle and turn around; or we'd go the other direction along our street to the corner, then down the Uplands to its merger with steep cobblestoned Roanoke, where my father would, for the nth time, wonder at the house Julia Morgan had managed to cram into an unpromising lot, and on along curving Hillcrest as far as a large shinglestyle that clung to a steep hillside and housed Miss Dart Tinkham's Dancing Academy, identified as such by the discreetest of signs and persistently memorable to me as the 1, 2, 3, 1, 2, 3 venue where I learned to waltz and two-step & (the girls were at this stage taller) pirouette under my partner's hand, taking care not to step on her maryjane & whitesocked feet. Across the street from the dancing school was still another Berkeley shinglestyle and eventually a painter moved in there and took up his craft in a little shed studio in the rear. Usually this bohemian face-off —Art vs. Dance—would deter our little band from further pre-prandial progress and we would turn about & retrace our steps, going uphill now and pausing along the Uplands to glance across the valley and along its steep upper slope, where like so many postage stamps our house and its neighbors bravely adhered to the winding route described by our own street. There's the next-door neighbor's house, a Maybeck built of stone & brick as well as wood. And now our house rising a full four stories to the street, and comprising 20 rooms, not counting decks and enclosed sun porches. This shinglestyle behemoth had been built at the beginning of the century by Berkeley's first mayor. The house heeled pretty much after Greene & Greene; there are many felicities and surprise touches.

Did little kids in mid–20th-century Berkeley, California, actually snob on other children, with regard to their parents house, car, job, etc. You know that they did, dear reader. Berkeley was completely stratified, from Bay to hills, and any given street usually had a good side and a bad. It was ruthless. I had 27 cashmere sweaters in my drawer.

Except for the very fine portrait of my mother, which hung in the library, there was no real art in our house. Expensive furnishings and antiques, yes. Oh, and a Picasso bullfight lithograph. My little sister wanted it; it's still hers. Otherwise, it was all reproductions. Rembrandt & Titian for the living room, Kandinsky & Marc in one stairwell. In my quarters, Van Gogh's bedroom. What in the world could my parents have been thinking? Did they not know that 3% of boy-children who grow up with *Bedroom at Arles* become serial killers? Another 3% art critics? And fully 12% were found to have severed an ear & presented it to the woman who drives the UPS truck or to their favorite bank-teller. But in extenuation of Dr. & Mrs. F. G. let it be said that they were no stupider than the next parents; they simply couldn't see.

Besides, there's such a thing as Destiny. I might have grown up to be an art critic even if I'd had a Cindy Sherman photo of herself as Eleanor Roosevelt on my wall.

Now a lot of people think that an art critic is some kinda Tourette's Syndrome person, goes rushing thru the museum shouting "SHIT, PISS, FUGK, SHIT, ETC." Those people are right, they are right. However, it's more complicated than it may seem. Let me explain how I got to be an art critic thru babysitting.

When I was eleven I began accompanying my mother on her visits down the street to her best friend, Elsie Marx, who was somewhat older than my mom. Elsie was privately educated on West 86th Street and her piano was good enough to have offered a career. Her marriage to a Swiss watch-manufacturing tycoon ended with his death when I was about 15. Elsie filled the time by taking up painting, going over to Cal and studying with Margaret Petersen, an artist whose style fused Picassoid synthetic cubism with Kwakiutl elements. Tall & gaunt, with her hair dyed black, Mrs. Marx kept a house in Switzerland, a pied à terre in

■

Paris, a dog whose name and breed I can't bring to mind, plus a daughter, Mona Beaumont, who painted ineffectual geometric canvases reminiscent, a bit, of Jean Hélion. Mrs. M. was a great cook, and she brewed a mean cup of tea.

While the French flowed over my head I would sit on the living room floor, turning the pages of artbooks. Or I would get up and wander the pictures. Above the mantel was the *de rigeur* Canaletto. In the drawing room itself was a good-sized Cranach the Elder *Judith,* the head in her lap painted out; evidently some seller had wanted to make the work more accessible. The downstairs corridor was end to end with the exquisite tracery of lithographs by Constantin Guys, the recorder of High Society at play. Pretty, fashionable women alight from wish-I-had-one broughams. They are headed for the opera. These illustrator-y works of art are as trivial and nugatory as their Vanity Fair subject matter, however valuable they may be to the fashion historian. Guys was hardly more than a graphics artist, not really a painter at all. Yet he was tremendously visible toward the middle of the 19th century and about him the critic Charles Baudelaire made, in a rare moment of equivocation, one of his major mistakes. Baudelaire made Guys the basis for his *Peintre du vie moderne,* with its celebration of the glories of contemporary Life all around us, its plumping for the primacy of the here & now, its assertion that we too are Beautiful in our frock coats & top hats, its implied preference for *La Traviata* over *Il Trovatore.* He chose Constantin Guys, whom everyone would find acceptable, when he could and should have picked his friend Edouard Manet, whom the world wasn't quite ready for.

The downstairs corridor gave onto a billiards room and on either wall hung wonderful pink-angel blowsy nekkid ladeez by the Dutch-Jewish Fauve Kees van Dongen—a great painter in some ways but nonetheless a Matisse follower and epigone. But frigging-A! good reader. These were barroom odalisques to reckon with forever and one 4 the road.

Quite a bit of my teenage time was spent at Mrs. Marx's house with my Mom, trying to kibbitz on their French so's I'd be in on the gossip they were passing back & forth, turning the leaves of her artbooks—deciding for myself, for example, that this year I didn't care as much for, say, Dunoyer de Segonzac as I did a year ago. I knew Mrs. Marx was fond of me, and one day, looking up from a book of Old Masters, I hazarded a question. "Elsie, shouldn't these paintings be over in the de Young or somewhere? How come you have 'em here?" Mrs. Marx was thoughtful, concluding at length that this was not an impertinence. The answer she made has stayed with me thru-out life, whenever I ask myself what paintings are worth.

"Jacques & I had many, many paintings like these in our Paris apartment, and bronzes too, and various *objets d'art* that we found charming. We had to leave almost everything behind in order to try to reach Portugal. . . . The situation was urgent. . . . We were able to get to Lisbon . . . because we had money. And from there after a time we managed to book passage to this country." In my entire life I've never heard a phrase uttered in the tone of apologetic courtesy that Elsie Marx gave to her admission that they had escaped "because we had money." "Many of our friends," she went on to say, "simply could not leave behind their pictures and all the Ghiordes and Isfahan carpets and Louis Quinze furniture —they were attached to them."

Her friends that stayed, Mrs. Marx did not need to tell me, were interned at Drancy outside Paris and sent on to Auschwitz. What are pictures worth, friend reader? Not a hell of a lot in comparison with the worth of Democracy, the value of Freedom. Pictures, however, do have their own kind of value: aesthetic value. Some pictures in this respect are better than others. This was borne in on me one summer when I was saddled with taking care, part of the day, of my sister Honora, 11 years younger and a handful. My idea of babysitting at its best was to park Honora at her best friend's house & pick her up whenever. Gretchen, H.'s pal, lived in the shinglestyle mentioned above,

the one across from Dancing School. Her father was a painter. To Gretchen's embarrassment at school, her dad was said to spend his time drawing naked girls. For sure he spent a lot of his time talking to me in his backyard studio because I started to hang out there, oftener and oftener. It got so that while Tues. & Thurs. I might be found over at one side of my house, talking with Mrs. Marx, the remainder of the week, Mon., Wed., Fri., there I'd be down on the other side absorbing what I could from this painter.

From the first I was conscious of the formative influence Mrs. Marx was having on me. My parents read Proust but they did not particularly want to discuss it with a kid who needed to pick up his room. I began to think of how I could do something for Elsie. One day I spoke up. "Mrs. Marx? You know those Van Dongen paintings you have downstairs?" I asked, needlessly. "Well, there's a painter lives the other side of us, his name is Richard Diebenkorn, and the paintings he's making in his studio are as good as the ones you have." My mother was rolling her eyes and signaling me. She knew the Diebenkorns socially and didn't think much of them, feelings that were reciprocated. If you rose above my mother's insufferable snobbery, her more than occasional rudeness, and her tendency to think mainly of herself, then you might not mind the lady. The Diebenkorns minded (hundreds didn't).

I continued to pitch the paintings of this young painter whose work was beginning to be known— but only to a coterie. I said I would take her over there if she liked. Mrs. Marx was infinitely polite; her courtesy was bottomless. She said I might well be right, yet excused herself on the ground that older people have a difficult time interesting themselves in the art of the new generation coming along. That'll be the day! thot I sillily. For some little time now I've noticed myself give out the selfsame exculpatory disclaimer; GREAT LADY OF IRONY, THOU MAKEST THE WORLD GO ROUND.

Soon enough I left off trying to persuade a gracious elderly friend & neighbor of something that,

I came to my senses and realized, she was after all, never going to be able to give credence. A genius down the street? Not too likely! I walked home alone, leaving my mother to chortle, no doubt at the absurdity of my proposal—"the fellow down the street in a league with Kees, how amusing!" and "I thank you for not laughing outright" and "Elsie, my dearest, I brought him into this world, can you forgive me?" With Mrs. Marx, "Now calm yourself, Elaine." No, she would say, "Ilyena." "Soyez calme, Ilyena, il n'y a qu'un petit garçon," and "After all, Ilyena, you know how bright the boy is." And my Mom, "No, no. He'll be a regular art critic one day, you will see, you'll see. The Founder of the [MORE HYSTERICS] Neighborhood School of Art Critics." And my Mom would supply her silvery laugh. "Oil paint! He needs to worry about oily skin! How many of these bonbons did he devour? Thank you, thank you. They will give him zits."

I walked on home, not minding what was being said behind my back, and not stopping to inspect my usual admirations, like Mr. d'Archimbaud's La Salle or the Grogans' triumphant wisteria. My soul was flooded with one word, the Word I had withheld from Mrs. Marx, not daring to speak it. Perhaps that Word will permit the reader a peek at the real Me, whose existence I am not at times altogether sure of, and whom, like the reader, I am sedulous to protect from prying eyes, even as paradoxically I wish the sympathetic good cheer of him.

That word was BETTER!

I could *see* that Diebenkorn was the better painter (fig. 12). I hadn't gotten it out of some book. My alternating trips, Tues. over the Mrs. Marx way, Wed. down by Diebenkorn—these had taught me that Van Dongen could not stand the comparison. I was absolutely sure of it. Moreover I had earned this knowledge myself. I was dead certain I could do it again and again. This "power" is all you need to take on the role of "art critic." All the rest, Philosophy, History, Linguistics, Science & a bit of Math, Aesthetics, they are all window-dressing. You've got to be able to *see*

12

Richard Diebenkorn,
*View Toward
Oakland,* 1960

that Chris Brown or Peter Plagens do not amount to much. Otherwise, don't try it. In fact, don't try it, no matter what. It's a bad métier, as I've said many times. Be a lepidopterist, if you want to stick pins in butterflies for a living. In my case all's I can plead is Destiny, vague concept, probably not extenuating when I come up for Judgment. Nobody made me do it. Yet I became an art critic. Have mercy! as we used to say on the railroad. I became an art critic, friend reader. And yes, I am a neighborhood critic. California is Better.

Now there are several ways to do art criticism. Far the best—in fact the only true kind—is where you examine Art as you know it and you yourself make some art that corrects the present situation. For instance Joe Raffaele did this when he saw no one was basing his or her paintings on photographs, so he up and did it himself. Talk was, you "can't" employ the photo. Joseph could. Peter Voulkos, finding you weren't permitted to combine thrown vessels into man-sized "sculptures," gave himself permission. When I myself badly needed to do some art I looked at my friend Allan Kaprow & saw how Allan had first added collage elements to his 2nd-generation (they weren't all bad at all) action paintings; that he'd then subtracted the painting—leaving the "added" elements to exist in themselves on the gallery floor; that he'd then gone out the door with them, and on into the "real" world, where he & a few friends "performed actions" that had the character of simple ritual. I saw that I could expand and elaborate on this, basing my "real world" pieces on the neglected arena of the art of the museums, so dear to me, and that all I had to do was to take seriously Cézanne's dictum that it was only required "to re-do Poussin after Nature," to look to the art of the museums, in other words. I saw I was in position to correct that negligence and I understood that virtually all "new" art is actually inherently "post-modern" insofar as it represents a throwback to prior art, a life buoy tossed to keep earlier art from going down the whirlpool of art history or even a sort of transparent umbrella held over past art to prevent its being washed away. The idea behind my Events was that 200 or so people could walk thru the picture plane of an Old Master painting and experience what may have gone on when you are compelled to drag & haul a cross up Calvary. Or you were invited to regard G. B. Tiepolo's *Triumph of Flora* as if it were on Pause on a tape machine, then re-wind the picture an hour or so, then let it run forward again until it reached the place where Tiepolo had "Paused" it—or a few minutes past that place. That way you'd get some sense of what it'd be like to be "in" the painting (in the de Young) and, if you performed it with an hundred Knights Kneeling, instead of Tiepolo's two, well, it might look pretty good.

The Events, my thinking was, would provide one way of re-doing the art of the museums after nature, with real people, real trees, flowers, clouds and so on. And of course in "real" Time rather than on "Pause." So I offered my Events as a critique of past art. I hoped, with all respect, to "correct" Tiepolo, and to explain him, to lay out what was really in his picture. I thought what I and my dear friends who put themselves on the line for me were doing was definitely Good New Art; and I figured it was the best sort of art criticism.

What did others think of this brand of art criticism? Well, that's not a relevant question (altho' it interests me). The Pilot Hill regulars—students, ex-students, teaching colleagues, classmates & friends of ours & of our children, artists, museum curators—these people came, and came again. Doctors came, lawyers, a few oldsters, mostly young people, and except for a sprinkling of gays, they came two by two. Some of them may have started out for Pilot Hill their 1st time in the misprision that they were going to attend some kind of wild gonzo party; they very soon learned that they were there to help me try to do some art. I thanked them then, I thank them now and always. The first couple of years I did worry about "using" my friends. That worry dissipated for good 15 minutes after the conclusion of the 1974 *Seven Deadly Sins* Event, when I overheard a

13

Harold Paris,

Et in Arcadia Ego,

ca. 1970s

woman tell her husband: "Well, that was worth about 5 years of analysis!"

The Events did have a tendency to open the book on yourself sans the drawbacks psychedelic drugs can exercise on your awareness. But I was never out to provide "therapy" for myself, much less for others. Nor was it my aim, except very tangentially, to strike a blow for sexual liberation. Down with Repression was not my cry. I was interested in the formal issue, and the ontological. I wanted to violate the picture plane, to get into one of Poussin's Arcadian fantasies and put its Utopian character to the test (fig. 13). I was ready to accept whatever resulted, and while I had my King's X & super-dibs on Love Peace Harmony, I didn't really stack the deck.

Just a word now on those stay-at-homes who didn't want to involve themselves in a Wild Party and (surely) an ORGY. This I have to admit hurt my feelings. So, surreptitiously (and at some little expense), I had these people's sex lives researched by moonlighting college administrators (rank of dean or above). The bonded findings reveal that had these prurient souls *attended* a Pilot Hill Annual there might well have ensued a predictably flaccid ORGY. Because these poor folks would likely have found each other and then . . . I shudder to think. Otherwise, you could safely have brought your kids. Lots of people did.

Have I been too peremptory just now, too sarcastic at the expense of citizens whose only crime was not caring much for the notion of running around in the woods in the altogether with hundreds of people you don't know—or worse, *do,* all pretending to be a satyr or a maenad or some damn thing? Yes, I admit it. First I try to scare 'em off with announcements that, yes, there may be some risks, no, we may not be able to protect you . . . etc. Then when they scare, I blame 'em. Not fair. But consider: I didn't *want* anyone on my Arcadian hillside who could have a scare attack at Event hour zero. Did I really have the Scaredy-cats' sex lives investigated by college presidents? Don't be silly. In order to study one, you have to have one.

Let's get back to the point, reader. The best, the *only* way to do art criticism is to MAKE some ART yourself, art that supplies a felt need, art that goes past art one better, art that grabs hold of your laggard rivals and, in the memorable locution of Floyd Duncan, Yardmaster, shows them where the boar et the cabbage.

The next best form of art criticism is to BUY ART. From the beginning I've maintained this and almost from the beginning I've put my money where my mouth is. Fortunately, "my" artists & their dealers have been so kind as to take that money out of my mouth or, dear reader, I would have choked to death long ago. Always have liked that "money-where-mouth" phrase for the unspoken assumption of an identity between Gluttony, the 2nd Deadly Sin, & going shopping for objects of symbolic value, like Pictures. Buying art does several things, most of 'em helpful. First of all it makes very clear your predilections, as good art criticism should. Talk is cheap. A Manuel Neri is not. Any art collection is an essay in art criticism.

Because art fish swim in schools, if you elect BUYING ART as your form of art criticism you may well find yourself in our own happy situation: you will have a richly rewarding collection of Friends on the wall (figs. 14, 15). Artists very seldom hit it rich in the art market right from the outset. The critics aren't there, the patrons seem from some other universe, there's no room in the galleries. In short, there's no one to make your art *for*—except, that is, your friends. So you make it for them— they at least will grasp what you're doing. Your work stands or falls for you on the judgment of your peers. And this remains so even when success is yours & you can't believe the tuition they're demanding at Druggdeel Prep and your main problem is you have to go to Switzerland Thursday to sign yer prints 'n' you hafta miss the playoffs. Still in the back of your mind you're measuring yourself against the fate of the initial gang you came up with. Thus when Bischoff followed Park, and Diebenkorn followed Elmer into Bay Area Figura-

14

Luis Azaceta,
Barking Head #10,
1985

tion (a movement immediately deemed retrogressive by Eastern observers) (fig. 16), the three friends cared only about each other's moves, not whether those moves were a backward step in terms of the Modernist project. And when R. D. shifted back to (Ocean Park) abstraction, Elmer followed suit; he knew who his main rival was, he knew whom he was painting *for*. And it wasn't Jasper Johns or Roy Lichtenstein. Similarly, when their groundling students found their Bay Area Old Masters exulting in the royal suite high above, they all (Manuel Neri, Joan Brown, Jay DeFeo, Bruce Conner, Wally Hedrick, et al.) became friends (and sometimes lovers) and did purposely "low art," confected from "low" materials. (They did their art for each other, friend to friend.) Over

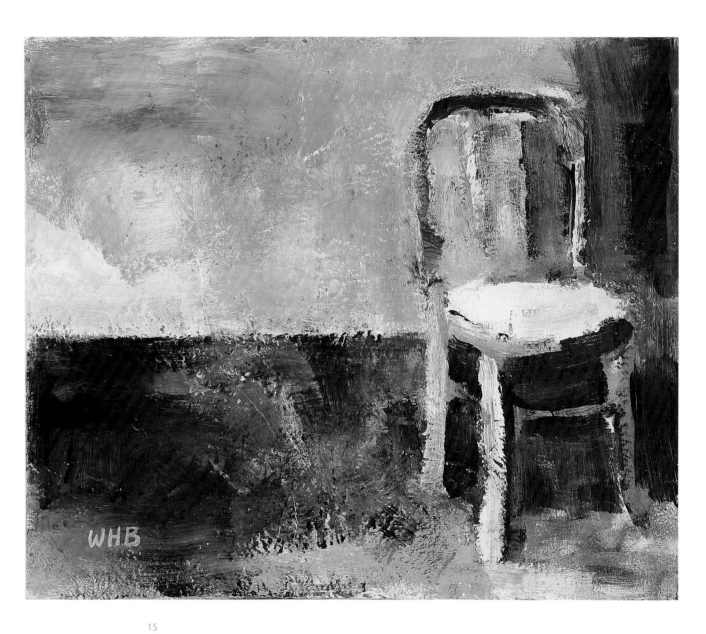

15

William H. Brown,
Chair, ca. 1960s

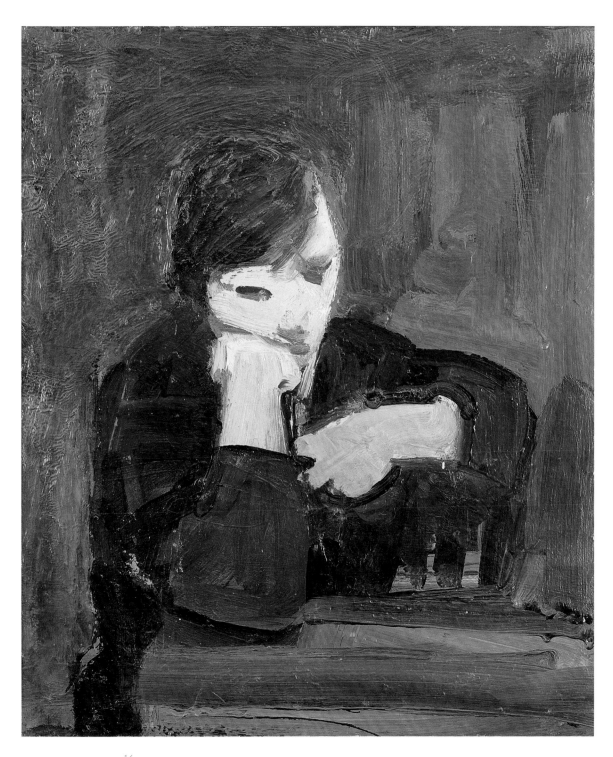

16

Elmer Bischoff,

Woman Resting,

1958

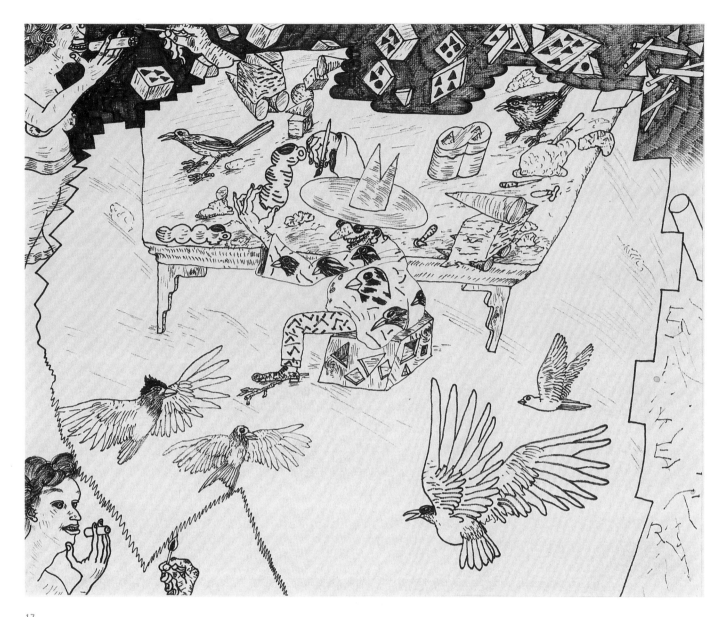

17

Patrick Siler,

Ceramist with Birds,

n.d.

in Berkeley, just a little later, mid-'60s, I think of a High Sierras camping trip complete with Jack Daniel's hangover, by three of Jim Melchert's students: Bill Dane, Wm. Wareham, and Patrick Siler (fig. 17). If, 40 years ago, you'd purchased this I.P.O., today you'd be called prescient. And you'd have friends on the wall, perhaps the greatest dividend of the critical policy: BUY ART.

MAKE ART, that's the best kind. BUY ART, that's the next best. And next? The next step down? TALK ART. Talking art doesn't cost you anything. It does-n't force you to open up, to undertake the painful step of creating something new under the sun. Talking art doesn't force you to reach for your wallet. It puts no money in the artist's pocket. Talking art asks you to attempt something rather absurd on the face of it. TALK ART, or written art criticism, asks you to hold a mirror up to art; it asks you to hold a *word*-mirror up to a perfectly good painting and turn it into language. TALK ART! commands you to turn a tall shining prince into a frog. CROAGK, CROAGK.

Who could possibly overestimate the Badness of much art writing? At random I culled the following sentence from a curator-critic's assessment of Rosemarie Trockel's *56 Brushstrokes,* a faintly comic, faintly menacing Duchampian exercise from the teasing hand of that amusing German lady: "This work unmistakably questions what is taken today to be the constitutive process of painting and revolves around the production of aesthetic experience the institutional context in which perception is structured." Reads like it was translated from the German? It was.

A reliance on too many multisyllabic latinate words strands the sentence at too high a level of abstraction. The situation's at its worst when a critic (Rosalind Krauss, say) forces diverse works of art onto a Procustean bed of linguistic and philosophical analysis derived from Foucault and Barthes. She drags out poor stick-in-the-mud Ellsworth Kelly, who fails to understand "that Painting is not taken to be a signified to which individual paintings might meaningfully refer." A typical Kelly 2-panel uninflected color painting is taken to task for its easel-painting "detachment," it's a moveable treat; as well as for its "conventional" reliance on "painting understood as a continuous bounded, detachable flat surface"; for its further reliance on drawing and hue (the shape of the 2 planes, their color)—in other words on the "inner logic of the work." And all these reliances add up to what she calls Kelly's "discontinuity" (a vital borrowing from, I believe, Foucault). This is all-important because

unlike the continuum of the real world, painting is a field of articulations or divisions. It is only by disrupting its physical surface and creating discontinuous units that it can produce a system of signs, and through those signs, meaning. . . . And Kelly's work is about defining the pictorial convention as a process of arbitrary rupture of the field (a canvas surface) into the discontinuous units that are the necessary constituents of signs.

One could say, then, that the reduction that occurs in Kelly's painting results in a certain schematization of the pictorial codes . . . [That] schematic . . . is one that takes the process of pictorial meaning as its subject.[1]

One goofy irony here (aren't they all?!) is that, among significant abstract painters, Ellsworth Kelly is perhaps the most insistent that his work is always based on an initial experience of seeing in the real world. A door ajar in a wall, a row of cars parked parallel to the kerb abutting a row of diagonal parked delivery vans. And so forth. Krauss doesn't mention this, if indeed she knows it. She is intent on dressing her doll in post-structuralist garb and cruising on down to the Post-modern Fair. Well, that's not a crime, however tough it may be on the reader. God pardon Sin, as the friar remarks when he finds out Romeo was out all night but not with Rosaline.

One afternoon unstoppable Stuppin, the investment-banker primitive, was in Berggruen Gallery, S.F. Jack was in a charity auction there. So was Ellsworth Kelly. They were introduced. Now Jack Stuppin's lungs are so constituted that given any situation where there is ± 20% oxygen in the room, they will talk shop. "How do ya get that color-goes-all-the-way-down look? D'ya have studio assistants? Ja see the Cézanne show in Philadelphia? Whaddya do about storage?" And so on. Ellsworth Kelly did his part: "Just what is it you do, Mr. Stebbins?" So Jack, seeing that the question was genuine and innocent, told him. "Well, I just take my paints & brushes and my portable easel and I head out for the hills or down to the ocean . . . I'm a *plein-air* painter and I bring back mebbe 2, mebbe 3 canvases a day."

The years fell away from Ellsworth Kelly, returning him perhaps to those early Paris days of pared-down delicate drawings of flowers achieved with line alone, sans shading, the very evocations of flower essence. "How I wish *I* could just go out & do that!!" Kelly said, plainly engulfed in honest nostalgia. And before the burden of Modernist reality descended once more on his shoulders his

body language vouchsafed a skinny dipping frisson of pleasure and freedom.

You don't deal out irony to Stuppin, something warns you it would be superfluous; so I take this anecdote to be pretty much authentic. Did Kelly, for the merest moment, actually re-imagine his options? Did he picture himself out there trying to accommodate Mt. Shasta in, say, a 3-panel, 5-color format, the "inner logic" of the painting shored up by all those gratifying ana-clitic relations? No, of course not. The whole thing is way too silly. But it is true that Kelly and Stuppin and you, patient reader, and certainly me too, are all of us fairly well closed down and immobilized by our accumulated Past. Very few of us are capable of taking our cue from Bob Brady, who reinvented himself in wood when he became bored with himself in clay. So it's not entirely out of the question that Ellsworth Kelly wasn't just being polite when he expressed the wish that he could follow this Stebbins fellow's footsteps into the Sonoma sunset. It's no sillier than to suppose that Kelly turned away from Stuppin in relief & went back to mulling how best to schematize the pictorial codes so as to continue taking the process of pictorial meaning as his true subject.

Anyhoo, most art writing is fundamentally unreadable, much of it finds the art critic riding her or his hobbyhorse, nagging the art half to death. Also much art criticism is off base, mistaken in its estimates, demonstrably has a poor track record, over time. I remember that when David Park was alive both Park and a painter called Theodor Polos had 1-man shows at the de Young. In the *Chronicle* Alfred Frankenstein devoted 2½ columns to praise of Polos, and dismissed Park in 2 sentences. If you set up to TALK ART, you'd best be right.

Why do I sense that out there somewhere an unpersuaded reader lurks, oblivious to advice, and all too ready to step into my patent leather dancing shoes the moment I waltz my way into Eternity, CROAGK, CROAGK? Alright, I'll help you. You cannot MAKE ART, you cannot afford to BUY ART. Yet you still want your predilections known, so you can say "Nyaa, Nyaa" to your betters, like a true art critic when the Future scrolls up & you turn out to've been correct. What you can do is you can do it the racetrack tout way. That's all a critic is, anyway.

Let me show you how to proceed:

NEIGHBORHOOD JUVENILE HANDICAP
1½ Mile, Purse: 15 million marbles
(for Older Horses, including Old Masters)

RICHARD DIEBENKORN 5/2
Figures to crush these in Drive

ANTONIO CANAL 8–1
Better than most Art Histories credit

LUCAS CRANACH, SR. 7/2
Once could've tow-roped this bunch

KEES VAN DONGEN 12–1
Matisse stablemate may try to steal it

CONSTANTIN GUYS 50–1
Light weight only help

Face it, readers, this particular short cut to the "problem" of art criticism as it is being discussed to death here is plenty welcome at this point, and may offer unforeseen possibilities and applications. At the very least the *Racing Form* model for criticism is deserving of a return engagement—perhaps for The Clay Handicap or The Funk Stakes (figs. 18, 19)? There are many congruencies between writing art reviews and touting horses but the main sameness has to do with bringing people along to your evaluation. Both vocations are fueled by a secret hope to amaze yer friends and stun yer enemies. That tout [critic] sure had it right! The reader begins to know me and my propensity to extrapolate from something that happened to me and draw or drag it into an explanation of how I operate as a "critic."

OK. I began playing the horses when I was 14 years old, with the bookie who could be found in the locker room of the Berkeley Tennis Club. This chap owned a stamp store downtown, near Berkeley High. The philatelic enterprise took up the front

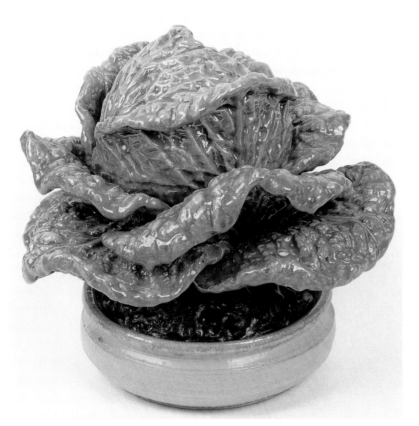

18

Victor Cicansky,
Cabbage, 1996

19

Victor Cicansky,
Jar of Corn, 1981;
Jar of Prunes, 1981;
and *Jar of Trilobites*,
1980

room. The back provided the locus for a small gambling operation: telephones, chalk boards, wire service. I had been studying the horses in the sporting pages for some time. My pal Ronnie Woods (later my doubles partner both at BHS & on the Cal freshman team) was doing the same. With my heart between my braces I ventured my $2 on a horse in the 2nd at Tanforan, a 6-furlong sprint for maiden 3-year-olds. The filly came skipping home, too, just as I'd foreseen. Guess if I exulted? Mi Chinita was her name & she paid $6.20, thus guaranteeing that I would be a sleazy art critic today, instead of a Federal Judge. Most horse players of any commitment will allow to you that if they wanted to quit their job at the bakery they could make a living at the track. 'Tis a harmless self-deception. No need to start racial profiling, really. Just because an Irishman will take a flutter on any day that has a couple a vowels in it. There are worse things about the Irish than gambling, reader. What are they? Tippling. Skirt-chasing. Picking fights you can't finish. And then the one that, somehow, I've avoided—so far. I thank God & His Holy Mother. You insist? Well, it's Boasting. That's the one I stop short of. Against every criterion of my profession. The vows of an art critic are sacred.

Anyway as I didn't quite get around to confessing above, I am one of that breed of horseplayers who could, if need be, support their families on their winnings at the Curragh or Belmont or Santa Anita. Why don't I then? Because it would require a round-the-clock devotion to racing matters, it's a whole world unto itself, something like the art world. Better to stick at home & pick artist winners. Here's how you do it:

POST-WAR LOS ANGELES STAKES
1 Mile, Purse: 10 million marbles
(For artists well-fancied chez Pilot Hill)

DICK DIEBENKORN	1–1
Enjoys class edge. Should scuttle this crew	
CHAZ GARABEDIAN	5/2
Wins this if top one falters	
EDUARDO CARRILLO	30–1
Dark horse has real chance at royal price	
LARRY BELL	9/2
Versatile performer can do it all (fig. 20)	
MAXWELL HENDLER	8–1
Don't overlook. Best threatens (fig. 21)	
MICHAEL TODD	12–1
Elegant is as elegant does	
LANCE RICHBOURG	15–1
Contention runs deep	
JUDY CHICAGO	6–1
Figures to offer argument	
ROBERT IRWIN	5–1
All recent plausible	
SAM FRANCIS	3–1
Overrated School of Paris chic	
CRAIG KAUFFMAN	18–1
Locked horns with R.D., faded. Longshot!!!!	
ANTHONY BERLANT	20–1
Fits with these. Not impossible task	
LES BILLER	50–1
Useful sort steps way up today	
LOUIE LUNETTA	100–1
Pray for a miracle	

Scratched: E. MOSES, E. RUSCHA,
B. A. BENGSTON, E. KIENHOLZ,
V. CELMINS

My friend Ronnie & I learned a good deal on our high-school lunch hour. We'd walk up to the stamp store that fronted for the bookmaking operation and devote ourselves to conning the *Form*. The bookie, a nice Jewish man, was death-afraid of the character who ran the back room. I believe a sum of money was involved. With Ace Stolo it usually came down to a sum of money. I remember that Ace seemed "older"; I figure now, he must have been all of 36, 37, a slightly portly guy, short,

20

Larry Bell, *Untitled,*
2001

21

Max Hendler,
Yellow Brick Wall,
1985

stocky and given to wearing dark double-breasted suits to disguise same. A solid color shirt, ditto the tie. A dark fedora and (before these came into vogue) pointy Italian shoes. Such was Ace Stolo, *cap-à-pie*. Oh, I forgot the cigar. With Ace and us it was a case of mutual misrecognition. I misrecognized him as a mobbed-up guy straight from central casting (and complete with underling henchmen who drove large dark American cars with big fins). On his part he did not perceive us for what we were: obvious scions of the upper-middle class cadre that runs this country on behalf of the vested concerns of a much smaller cadre that owns and controls all material value beyond the not inconsiderable amount siphoned off by Stolo & his ilk. Baldwin Woods Sr. was vice president for Business at the University of California. Years before he'd lost out to Bob Sproul in a power struggle for the presidency of the university. Ronnie's father continued to hold powers but essentially his life was over. My father was Henry Kaiser's physician. He was installed as first medical director of something called Kaiser-Permanente, a position he maintained for a dozen years or so until the jealous machinations of a v.p. for Business, by name Trefethen, forced my dad from power; at this (teenage) point, of course it was just being brought home to me the degree to which the players in these scenarios of corporate power were basically interchangeable. I would be halfway through Yale before ever figuring out what I personally could do about it: i.e., return to the railyard & consecrate my probably thoroughly silly, can't-stop-turning-everything-into-a-joke little Life to reading books in boxcars by lanternlight, the while letting every footfall along the 40-Lead sound my prayers. LORD MAKE ME A BETTER ART CRITIC.

(laughter) As for Ace Stolo he misrecognized us because our lives, Ron's & mine, such as they were, fell outside & above his relatively narrow band of experience. Ace—I'll give him this much—tried to fit whosoever stepped up to his bar into the Natural Order of Things, which Natural Order consisted in a list of persons who owed Ace a Sum

of Money. Small fry, such as ourselves, swam beneath his notice.

Every racing day (at Golden Gate Fields) Woods & I, working a small hand-cranked press in the back room, produced ACE'S BLUE CARD, an organ of prognostication fully as trustworthy as its eponymous publisher and at least as free from corruption as a New Talent to Watch feature in one of the art magazines. Your BLUE CARD gave the winner of each race, plus the horse Ace figured for 2nd, plus his Best Longshot play of the race. At the foot of the card, below the entries, were a few miscellaneous bits of information: "Jasper Jay—ridden today by Rauschenberg"; "Miriam M—filly is a real hustler"; "Cy Twombly—drops down to score"; "Robert Hudson—time to fish or cut bait." (I've made up the names here in order to protect the real horses' identities.) Ron Woods or I would run a sheaf of these tip sheets down to the track, and one of Stolo's minions would grab 'em & start yelling at the fans lined up at the turnstiles before the grandstand. "Hey!!! Getcha BLUEKADD here! ACE'S BLUE CARD! Righchear, 2 dollas!" Occasionally, thru illness or absenteeism or emergency Ron or I would be deputized and get to stand behind the little Outside lectern and shout our ware. You weren't supposed to badger the patrons walking past you and there was a developed etiquette of fair play among our competitors, like BOB'S GREEN CARD and HERMIT. I learned a thing or 3 from this whole curious business with Ace Stolo, one of the worst human beings I ever encountered. One day I said to him: "Ace, how much you putting on Valdina Rhythm in the 6th?" The horse was the ***ACE'S BLUE CARD*** "Ace-bet-of-the-day."

"Valdina Rhythm! That dog don't have a pig's chancet" Ace turned away in incredulous contempt that anyone over 18 years old could believe Ace would put his money on his own BLUE CARD best bet of the day. (Of course this illiterate gangster who wasn't guilty of mixing metaphors as alla time Ace did—because to be guilty of something you hafta know what you did wrong—was perfectly capable of believing Ronnie & me when we

told him we were over 18.) So I guess that one thing I learned was that, if you could run your Life on the principle that a sucker is born each day, you are extra likely to head someone else's sucker list. Ace wanted to think we were old enuf to work because we were cheap & we were available.

This is how you run a tip sheet. For plausibility you select a few favorites on each daily card. But what you're really counting on is finding a long shot or two with a semblance of a real "chanct". If you can more or less accidentally hit a horse that pays 16–1 during the first days of a race meeting, your card will sell well thru-out the season. People remember that "price" horse. They are willing to believe that you have inside information. And against all common sense they are willing to believe you would be foolish enough to share that info with them, total strangers, for the price of a $2 mutuel ticket. Very dear readers, much as I value you, much as I admire you for being bred for the distance, is it at all likely that I would have fed you the fact that Robert Colescott would emerge as one of America's greatest painters (fig. 22), along with Joan Brown, one of the true heirs of Elmer Bischoff, *before* the general art world caught up & onto the idea? If you know who is going to win the Hollywood Gold Cup next year, you don't come to me with the winner, you go straight to the mutuel window.

The last good look I got of Ace Stolo gave me something to apply to situations beyond the Turf. It was the final event of a 9-race card on a rainy Spring afternoon. The rain-dark air allowed the totalizater board to shine its numbery face upon 5 of us seated in Ace's box on the clubhouse turn, everybody holding a *Daily Racing Form* above his head. The Stolo crowd did not countenance umbrellas. We had all been losing all day, Woods and I splitting $2 bets while Ace & his pals figured to be down a sum of money. We were all about to get well, however, on this mile-&-a-sixteenth closer for older mares. Our horse was called Gail-west, and it wasn't common knowledge that she had "won off by herself" on sloppy tracks in the

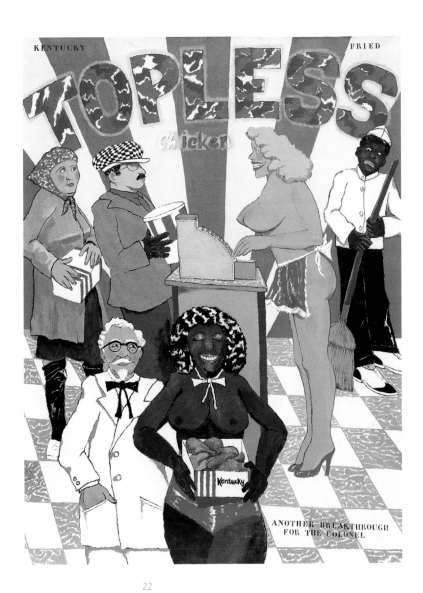

22

Robert Colescott,
*Another Breakthrough
for the Colonel,* 1972

Pacific Northwest 2 years prior, races that didn't show up in today's *Form*. Gailwest was 10–1 Morning Line but when Ace got back from betting the horse had dropped to 7–1 and that's where she stayed at post time. Ace stood up. He had a beer and a cigar in his left hand (he'd brought nothing for anyone else; the hench hoods passed a look between them); the other gloved hand held $50W tickets. "This hawse hazzta be in front when they go by us heer aw itzall ova," Ace said. The henchmen nodded at this succinct expression of the Truth that would govern this race. Gailwest was possessed of a high turn of early speed. If she used it to go to the front immediately, she would very possibly make every post a winning one; our investment would be rewarded. If she couldn't get the early lead from her outside post position, well, forget it. Nothing in her past performance sheet indicated that Gailwest had the potential to win from behind. We waited. The post bell rang, the gate sprang open, the field of horses raced toward the clubhouse turn. As they swept by us, there! I spotted number 10, Gailwest, already shuffled back to 7th or 8th, a good 6 lengths off the lead and "eating" plenty of mudsplats from the heel hooves of the front runners. Ace flipped his tickets onto the floor of the box, as in 52 Pick-up. Ace turned his young heavy body, he exited the box. The bodyguards took a look at the floor, they cast an eye on us. But they too turned and left the box. By the time my friend & I had gathered the tickets, the race was over. Gailwest had never threatened; she finished down the line.

How many times have I known not to pressure a losing situation, known when to quit when I recognized I was behind? The whole lesson of that day has over the years reduced my suffering considerably. Learning to say enough is perhaps as important as to say no.

Shortly, Ace withdrew his operation from Berkeley, CA. In good time, too. Ron's father had learned of Ron's truancies. I had sought per usual to take the blame (my parents being more the lenient sort). This time, tho', both fathers were in

arms. My dad was in many respects a violent sort of guy. He was definitely the non-Stolo-tolerating kind of All-American executive. Phone calls would have been made. Stolo would not have been protected by me. I didn't like the way he tortured the bookie. In any event, Ace subtracted himself from our lives before we got grown up enough to savvy the nature of his connections. Only a few years later, in New Haven, I was able right off to understand how the iceman at Deke (who drove a black Caddy) fitted into the Mafia-controlled bookmaking apparatus in that city. At this distance my memories of the circumstances under which Ace Stolo went back to Reno are none too sharp. My seat of the pants conviction is that Ace was called to his Reward there. Biggest little city in the world. Was a Sum of Money, owed to Somebody, at stake in Ace's disappearance? I would have to make that my 4-star best bet of today's card.

My father was more than capable of violence. An aura of violence in reserve hung about him. This was all to the good in his role as Medical Director at Kaiser, that new-fangled idea for bringing health care to the American working classes. The AMA tried to crush Kaiser from the outset; the monopoly would be broken. But you didn't really want to go into my father's office with some guff about "socialized medicine." There was that chance you might say the wrong thing. . . .

Paul Fitz Gibbon was quarterback on the Packers for the 5 years of Curley Lambeau's first glory reign. He was a versatile athlete who gave you 60 minutes of running passing kicking tackling blocking and various other gerunds including thinking. Wherever football was talked, or bar or Board, my dad was a big celebrity. I had little idea of any of this 'til one day, rummaging in a storage closet, I came upon a box of old clippings. My father was absolutely not one to set up hurdles in the living room, and he is greatly to be thanked for *never* letting me think he was in any way disappointed that I had failed to grow into a stand-up guy. In truth I had grown up to be a sit-down-with-a-book kinda guy. Quite unsuited, then, for football. Nor, cowardly as I guess

I am, did I relish contact sports of any category. Unless sex, if that counts, and it should.

Paul Fitz Gibbon was, like my namesake son, a doctor of great distinction; he was one of the neurologists called when Bobby Kennedy was shot; he loved the medical life as much as he hated the year he had spent in law school. He was a doctor who read the best literature, appreciated Stravinsky, kept a box at the opera, went all the time to museums—and had no care nor sympathy for contemporary art. In all he was a pretty lucky parent for an art critic. As to sex, my father was charming, good looking, rich, and had the manners of a prince; I cannot call to mind a situation where some girl was not trying to crawl up his leg. Once, perplexed at myself for always having some maiden on the string despite having at home a loving and perfectly perfect wife, I took the issue down to Laguna Beach, where my dad maintained a *pied-à-plage*. "I had a similar problem," he said, looking out over the glinting ocean, "so I took it to John McNally." A tall handsome black Irishman, McNally was my father's best friend. Said to be a principal heir to a publishing fortune, Johnny Blood, as he called himself, could pretty much carve for himself. He was a mainstay of the Green Bay team during my father's era, an all-time NFL Hall of Fame halfback. I first remember meeting him in Los Angeles in 1940; he was on his way to Burma, to join the Flying Tigers. So my father asked McNally if he thought having so many girlfriends could be right? McNally, whose mental stock-in-store ran to asking himself if there could be a Buddhist aspect to Kant—all that sitting and staring in Augsberg—did not hesitate any longer than it takes to get downfield under a punt. "Well, Paul," he said, "I envy any man who ever screwed a woman." Neither Johnny Blood nor my father used 4-letter words. "Dad," I said, "that's a good answer from Johnny Blood, but I guess it's not definitive for me."

The unsolvable issue of gender relations is nonetheless defined pretty well in Lance Richbourg's two paintings of my father with a chorus girl realized from a *Des Moines Register* photo shoot of the mid-'20s (fig. 23). How shall these twain ever come together in love? Not one artist so far mentioned has had one darn thing to tell us about how the genders can make peace! Lance is the first to try— and he actually doesn't want to try, he'd rather be painting the National Pastime.

Lance Richbourg and Ed Carrillo, not long out of UCLA, married sisters. Who gave them children. Eventually, they divorced the sisters. And remained brothers. The brotherhood came easy, dealing with the sisters hard. Yet Richbourg knows as much about love as the next person of his gender. He struggled for seven years with the big watercolor/collage, tearing out & pasting back in huge chunks of the painting in a long agony of trial, substitution, and try again. This battle with the painting absolutely reflects the subject matter: Man confronts Woman. Just examine the gulf that separates these bonny exemplars of Male/Female sexiness! And just look at the emotionally laden color he's invented to convey the full drama of this stand off in Des Moines: the Football Hero vs. the Follies Star. And the protagonists are happy with the situation! They're eager for the combat. But, oh, Lance wrestled with it. Eventually he developed an abstract play of aggressively torn shapes that broadly activate the picture plane without counteracting the primacy of the "realist" image. And he was done.

Frankly I feared, during the long gestation of the painting, that it would prove to be Richbourg's *bête noir*. He and I have been close friends for a third of a century. Lance is a volatile personality, capable of going off in many directions. I didn't wish to ask him to turn down a Not a Thru Street. I feared I had obligated him without thinking thru what I was asking him to portray: a skilled, confident Man meets up with a skilled, confident Woman; they are at the peak of their young powers; neither has the first inkling of what the other is "about." And never will have. I am minded of my friend Michael McClure's play *The Beard,* where Billy the Kid faces off with Jean Harlow in Eternity. ∎

"RED" Fitzgibbons, Creighton university halfback, Omaha, looking over new material to ball Justine Johnstone, former Follies beauty, and still beauty, puts a real "kick into her tryout. Wide World.

for John
Lance '94

23

Lance Richbourg,
Study for *New
Material*, 1994

Lance's painting doesn't solve the gender contretemps. He did manage to define it. Had I submitted (instead of the publicity pix) a clipping of Paul Fitz Gibbon tackling Jim Thorpe or lateraling to Johnny Blood, Lance woulda breezed thru it. Already he had achieved a full reservoir of baseball players-in-action paintings, many of which featured *his* father, Lance Sr., a veteran major leaguer—and looking every inch the 'baccy chewin' part. Richbourg's aesthetic father is of course Thomas Eakins. We were in the Yale Gallery one afternoon, Lance & I, and in the American wing came across Eakins's 10-ft.-high painting of *A Knockdown*. I thought Richbourg was going to take a knee. The reader has heard the expression: "It knocked me out." This was it. Whistler is in Lance's pedigree too, his *Nocturnes* in especial. The Butler owns a good-sized watercolor from the early '80s of a nite-sky fireworks display above the Oakland Coliseum after the A's won the '74 World Series. Pure Whistler with its fulminating pockets & shreds of color worked wet into wet.

With the painting for Pilot Hill behind him Lance went to work on a year's worth of loopy-doop book-illustrator-y book illustrations for his friend Elaine Segal's tender, not unduly whimsical big children's tale of the time the Beatles' limousine breaks down in front of a suburban little girl's house. These drawings, executed at scale, have something of what the Fab Four had: panache & a sense of fun a-plenty. A larger audience would not harm the world as we know it.

Time and the odd medical reversal have gentled the whilom Wildman Richbourg, who now cuts a professorial figure as he walks the campus of the small Vermont college where he's taught for many quiet years. On the other hand, in the various communities he's lived (including Burlington) Citizen Lance Richbourg has taken aggressive, litigious, in-your-face stances whenever there's an issue of planting neighborhood baseball diamonds. A regular ruffian before the city council, Lance puts on the Snarling Canine persona of his performance pieces (and the elastic energetic freely drawn-in-the-paint

Mad Dog series that bolsters the shock-and-storm of these explosive Events or "Happenings"). Conflicting winds blow thru every artistic personality. Perhaps the painter habitually tied to the photograph may be allowed some latitude to ventilate contradiction.

The National Pastime. Tax-Fudging? No. Watching Television? No. Shopping? Strike Three!!!

The National Pastime is Baseball. This is lucky for Lance Richbourg because it's allowed him to fashion an epic view of America, crisscrossing from city to city, from Baltimore to Seattle, from Los Angeles to Boston, from the Cardinals to the Yankees, from League to League, ever on the move, ranging over the great Nation. And it's allowed him to hop the decades back and forth in Time, like checkers on a board.

Over the past 25 years Richbourg has developed this epic view until at this point it seems to belong to him. A painting like *Hobie Landreth Diving into the Dugout* (1982–83), has the cachet of a film like *Bang the Drum Slowly*, a novel like *Box Socials*. You could say that Lance is our painter-laureate of the National P. There are plenty of baseball painters, but the most interesting ones (Tony King, in his photo-transfer period) seem to quit the sport after a while. Richbourg himself has other schtick he works—notably cowboy send-ups, pirate-movie buccaneer burlesque, even family portraiture (when he's broke). But Lance has buttered his bread with baseball. To be sure he has sacrificed the lyric to the epic all along, but as the millennium proceeds there are hints, rumors really, that the painting-as-love-poem may yet have its hour. Don't bet your peanuts & crackerjack against the possibility of a Joe/Marilyn series.

Meanwhile there is a tricky dimension to these baseball pictures, a hidden figure in the ground. Lance Richbourg's baseball paintings are governed by a single extended mirror-simile: Ballplayer is like Artist is like Ballplayer. How well does this embracing metaphoric umbrella hold off the odd carping objection? Well, the hand/eye/occipital

cortex cooperation is very like. Good coordination's what's at stake here, what you'd have to call "major league" coordination. There's an aspect of Intuition involved; and a role to play for what the tennis set calls "Anticipation"; you have to kind of know what's coming next, you have to guess right. Properly understood, guessing right is not guessing. There's a notion of grace in all this, too: of making what's very difficult appear easy, natural, effortless. A ball is hit over the centerfielder's head. He turns, races toward the wall. And catches the fly over his shoulder. Say-Hey! This notion of grace is of course raceblind. It's a feature of Richbourg's art. Although you may wish to conclude from a work like *Henry Aaron Leaping* (1981) that white men can't jump—not like Hank, at least. And of course the game itself is a performance in the arena while the making of the painting is a performance in the studio—allee samee Harold Rosenberg's definition of Action Painting.

Above all the sport of painting, the art of baseball are about having a *technē*, about mastering a skill, or set of skills, that raise you above the hopeful throng of competitors. Richbourg's baseball oeuvre as a whole is a Pindaric celebration of the Triumph of Quality in a system that works infallibly to winnow the field (starting with every guy who went out for 2B in high school—no, make that from every kid who pitched Little League) down to where Chuck Knoblauch is standing on the bag, Pedro Martinez on the mound.

In other words from every pimply brat badgering his art teacher to let him watch the World Series during 5th period, please!, and from every Des Moines or Phoenix or Chattanooga whizkid now climbing his 5 flights in SoHo or Chelsea or crossing water daily from Brooklyn, from Jersey right down to the starting lineup for George Adams or Phyllis Kind or John Berggruen or (in Richbourg's case) for Ivan Karp.

So Lance Richbourg's baseball pictures provide one more end-of-the-century example of Art about Art. And if they didn't perform that function they would amount to no more than *sportsillustrated*.

Lance Richbourg's baseball pictures are "about" Art. But what, reader, pray, is Art about? Well, Art is normally about Birth, or Death; Or it is about True Love. Subjects, in other words, tangential to Richbourg. Up to now.

Hell and Heaven are also perennial art subjects, as much now as ever. How much print's been expended on the Idea of the baseball park as a bucolic pleasure ground set into the urban wasteland surround! The ballpark perceived as remnant, as a holdover of the Golden Age. On this view the diamond-plus-outfield reads as an idealizing play of neo-classical geometries, as a formal garden: a parallelogram inscribed in a truncated fan, with lines extending 60 feet, 90 feet, 330 feet, 420 feet, 360 feet, and so on. The whole 18-player set up easily expressible by ratios incorporating the holy numeral 3. Behold: a lost Natural Paradise (but retrievable for 3^2 innings!).

Give or take a few commercial billboards, which he loves to paint and which they didn't have in Arcadia, Richbourg's pictures only go as far down this mythologizing country road as the next baseball painter's. So while the return-to-paradise motif, the revisiting of a heavenly playground is a familiar enough art subject, Richbourg relies on it sparingly, casually, and indeed tries to steer his work away from what smacks of Art *per se*.

But in Art, as in many another area, self-denial leads to a payoff. By downplaying Emotion, Richbourg is able to find the poetry in Motion; like Pindar he sings the strong arm, the sharp eye, the speedy foot; he holds up to admiration a whole range of spontaneous decisions-making endemic to Baseball. The pick-off play. The strategic bunt. The perfectly executed hit-and-run. The throw-out at the plate. Turning the double-play. Foiling the attempted steal. These manly feats can be construed as so many demonstrations of artistry; *vertu* equals virtuosity in Lance's familiar trope. It's enough for him that the ballplayers stand in for artists, the diamonded greensward their arena/studio. It's metaphor, not mania. He doesn't insist that Yankee Stadium double as the Louvre.

24

Robert Bechtle,
Pilot Hill Deck, 1989

And there is, after all, for the lyric-starved fan, something sexual, something potent at stake, in his treatment of the epochal long ball—as in the recent studies of Sosa and McGwire and Barry Bonds. Here one can feel the bat as living extension; the thirst of the bat itself quenched in the homerun. The bat's role as "good wood." Ithyphallic. Perpetually hard.

Photo-realists both glory in the free information the photograph provides and chafe at the dictatorial restrictions it enforces. Such OK Harris teammates as Richard McLean & (slightly more painterly) Robert Bechtle (fig. 24) feel these constraints much more acutely than Lance Richbourg who, working

from black-and-white newspaper photos—working in fact from *old* newsphotos, can capitalize on their very fadedness and poor resolution to invent his own brand of close-valued, memory-filtered color and to subvert, distort, & harry his *donnée*—the "given" shapes of the wire photo—toward ragged blurry very painterly surface-holding patches that seem to confer on the painting something of the energy and freedom of Action Painting.

For the full-sheet watercolors and the oils, Richbourg has, in the '90s orchestrated out of blubby pointillist touches a warm glowing jewel-like surround for the figures, a metaphysical soup in which the ballplayers seem to think and ponder ■

25

Lance Richbourg,
Bat Boys, 1984

their moves. In our watercolor of the early '90s *Three Batboys* dream away their futures seated on the old Boston Braves bench—Lance Richbourg Sr.'s team. They are growing their manhood, fixated on the heroes and role models of their ballclub. We *see* them thinking, the colored-*sfumato* 'round their heads the vehicle of their thoughts.

A mellow rubicund Rembrandtian light suffuses one large vertical oil painting from 1998, *George and the Babe* (Gaines coll., Orinda). The noumenal world has settled down on the phenomenal, filling it with Love, Tenderness & Understanding and the Aura that proceeds from any great personality. Babe Ruth (for it is none other) has come down onto the field of the college stadium in the flittering contrasty dance of light & shadow, so reminiscent of Rembrandt. Mediated, too, by the inspissating ambiance of Eakins's sports paintings, the Babe appears gaunt, cadaverous, cancerous, yet hundred-hearted. The year 1948. George H. W. Bush, on the other hand, is callow, unformed, all youthful impressionability. Today he will be grazed by a goodangel's wing as surely as though this ostensible celebrity cameo were an Old Testament paternal blessing. It is one of those moments in life that lead to something, when you are touched by someone authentically great and first comprehend that you too can reach for greatness.

No ordinary artist could have delivered this message of the passing of wisdom, compassion and aspiration from one generation to the next. That's why, increasingly, Lance Richbourg's to be regarded not simply as a skillful photo-realist with a taste of journalism in his brush, but as a Delphic photo-oneirist whose field of dreams encompasses Love & Death & the whole damn thing that belongs to Art. Because Lance is right: baseball pictures should be about Art, not Sport (fig. 25). And though he can't be expected to square the circle, yet he has begun to circle the diamond.

■ "ALL BROKE TO HELL, HAROLD, all broke to frigging hell. Fugk, Harold. All broken."

Harold Paris had just come out of the afternoon Berkeley sunlite, now that the fog had burned off, and found Peter Voulkos's studio dark and Peter Voulkos sitting there in the gloom, not just saving electricity but evidently moody and disconsolate himself. Pete was perched on a large wooden case stamped with the name of his gallery back east. His feet rested on a smaller box and there were two more by the doorway, all apparently just delivered and not yet opened. "All broken, Harold, Fugk!"

The studio is the same one Robert Brady inherited (that is to say, *purchased*) from Voulkos when Pete and the University of California at Berkeley went their ways. Bob had been living in Crockett and not relishing the long commute to Sack State. With his back and all being what it is, Bob went ahead and bought the studio P. V. vacated. Above all, of course, he wanted the associations the place would always have with Peter Voulkos. (When Bob traded with Pete, Bob made a piece unreasonably big, more than twice the size of anything he's attempted, before or since; Voulkos could only shake his head; but Pete understood.) The other main consideration was that now he would be within bicycling distance of his work since Bob lived in the certainty that he would succeed Voulkos in his job as well as his domicile.

That's why I love and I mean LOVE Brady (fig. 26). He's a cocky Irish boyo, and it never crossed his Gaelic mind that he'd not be chosen to step into Peter Voulkos's stylish loafers. How many first-rank ceramix teachers does America count, anyhoo? Hunner 'n' forty-four . . .? close enuf.

Ladeez & Gennumen: Richard Shaw (fig. 27) is Professor of Ceramics at CalBerkeley.

And Brady is tugging at his wallet for $2 so he can clear the Carquinez Strait.

We step in here (Yes! We assume the right to assume the authorial "we" whenever it likes us) to point out that damage from this potential tempest in a bucket of slip was kept to an "it's all in the family" minimum. Voulkos, Brady, and Shaw share a ■

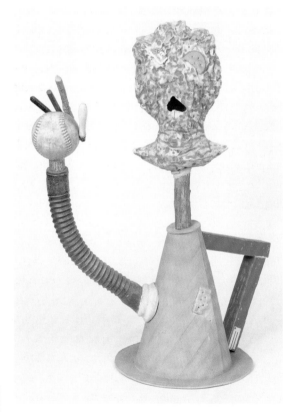

dealer in the kind, cultured, witty Ruth Braunstein, blessed with a true eye, a surplus of heart, a breadth of intellect. Even in our Northern Calif. artland, conspicuous as it is for dedicated trustworthy dealers, Ruthie long has established the benchmark for fair play, absence of "hustle" and unstinting commitment.

The interested reader is welcome to file the above away, under the generally disused rubric of DEALERS GET GOOD RAP.

The fact is, by the time, long ago now, that Harold Paris stopped in to see his down-in-the-dumps friend, most of the first-generation artists in this exhibition were achieving solid recognition. This didn't mean the money was much to shout about. Artists still relied on their teaching to get by, or on a bluecollar job, or by any means necessary.

"All broke to Hell, Harold. Fugk it, all broken. They only sold one piece, and my show came back all broke to bits." And Voulkos gestured around him at the wooden crates marked FRAGILE and HANDLE WITH CARE. To Paris it was evident his friend had a drop taken. "Keep the cold out, Harold," said Pete. And he poured a mug of Ballantines, and passed it over to Paris. "Here's to the fugkin' Insurance Co., Harold, they aren't gonna like it."

"Like what Pete! Like what? You haven't opened this stuff. You haven't opened one box."

"Fugking broke to Hell, Harold. I packed it myself."

All broke to fugking Hell, Harold? My acquaintance with Peter Voulkos went back more than 4 decades but unfortunately this was just a shade short of enough, so it took me much longer to catch on to Pete. Those friends who knew him from still earlier on report of the shy boy who came to Los Angeles from Missoula, Montana, that if a curse word were uttered in his presence Pete's beautiful oliveskin would blanch and that if a pretty woman should enter the room Pete would look at the floor. If you can keep in mind this foundation level of innocence and delicacy it does much to illuminate the ethereal aspects of his sculpture and to explain why all attempts by other

artists to match the raucous-Voulkos vein in his work are pre-doomed to hortatory bluster.

To all & sundry it appeared that Peter Voulkos dominated the clay; overwhelmed it; subjugated the amorphous medium to his ferocious will. In actuality it was much more a question of P. V.'s acting quickly & decisively, so that many gestures seemed a lone single subsuming gesture. Watching him demonstrate, he was so in tune with the medium that, to me, the clay itself seemed more acting than acted upon; it was as though, capitalizing on every chance that offered, every potentially happy accident, en route, he was merely letting the clay find its own shape. That's how deep the collaboration went, how far he could rely—safely rely—on the instinctual realm within, a realm (if this doesn't beg the question) greater in Voulkos than in other men.

Many of us who knew Pete share the illusion that he was a big guy, a giant of a man. He wasn't! Pete just SEEMED big. This phenomenon happened to me only once prior: with Siqueiros.

So Voulkos wasn't all that large, but he looked to be one of those brawny hairy-chested guys and, if matters grew a little heated during a teaching demonstration at the Pot Shop, Pete would like as not prove it, in one swift motion pulling off the French sailor's jersey he wore in all seasons, year in year out, in outright homage to that Master of Villauris who from the early studies for *Les Demoiselles d'Avignon* down to the Artists&Model sketches of his 90th year depicted himself in the same cotton garment. From Picasso, P. V. derived the most basic recognitions: life is a perilous sea journey thru the womenwaters; don't be afraid to try anything; it's OK to do ceramics.

When Voulkos arrived in Berkeley in 1960 there was an art-major requirement of two semesters of clay for all students planning to go on to the teaching credential in Art. In fact Voulkos was probably hired to meet this very demand. This clay requirement, DecArt 141 A&B, naturally had to be filtered thru a subordinate mini-dept within the Art Department. So decreed the band of self-perpetuating 2nd raters who constituted the main dept. They shrank from contaminating the elevated arts of Painting & Sculpture with the lowly down-market crud of ceramics. Thus P. V. slipped in. The "real" art professors couldn't be bothered to vet him.

Now University deans, never mind the popular wisdom, are not utterly destitute of brain. Sizing up Voulkos, the dean installed one teacher in the regular Art Building, a namby-pamby guy who showed students how to teach kids to make plates & cups and how to throw 6 nesting bowls for Aunt Agatha. And he put Peter Voulkos (and his instant wolfpack) in the basement & backyard of an old semi-Victorian down the street, a building dedicated to student housing offices, and scheduled (Voulkos would help accelerate this) soon to be phased and razed out of this world. This literally backdoor site with its warren of underground rooms given over to glaze calculation shelves, & drawers, or sandbag piles (so convenient for the student or 2 or 3 who actually *lived* there), this out-of-dean's-mind, out-of-public's-eye cellarage was called the Pot Shop and its out-of-doors walk-in kiln with adjustable firebrick shelving guaranteed that plenty of pots could indeed be tended with the full panoply of ritual joys and kicks and excited fun 'n' cross-yer-fingers hopes & fears that kiln firing entails.

The Pot Shop was spinning (to use today's lingo) 24/7/365 because your authentic ceramic student is oblivious, he acknowledges nor season nor history. Voulkos was sometimes there at scheduled class times, sometimes not. But if you missed him today you'd see him tonite, or on Sunday, or the 4th of July. Important young artists "hung out" with Pete; for Melchert, for DeStaebler, it was a far cry from Princeton. Harold Paris was often on hand, cape swirling behind him, beret pushed back, as he hacked, chopped and sliced at the clay with his sword, preliminary to firing chunks big as the Ritz. Harold lent a touch of children's-adventure fantasy to a situation already magical by half. Crew-cut Cal kids carefully peel back the humidifying plastic from one of Harold's grand *Walls,* and risk a peek. ▪

Unholy Moloch! Will they be struck dead? No. They step back, awed but alive. Lucky for them Harold didn't suddenly show.

If a friend had new information Harold Paris had the knack of milking him of it and using it for ends all his own. This is how he treated his friend Pete. Nor, it must be said, did Pete miss anything; there was plenty to go around. What happened goes something like this: Harold Paris, with no prior experience, landed on Ceramics, finding Peter Voulkos in charge. Over a short period Harold Paris absorbed EVERYTHING from Pete—and yer welcome, Harold! Voulkos knew something (actually quite a lot) about Abstract Expressionism—having gone up to N.Y. from his Black Mountain Summer and rubbed shoulders with Kline, de Kooning & the rest of the company. Paris was as ignorant of Abstract Expressionism as he was innocent of clay lore, but he knew P. V. was onto how to link the two. Peter Voulkos had seen that the ethos of AbEx could be brought to bear on clay procedures. One conclusion that Voulkos drew is that you could work Big. So Harold Paris worked bigger. From his pal Peter Selz he picked up as well the idea that vague figural tendencies persisted in Abstract Expressionism. Of Pot Shop clay & kiln Harold realized three gigantic *Wall* pieces, ambiguously, allusively figurative, allusively, ambiguously Old Testamentary in putative Content. Then, having looked at what he'd done &, along with everyone else, pronounced it Good, Harold withdrew from ceramix, returning the field to Pete who hadn't noticed its temporary absence. And the two friends turned their attention to playing the bronze game.

To the history of clay, how important were Harold Paris's Berkeley contributions? Very. Whenever I walk the few steps from my daughter Pinkie's house up to the garden of the Jewish Museum in order to see the Paris *Wall* there, or when I stroll in the other direction, along College Ave. toward the University Art Museum, and stop at the Newman Center to have my 947th look at the DeStaebler installation there, I consider freshly

how edifying it is that some of the 20th century's most successful religious art came smoking hot out of the Pot Shop, on Peter Voulkos's watch.

Not everything that happened at the Pot Shop was significant, of course. Take Jane. Jane claims to have been the least important potter whoever kicked wheel. She sez her contributions to clay history were nil. In fact she claims to have *subtracted* from clay art history, citing the time she fell asleep on kiln watch duty and 8 shelves of mostly other people's work were almost martyred.

Jane is modest. Pretty near everybody threw acceptable stoneware jars & vases in the Pot Shop manner. The ones Jane didn't give away, we still have and use. They are full of merit. Voulkos started students out throwing hollow cylinders, getting it up as far as you can and striving and praying for thin, even walls. Then this "sewer pipe" would be cut off at the bottom with a wire and the cylinder crumbled back into the vat of clay mix. And over again you started. You had to supply your own wire, and girls were directed to go into the guitar section of Tupper & Reed Music down on Shattuck and ask for a G-string. Jane, puzzled, brought the assignment home to me, and I explained. My big Merriam-Webster, 1961, doesn't contain the word *sexist,* and I myself thot Pete's little joke amusing. In a similar vein I recall applauding the discovery by N—— O——, one of the many already famous artists who came visiting, that if you went up on the roof of the Housing building, you could peerpeep into the Women's Gym outdoor pool across the way, where, the rumor was, coeds often swam *au naturel.*

Jane was getting ready to graduate; we decided to buy a plate from Pete. At the time P. V. was turning out a series of honey-colored, broken-lipped platters, not too large, made dysfunctional by a run of three or four knuckle holes, as in a bowling ball, with perhaps a slash underlining them; or perhaps the whole plate would be inflected by an eccentric gash toward the middle. How else to put it? These plates were too classy to believe.

We went to Pete.

EIGHTY DOLLARS!!

We simply didn't have it. And we bought a refrigerator so the milk for the kids wouldn't spoil.

With the Pot Shop sublimated into the lower grounds of the new U.C. Art Museum, Voulkos now began to test the parietal regulations for fair. He transferred his classroom obligations to his own studio down by the Bay next to the Southern Pacific main line. With this step Voulkos restored the teaching of sculpture to the Renaissance apprentice model. The art secretaries didn't know the whereabouts of Voulkos, and if any notice happened to be posted, it was soon torn down or covered over. Only the kids with the right ambition, self-reliance, drive and luck found their way to Voulkos.

All the years I worked in the West Oakland yards the most coveted graveyard assignment was to the Richmond Cannonball. After you'd dawdled a little picking up your cars, you'd pull into the siding next to Voulkos's studio and tie up early for beans, walk past those intriguing metal contraptions ("Iz this sposeta b Art?") Voulkos had parked out in front and go in Pete's open door where you were sure to find girls and beer and the Poker Game and "crazy Art" plus girls. The average switchman didn't know much about Art but he knowed what he liked. Thus Voulkos magnetized the hogheads and firemen and brakemen and mudhops off the S.P. the same way he magnetized the students and the sizeable coterie of lesser artists who attached themselves to his capacious personality.

One summer Ron Kitaj was in Berkeley for a visiting teaching gig. He announced that on my birthday he would take me and my elder son to the A's vs. Yankees game. Oh, and Mel Ramos & his boy could come along as well. I was pretty much thrilled at the prospect of listening to Kitaj; he would, I figured, talk about Art with a vengeance. The day appointed came, and after a light supper during which Kitaj patronized Mel and me (while consuming two pieces of birthday cake), Ron condescended to ride out to the stadium in our own van. Which we did without incident, Ramos and I coming under a light Kitaj condescension the while. He continued to patronize us thru-out the game—which I began to resent (even tho' I know he can't help it, it's his way), not so much for me as for Mel Ramos who is a better artist than people in this country think (figs. 28, 29). Ramos's travesties constitute a brilliant deconstruction of art history suggesting, as they do, that all the Cupids & Pysches of the museum walls do little more than mask the daily hunt for that little triangle at the heart of so many Peter Voulkos plates.

As for me my thoughts ran along the lines of, Who am I, after all? Don't amount to much even in this local art world. Perhaps this guy has perfect right to look down on me. But he should lighten up on Mel Ramos. Years later I mentioned this episode to Ramos and he said he couldn't recall being patronized. That's Mel.

Back to the ballpark: at the 7th-inning stretch the boys stayed in their seats while the 3 of us went up to the semi-rotunda behind the stands for hot dogs, etc. We were ambling along, chatting together, when, lo, coming counterclockwise right at us not 30 feet away, walking 5 abreast, here cometh Voulkos, with Vaea and Ted Odza flanking him and another P. V. satellite at either end. Both groups stopped dead; our condition was mutual shocked stymie. The stadium disappeared, and Oakland, and the Universe, while the shock waves collided and the moment lengthened like the finish of a good wine, as each group inwardly debated whether the other had any franchise whatever to witness a Yankees vs. A's game that Nature had intended to stage for them alone.

Eventually, recognition signals were flagged across the 30 paces and a shoot-out was evaded—for now. Who went armed in Oakland anyway, back in those dear days? All retreated seatsward, the game continued and Kitaj began to belittle ceramics in general (nothing new about that) and Voulkos in especial—the 4 lieutenants falling beneath his contempt, and this condescension saw us safely home and me up to bed where a sleepy Jane asked, "How'd it go?" "Yankees pulled it out

in the top of the 9th. The three of us," I added, "ran into Voulkos." And I amplified.

"You should have gone to law school, like everybody told you," she said. "Now go to sleep, the art world is the same as all the others."

Usually I learn from Jane asleep or awake.

One world not at all magnetized by Voulkos was the cop world. Another was the college-administrative world. These worlds are in fact one world—or at least they inhere in each other. *Das ist nicht Neues im Berkeley, hein?*

The motive I had for interesting myself in P. V.'s mounting drug/alcohol problems differed from the authorities'. The University administration quite missed the irony of their position. They wanted Voulkos out because this Greek was apparently bent on corrupting young people. (Translation: they feared negative publicity.) They wanted Pete out of there notwithstanding the national prizes, international honors that continued to be piled on Voulkos. The only thing that might have saved Voulkos's job at Cal is if he had been awarded the Nobel Prize in

29

Mel Ramos,
Untitled, 1979

ceramix, a prize they don't give; but if they did, it would certainly have gone to Pete. They love to count their Nobel winners at Berkeley.

The cops, on the same hand, thwarted, checked, baffled and mocked by Voulkos & his lawyers, the cops, humiliated and defensive, wanted nothing more than to make an example of this defiant bad-boy; and to this end they laid on their newest surveillance technologies: infra-red this & that, computer savvy, searchcopters, CODE:BLACK_PENGUIN ENGINE_TOMCAT—ENGINE_WHITE. CODE OVER, and like that. On the assumption that P. V. was conducting a hard drug deal inside an East Bay motel room, a plainclothesman burst through the door, requiring Voulkos to throw him back into the corridor, and nex' time please knock an' be reddy to show yer badge. This scene is reminiscent of what happened to Ken Kesey one evening at his home in La Honda. Kesey was in his bathroom seeing if the toilet would stop making that noise when "a Chinese fuzz in mufti came thru the window" and the former college wrestler was obliged to defenestrate the invader.

In the last century there has been worse oppression leveled at artists than drug harassment, but you have to look at totalitarian regimes to find it. They did more under Soviet repression than spray your marijuana roof garden from a copcopter.

Voulkos in the end yielded to societal pressure and cut a characteristic hard-bargained deal with the University enabling him to devote the rest of his life to giving the workshops and demonstrations that made Pete beloved and revered throughout the world, wherever clay cried out to be kneaded, punched, squeezed and poked. The police backed-off, eventually, and with the aid of his friends and the continuous concern of Ann Adair—Mrs. Voulkos—Pete got a handle on the ruinous insidious need. And Peter Voulkos resumed with clay. In the long devastating trauma over drugs the artist had lost stride but not Quality.

By way of apologetics Karen Tsujimoto's thoughtful essay in Rose Slivka's fine book on P. V. brings in Jung and Alan Watts as emollients to rub

on the whole idea of Voulkos's drug-woundedness. Well and good. Drugs can and do open doors. They can wildly enrich experience. But P. V.'s disastrous affair with drugs requires compassionate understanding, not justification. Consider, skeptical reader, if it were you who revamped an entire phylum of Art, who released clay from the doldrums of iddy-biddy teacups, who bore the brunted impetus of the resentful entrenched and angered ceramics old guard, who terrified the nicey-nice potters with those mutinous-sailor-fierce looks. ("Pirate Pete" some of his Berkeley "colleagues" had it. "He looks like he should have a ring in his ear and a tattoo!" averred another professor-artist who died—luckily, I guess—before that "look" took over the streets of not just Berkeley.) Then there were the (always a good bet to find poison) letters-to-the-editors ("A Barbarian, not a Greek!") and worse, much worse. All this took its toll on Peter Voulkos.

In any revolution in art the leader of the vanguard pays the dues. Voulkos had the personal authority to pry the ceramic world from its clamlike adherence to the rock of Craft Aesthetics. Nor was it just the Philistines his work insulted. He knew full well he was betraying the very potters who'd spotted his talent right off and provided him affection, recognition, opportunity. God only knows just how costly this was. Even St. Christopher, ferrying the Child across a river of indifference, found out in mid-stream how intolerably heavy it is to bear away the sins and follies of a fallen and distrait Mankind. You are not a saint, skeptical reader. Nor am I. Neither was broad-backed Peter Voulkos. Yet, like Christopher, he had to continue what he started. He did so and he did so for everybody (fig. 30). Sometimes, with a great heroic, innovative artist a certain hesitancy sets in, and this can lead to revision & reversion. Voulkos's career displays *hiati,* as when he quits clay for a while in order to take a look at bronze. But he never looks back.

Just how good are Pete's metal sculptures? Well, they break no new ground. But they are the most securely virile since Henry Moore. And they are

devoid of pretension & braggadocio, which can't be said of Richard Serra or Mark di Suvero, now can it? The Crocker Museum's piece, *Osaka* (1970), low-slung and understated with a characteristic reciprocity of Form, boomerang-like, is from that moment when pretty near all outdoors sculpture was hunkering down alongside Tony Caro, hungering for the ground plane. Not one of Pete's best but it serves, it serves.

In the late '70s when P. V. began throwing those heavy, wood-ash fired plates at Peter Callas's place in New Jersey, the most gorgeous plates ever seen, I says to meself, sez I: the time has come to get one of this run for Pilot Hill, give us somethin' t'look at. Because these are the sexiest plates since de Sade useta take his omelette on Fifi's buttocks.

Eighty dollars is what I would offer Pete, I decided.

Plus my best Niu Guini carving: a huge Kandegei village initiation piece this was, the scarifications on both sides of the figure cut so trenchantly that it took a while to perceive that their urgent dynamism also served a decorative end. If you were a teenager forced to co-habit the Spirit House with this great Warrior-Ancestor it was going to prove a long fearful weekend. "Pete will love it," I told Jimi Suzuki. "Moreover it may be quite useful to him, this big suspension-hook; he can hang on it the skulls of his enemies, be they Turks, or cops, or Heaven forfend! yer over-nosey brand of art critic."

Suzuki helped me transport the tall figure to Oakland, and Pete admired it, as who wouldn't? He didn't have any of those plates around, but he would, soon. "All back there, John. All back East."

"OK," I said.

These art trades can take years, even decades to consummate. A great secret in Life is to have something to look forward to. Another is to have something to grumble over. It all comes from the unregenerate human satisfaction in making a deal.

The above paragraph can teach the empathetic reader two things. One, don't end a sentence with a preposition. Sure, it's a dated prohibition but

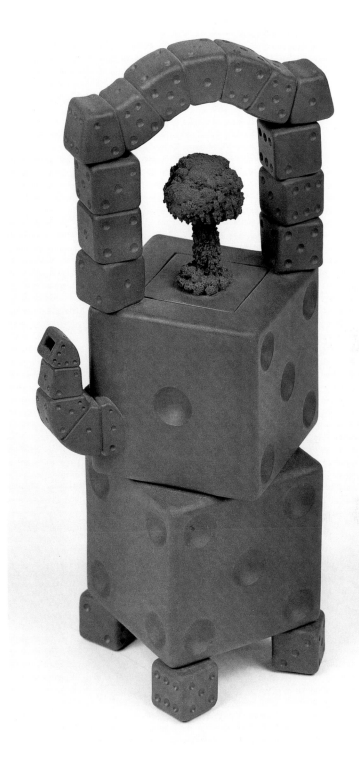

30

Richard Notkin,

Dice Teapot

(Variation #5,

Yixing Series), 1988

there's something noble about the old rules, sometimes. Two, avoid all pieties and the sententious expression of unearned philosophical "wisdom." Three—but three is something it'll be wiser to leave the reader out of.

A year passed, and another. Occasionally I'd see Pete at an opening, at a party. He'd put me off. At length in the mid-'80s I went down to see him, with Jim Albertson for company. Then in recovery, for 16 years Albertson had been a functioning (sort of) heroin addict. What I mean is, Jim isn't dead. Jim said he had persuaded Voulkos to let him stash some valuable photographic equipment with him, for otherwise Jim's "friends" in the addict community would surely steal the cameras and all. Albertson, too, I had traded: two free-standing Middle Sepik ancestor figures for a couple of Jim's hard-hitting early "Bad" paintings. Indeed he held onto these tribal pieces while all his other material sources fled. Finally, tho', he sold them to buy drugs.

We went to the Dome and Jim retrieved his camera stuff from where it'd been secured. We looked around for Pete, to thank him. There he was, in a swivel chair, awake but wasted. "Thank you Pete."

"Ishkabibble zonk zorn armuin anokee argulat-tkrk," said Peter Voulkos. "Mozzech sas webl poi," he added. Pete was speaking in sentences but could not form a coherent word.

It was sad.

Before we left I looked around for the big New Guinea sculpture. As proud an artefact as that culture affords. It was nowhere in sight. Later I was told it lived in the bedroom. Pete was in absolutely no condition to give away plates. You may be hungry but you still don't grab the paper lunch-sack from a second-grader on his way to school. Why, a reader asks, did I give Voulkos my best carving in the first place? That is one champion-silly reader, as I can testify, being myself a venerable (or at least elder) member of that curious tribe, the Sillies. Sweets to the sweet: that's why the best piece had to go to Voulkos; the Best to the

Best. Nevertheless I left the Dome in some confusion. When you addict to hard drugs you mainly victimize yourself; in effect you become your own vampire. At my side was Albertson, truly gifted as a painter. Some years junior to me, he appeared 20 years older. Back there in the Dome is, *pace* Margaret Tafoya, perhaps the greatest clay artist to come along, and Peter Voulkos is hollowed out and reduced to babble. Hovering over him are not merely the narcs & cops but the very University itself anxious to avoid contagion & bent on reclaiming his job. It's a topsy-turvy world, such was my thought. The Administration would have done far better by its art students if it had remanded the rest of the art faculty to the Good Ship Voulkos, with the understanding that Pete would sail them out beyond the Farallones and make them walk the plank. SPLASH! There goes the guy who tried to "get" Melchert. KER-PLUNK! There goes the guy who *did* get Bob Hudson (fig. 31).

It wasn't the only consideration, but his physical strength was a main reason I invited Peter Voulkos to lead the artist contingent in my *Peaceable Kingdom* Event, done for the bicentennial in mid-May 1976. In this scenario the Liberty Belle has been captured by Ford & Nixon and their retinue of violent beasts. The artists were landed on the shores of Folsom Lake (Voulkos arriving, of course, *en gang*). These rescuers (for such was their role) followed a fife & drum ensemble a mile or so up and into the forest, encountering bands of nude figures the whole way. These citizens with nothing to hide were exhorting the artists to their task with slogans, quotes & soundbites from American history & political life: Remember the Alamo! One Nation Indivisible! One Woman, One Vote! "A chicken in every pot," a young woman demanded. "Two cars in every garage," her boyfriend completed. "Free Miss Liberty!" offered one voice, while another called out: "Free Ceramix!" "You awreddy did that, Pete," supplied a fellow traveller. Voulkos, climbing inland and somedeal short of breath, was disgruntled to find, round a bend in the

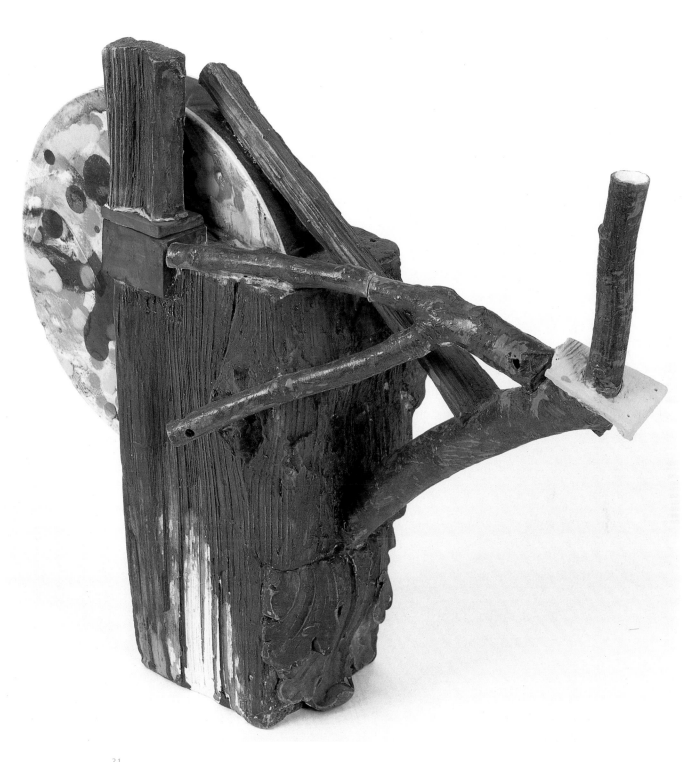

31

Robert Hudson,

Teapot, 1999

Peaceable Kingdom, 1976: Maypole with Liberty Belle

Peaceable Kingdom, 1976: Death and the Politicians

trail, the late fondly lamented Jim Pomeroy. Pomeroy was seated on a granite ledge, oaken staff in his big paw. Four naked girls held up a burlap sign: VOTE EARLY/VOTE OFTEN. "What're you doing with these other pricks?" said Peter Voulkos. Pomeroy, a veteran of the Pilot Hill Annual, kept to the script: tread softly and carry a big stick. *"Annuit coeptis,"* said the 1st girl. "A woman's right to choose!" shouted number 2. "Free the Liberty Belle!" urged the 3rd. "Tread hard and carry a big stiff prick," added number 4, *ad libitum,* establishing yet again in these Events that spontaneity is best.

Eventually the trail led into a small meadow, enclosed by blue and oracle oaks. Toward the center a maypole, and Miss Liberty chained to it. Two hundred naked Dryads & Druids were chanting: "We want Liberty. We want Liberty." It was just madness. Ford, Nixon & their Beasts were defiant, but they shrank from General Washington, who had been with the Artists from the beginning of their adventure. Now Abe Lincoln led Voulkos forward and handed him the bolt cutters. Pete stepped up to the maypole platform and made as if to snip off the Belle's long braid, which reached to her bottom. The crowd yelled: "Woooooo!!!" Then Voulkos settled down to work, easily cutting thru the heavy links before passing the cutters on to the other artists who wanted a turn. Finally freed and armed with a rolled copy of the Declaration of Independence as a wand, the Belle set free even Nixon and his crocodile, monkeys, hawks, and so forth. The maypole wound around to triumphant music and the participants found their way back to the house where Voulkos and company asked for a new deck and sat down to take up the Game. They had stayed up the whole night so as to prevent their missing the excursion.

After some hours the excitement generated by the Event began to die away and the bicentennial celebrants began to gather things and turn their heads toward home. I myself, exhausted by the events of the Event, worn by months of preparation, half overcome by the sheer madness, the

utter insanity of my vision of a *Peaceable Kingdom,* laughed a crazy laugh at my—for once—good sense in being already home when it was time to be home—and upon this *non sequitur* turned, walked out on the deck and peered in the direction of the Arcadian meadow, now obscured by trees in the green leaf where we had so briefly established a kingdom of sweetness & light. "You can't see it from here," Jane said. "Trees are in the way."

"So, what d'ye think Pete's friends thought?"

"They will think what Pete thinks."

"Pete told me he liked it fine once he figured out what he was spozed t'do."

"Pete is always gracious & polite."

I had to wonder. And to banish the doubts I hummed a bar or two of "My country, 'tis of thee . . ."

■

ONE WOMAN * ONE VOTE ONE WOMAN * ONE VOTE ONE WOMAN * ONE VOTE One woman*one plate*one woman one plate*one plate one pussy. . . Huh? How did that get in there? Good reader, we simply couldn't find a righteous transition to the idea, fundamental to our understanding of things, that Woman = Plate = Pussy. Oh, we don't expect to get every ballot cast. Bill Allan we'll likely lose on this one, our scholar/daughter Kate is very doubtful. When I approached her for support all she said was, "Oh, Da-ad, don't be so silly!" We were talking of a Baluchi prayer rug. According to Kate the vaginal imagery, complete with little button at the apex, just ain't vaginal. Now just because we tend to side with Freud's Magyar follower Ferenczi doesn't mean that we will disinherit Katie who has always been a good child and whose *Ikat: Silks of Central Asia* (1997) won the Wittenborn Prize for best artbook. We are duly proud, and that goes double for our loyal consort without whom we would have had real trouble producing our Katie. In fact, without JANE WE WOULD HAVE HAD REAL TRUBBLE, for sure. Nor do we wish to court trouble here. We understand that "pussy" gives some ears problems. We'll settle for p——y.

What Freud's Hungarian disciple maintained is that each time we perceive a concave form the

Peaceable Kingdom, 1976: Peter Voulkos Cuts Liberty Belle's Chain

Triumph of Flora, 1980: Knights' Advance

Triumph of Flora, 1980: Paul Cotton and Judy Chicago

Unconscious registers it as female, while each convex image reads as male. So in effect we can summon our own witnesses; we don't need Katie's subscription. Examples gross as Nature exhort us. So do examples drawn on Art. If we go into the Norton Simon and wander across a bronze of a woman lying on her back in what appears to be a Sadd'y night galvanized tub, our whole being cries out Plate equals P——y, and thank you, Degas.

There exists no more succinct analysis of this crucial Plate/P——y issue than the *Dinner Party* of Judy Chicago who *Triumphed as Flora* here at Pilot Hill in April 1980. A hundred naked men arrived to worship at Flora's pavilion set amid wildflowers down by the stream. Dismissing the goddess's horses, the men harnessed themselves to her chariot and slowly drew Flora toward the top of the hill. A hundred nude women attended Judy, chanting and dispensing flowers and seeds as they followed the chariot. At the last big turn where the road widens out Death descended the escarpment and attempted to halt Flora's *Triumph*. The Men fell back, impotent to stop Death. But Judy's Flowergirls took up the battle and with Music, Dance & blossoms they overcame Death and seizing the traces the women pulled Flora the rest of the way to the top, where a large isosceles triangle was mown in the grass. The flower-bedecked cart parked at the apex and, as men & women lined the equal legs, Judy was handed down by Hermes (Paul Cotton) and our goddess accepted bouquets from Steve Kaltenbach, Tom Witt, and Allan Kaprow, among other Pilot Hill regulars. The music ceased, the dogs quit barking, the people fell silent, and Judy read her poem—about a future reconciliation between men & women. Then the cheers and the music again and the dancing that signals the *finale* (always an *allegro curioso* if I may be allowed what is probably a musical neologism) of the Pilot Hill Annual.

I asked Judy Chicago to come and *Triumph as Flora* months earlier when I heard that museums that had agreed to show *Dinner Party* were starting to renege. "I am about ready," she replied, "to come

up and kick back." She did just that, and if you, dear reader, are among those folks who say they were there and weren't, all's I can say is more's the pity. You may well be among the even more sizable group who say they never saw the *Dinner Party* but did. You'll recall that Judy threatened the museums back in line; her show was held in venues all across the country. When was the last time you saw lines around the museum block on a Tuesday?

Oh yes, the plate business. Judy Chicago's *Dinner* table was an equilateral triangle set with ceramic p——ies, thirteen to the side.

Another example is required? All right, take Thiebaud. Whaaa…Wayne Thiebaud? Yep. A coffeeshop vitrine holds a dozen pieces of pie. The pie plates are drawn in the paint perspectively as 12 oblongs just off the circle. The pie slices are triangles inscribed in the plates. So he has it going and coming. The oil paint is itself shiny, sticky, and well . . . oily. "Paintstroking is similar to caressing," Wayne says in his São Paulo catalog statement, 1967. "[W]etness, softness are elements of lusciousness," he continues, "this attraction is certainly sexual." And, "Submerging sensuality can be a means of heightening and involving the viewer in an even deeper erotic sensibility."

If you look at a Voulkos plate (fig. 32), with perhaps a slit in it for fingerholds or maybe a triangle drawn with the point of a stick, try to see it for what it is—an urgent communiqué from the depths—and cherish it for what it withholds. Peter Voulkos's art has NOTHING to do with Egyptian pyramids and the lore thereof—that's all harmless garbage downloaded from late-night crackpot TV evangelism; nor is that triangle pedimental, as in a temple façade from antiquity. When, as in Pete's outdoor sculpture for the U. C. Art Museum garden, he attaches a pedimental form & calls it *Return to Piraeus,* the effect is entirely adventitious. In fact the only time Voulkos's art touches on Greek or Roman art is when he pits his own demotic Hellenism against the Laocoön in several of the large outdoor pieces and I would have to call this encounter pretty much a draw. As for Asian art—

Triumph of Flora, 1980: Paul Cotton, Judy Chicago, Allen Kaprow, and John Fitz Gibbon

32

Peter Voulkos,
Plate, 1981

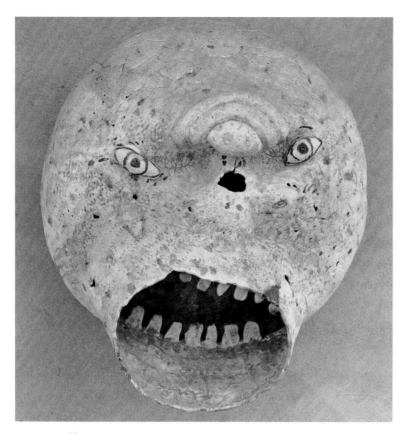

33

Robert Brady, *Rage*
(Self Portrait), 1980

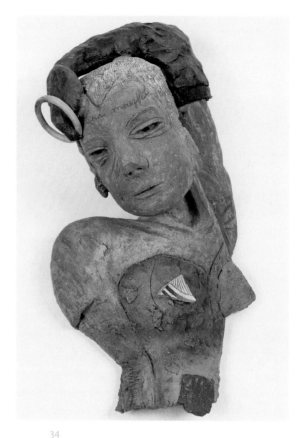

34

Arthur Gonzalez,
Untitled, ca. 1993

for instance the effect of *haniwa* on the great Stacks (at once funerary & uncircumcised phallic), well that is another matter and a story for another day.

The plates are among the great modern instances of exemplified passion, of desire frozen into form. It would seem from the manner of their making, that Pete poured his heart out every day in these love songs in clay. Is it curious or should it simply be taken for granted that these love-poems are also strongly tinctured with the Spiritual? When we think of Northern California clay, we become aware that the school of Arneson has prepared us to laugh. There is scarcely a laugh in Peter Voulkos's entire creative makeup. These plates are not funny. Earlier I spoke of the religious quality to be found in DeStaebler and Paris. What's more, it is also there in Brady (fig. 33) and in some of Vanden-

Berge's stuff. Melchert gets a part of it too. There's Steve Kaltenbach to be sure, and also Arthur Gonzalez (fig. 34). For all Pete's carryings-on, for all his macho strutting, for all his showing-off for the gang and playing to the public ("Hey, c'mon in, have a drink, lookit th'alligator"), there remained underneath the silent, observant boy whose idea of fun went no further than talking his brother into closing down the roadplace, hitching the dory to the pick-up & driving a few miles to one of the innumerable lakes where you just pole out to the middle and the brothers can STAND UP in the boat crying, "feesh, feesh!" and the fish would just jump in the boat, happy to collaborate in the grand plan that governs the world, happy, happy, happy.

Take him all in all, in no artist of our day and moment was the profane so wedded to the sacred.

Teach long enough and eventually there'll develop a whole roster of ex-students, half of 'em middle-aged, who share the illusion you were their greatest teacher. Every week just about, I get a letter (nowadays it's e-mail) & according to the correspondent I was their greatest instructor since Miss Marigold in 4th grade. What these people really mean is, THEY were great, long ago, when they were young and now they're remembering how great it was (and they're right—youth is great, only you don't, at the time, comprehend how fine it all is). They finally catch on, now that it's too late, and so you get the credit because you were there with them, you, their best teacher, ever.

Then there is the glad I bumpt into ya encounter, which can take place on the subway but more often in the museum. "You⸮ Here⸮! You changed my life! That thing you said about the First World War . . ."

Anyway I'm about to step into the Bischoff retrospective in Oakland and about to step out of the salon is David Newman escorting his latest girlfriend. David was quite a help to me in the logistical mire that was the Pilot Hill Annual (fig. 35); and later, with my blessing, he brought some ideas into the council of the Burning Man celebration when that ritual project was first mooted for emptiest Nevada. After Davis, David kicked around the computer world, he taught people to fly little planes, he did various stuff; at one point (and I believe this is a 1st for Thiebaud students) he spent a couple of years making composite portraits of criminals from descriptions supplied by victims. David's from a distinguished Peninsula/San Francisco family. His father's father was the noted philanthropist. David's idea of philanthropy was to buzz Pilot Hill whenever opportunity presented. Perhaps the majority of my friends, silly enough to say, fly small airplanes. The lure of breaking the silence here is not to be resisted. David Newman and Paul Thiebaud, the gallery dealer and, if memory serves, windsurfer, have in common that around the same time each showed some fleeting interest in Miss Pinkerton

35

William Morehouse,
From John's Aerie,
15 August 1991

Fitz Gibbon. If by deliberate mistake one should introduce into dinner conversation the name of either of these young men, the accidentally-on-purpose nomination would trigger in our younger daughter that singular outburst of scornful female hilarity known in our circle as "Pinkie's shriek," a phenomenon that shrivels the male psyche right and left and, some studies indicate, causes mental retardation in rats. Once directed at you, even if you are not a rodent, you'd prefer being struck deaf as Beethoven to having to hear it again. So I felt some ruth for David as he approached with his date, saying "John! You were . . ."

"Your greatest teacher, I know."

"It's more a tie with Wayne Thiebaud (fig. 36)," he corrected. And we chatted for a minute. "By the way," David said, as he was leaving, "Peter Voulkos is in the exhibition hall."

Into the great hall I walked, braced by my cane and enriched by Susan Landauer's catalog. I could feel Elmer all around me—and above me too, in that high-ceilinged space (I wondered how far Kevin Roche had anticipated the use of it?); the pictures were so to speak breathing Elmer into this space; and there he was—how weird to be making this claim!—sort of hovering over the gallery visitors, an angelic presence. The very best pictures—*Night Watch, Las Meninas,* Courbet's *Self Portrait in Studio, Guernica,* even—carry their own throwaway space with them, in the upper reaches of the canvas, as if they feared someday being stuffed into Brian O'Doherty's Modernist white cube. Bold reader, let your pictures breathe! Sky them up the walls (fig. 37). Pitch their tent on the ceiling. If it works for Rene di Rosa, if it works at Pilot Hill, it may very well work for you.

In any case perhaps because he was dead and had his guard down, I never felt so close to Elmer, 'cepting the time he had tickets for *Die Walküre* and we ate some hash brownies beforehand so that about mid-way thru Fricka & Wotan's tedious domestic spat, the drug unscrewed the top of our heads and our spirits commingled in the sonorous Wagnerian air.

Elmer Bischoff grew up just down the street from Erle & Pinkie's and before she got busy pinning down our art history for us, Susan Landauer, a couple of blocks further on, swept up jacks and skipped rope on the grounds of Emerson Grammar, while I had attended John Muir (John Manure, the Emerstinks called us), which lay between the Claremont Hotel & the Diebenkorn house. That's Berkeley. Meanwhile Jane went to the Oxford School in the Berkeley hills across town. From her off-semester class of 11 two of the boys were in my college at Yale, one girl married Fred Crews, '55, the pooh-pooher of Freud; another, Mary McKay Maynard, recently published a memoir of her family's jungle flight from the Japanese in WW II; still another, Bergliot Bornholdt, came back from Vassar determined to do something "unconventional" (it turned out to be modeling for Park, Bischoff, & R. D.). For the past ten years this group of childhood friends has met once a month for lunch in Berkeley. They talk about virtually everything BUT contemporary art, and not even the erstwhile model has thought it a good idea to acquire some. Which means (doesn't it?) that Landauer and Tsujimoto & Slivka and I are conspicuous failures at arousing the interest of even the talented intelligentsia in the art world we've espoused. The outside world doesn't find *cosa nostra* engaging enough to bother learning the teams, much less the players.

There I am, then, with my eyes wide open, thinking I can communicate with a friend I know's been dead 10 years, thinking in some *geistige* way Elmer Bischoff is present spiritually among his pictures in that room.

JOAN BROWN WAS RIGHT

Dear Elmer
I knew you when
You lived in poverty
Adelie and Elmer
Cottage in back
Cheap bungalow
Berkeley flats it was

Curtis Street?
Yes

Dear Elmer
I embraced poverty
Likewise
We rode motrsickles
Far and narrow
We rode up Tamalpais
In order to see
You better, Mount Diablo

Diablo, up you we noised
Dear Elmer
Skidding and kidding
For the sake of Tamalpais
And in order to hear
You better
My country 'tis of thee

O say can you see
Johnson Oyster Company?
In the Old Elmer dear
Millennium
You could get there
From here of a Sunday
Jane packed the pot
(Aluminium)
On the bunny seat. We
OutWalrused the Carpenter.

Walter Chrysler came to town
Bearing lots of Money
Elmer! You and Dear Dick and Dear David
Got drunk. On champagne, Bergie
Told Jane. Partied all nite whiff the models
The three of you bit on the bitter C
You said the Stanford surgeon flung
Your bladder across the room
Into the garbage pail. Two points.
Or do they give three for that one?

You enjoyed the fantastic
Gateward golden view,

Good Spelling, 1972: Pinkie

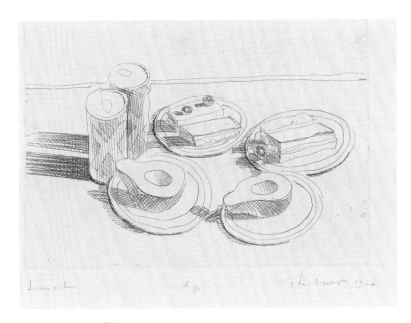

36

Wayne Thiebaud,
Lunch, 1964

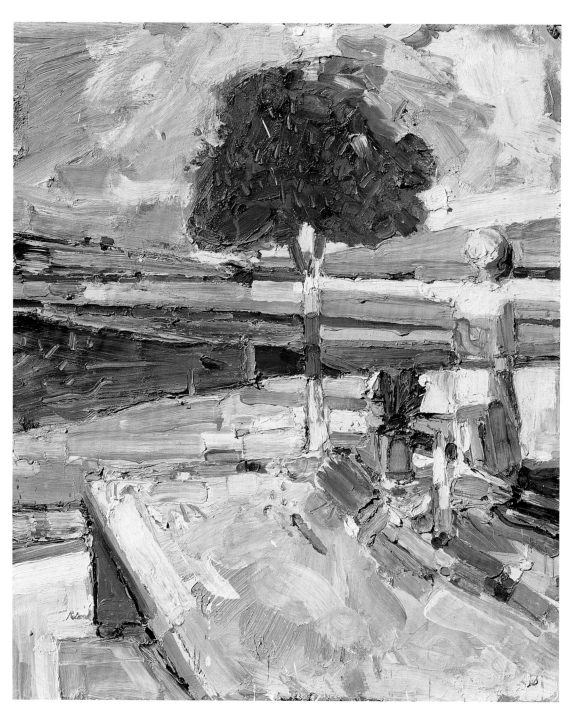

37

Roland Petersen,

Picnic, 1962

Endangered Elmer, so hubristic
You never dreamed Conflagration
Could undo so many pianos carpets
Libraries pictures and pet snakes
Your drawings have grown valuable
Thanks to an ill Wind not even
A "real" poet could funify,
Much less a Hudibrastic

Nineteen seven two
Dear Elmer You were onboard
As Wiley's teacher—A-horse
Makes it clearer—for our
Goodspelling Event: wise men and
Entourage pay visit to the Stable
Hundred Cowboys, hundred Angels
Nineteen horses, zero camels
Elmer the Angels wanted to wear
Cowgirl outfits, wouldn't you know

Elmer I apologize. "Never
Apologize" is bad counsel.
Elmer I sorrow for the arts
Professionals. Elmer, the art
Historians have failed to know
Sin. Elmer the art critics have
Paid no Dues. Dear Elmer Bischoff
The curators want to go to Lunch

After the *Et in Arcadia Ego*
Event in '71 one honoree
Came up to say: I think Elmer
Was the big influence on you!
Speak for yourself, Sweetie, Sez I
With as much charm I could muster
I have to apologize for talking
To Dead people but sometimes it's
The only way. Joanie, Yes!
You are right. I had in mind
Those Nudes-in-Nature pictures
Of Bischoff. And Thank You,
Dear Elmer & dear Joanie &
GOODNIGHT

What should happen at this point, just as I was coming down a little from daydreaming amid the Bischoffs? I got a mental e-mail, that's what. From a person who keeps pretty close tabulations on yours truly. That person is the elusive Real ME, who has yet to be seen by any reader (fig. 38). Have I mentioned him—I mean ME? I believe I promised a glimpse, no? "Mother Mary & all Her saints," ME's e-mail began, "so it's talking t'the Dead yer into? It's no surprise, I'll tell ya, no surprise at all t'those as keep watch on yer sorry behind. But let me tell you this & I'll be done: Ya dasn't try t'import yer rubbish doggerel into Ireland, God give us grace. Ye'll be better off saving it fer those California pals ye make so much of . . . talking with the Holy Dead indeed! And you're the very same lad just finished with mocking that deplorable PeeramidPower crowd—the ones that hang around with that ceramics demiurge, whatziz name, appears to have struck a bargain with the Devil?

VOULKOS!!!!"

Now the most unaware of all my readers is not at this minute more taken aback to discover that the real ME is a garrulous & more than likely whisky-ridden old Hibernian from the auld sod, than I was to be reminded of what the sublimity of the Bischoffs had totally made me lose sight of.

Peter Voulkos was supposed to be in the exhibition hall.

"Shut the fug up!" I admonished ME in plain English, and I began to look around, see if I could spot Pete. He wasn't in the immediate vicinity, but a tingling in the back of my neck turned me about, and there across the room was Peter Voulkos with Ann and a young friend. I waved, and Pete beckoned, and I began to cane my way across an expanse of hardwood floor.

Tap, tap, tap. Peter Voulkos looked terrible. He was gaunt, sepulchral. Tap, tap, tap. Closer I approached, the better I could see that Pete was the merest shadow of his yesterself.

Now from Peter Voulkos's perspective the equally cadaverous figure tap tapping toward him among the Bischoffs looked cored out, harrowed in

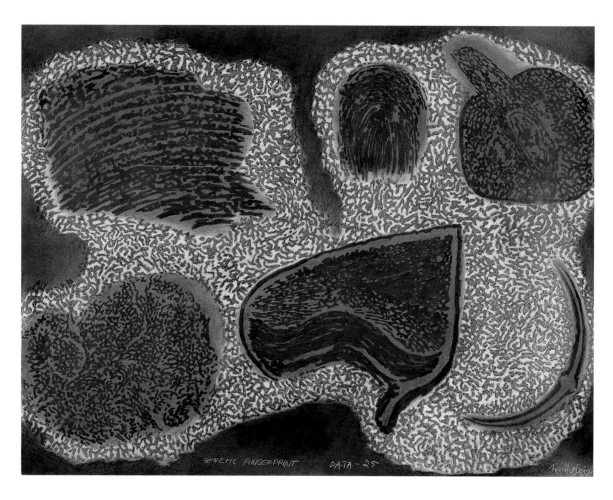

body and soul, and stricken, quite evidently, nigh unto death. Where Peter Voulkos looked ghastly, John Fitz Gibbon was blasted. To Elmer Bischoff, whether there, above, somehow, or gunning it in whatever motorcycle empyrean on high, it must have presented a touching scene: the two "Ghosts" accidentally met in Sunday afternoon homage to a third Ghost in heartfelt tribute to his shining art.

It takes me a long time to get from point a to point b, and in the slow progress across the floor I had to put up with ME in my ear, cajoling & commanding & generally needling me the whole way. "Is that really the Peter Voulkos I remember from the old days? He looks so brittle now, like an old Havana. Peter looks almost as bad as you do, me hearty boyo."

"And what do I look like, ME?"

"Like an old piece of lace in a cedar drawer."

"Ver good, ME, I mean it. I've gone back in the betting. What voice you in now, ME?" "Not in any voice right now. Just ME." (I forgot to tell the reader ME takes on whatever voice he feels like; the guy is a loose Echo.) "Bedder not hear you say the first word about that plate Peter Voulkos owes you & the missus!"

"Fugk off, ME! I won't say anything—but could I mime eating with a fork off a platter or somep'n?"

"Bedder not, bedder not. You do & I'ma tell Jane."

"Tell Jane what?"

"Tell her slash your clothes & throw your furniture outta the window." These threats, idle as I knew them to be, brought us within hailing distance of Peter Voulkos. And while I was still gathering my wits, PETER VOULKOS SPOKE FIRST.

But, good & patient reader, allow me to put Pete's salutation on hold just a little while, lest it surprise you the way it did me & ME, and let's address instead the issues raised by this slinking *sub rosa* Real ME's turning out to have these various voices. First off, there's only inferential proof that ME is like me at all. We all make new decisions every day month & Year, and ME could've slipped away from the path I chose at any nodal point along the way. I've never come face-to-face with ME—tho' I have searched for him these many a year. Suffice it to say that ME is a master of *alter ego* roles. There is a quasi-political side to ME and he is particularly drawn to the urban Negro sub-culture as it existed in the days of our youth when ME & I worked as a cargo handler & mail sack jockey on the old Oakland Mole. I would be remiss here if I did not bring in the name of one of our surrogate fathers, George "Sarge" Fortenbery, who would sometimes be plucked from our task of unloading box cars so's he could shower & change & go substitute on the Shasta Daylite for a railroad porter called in sick. From Sarge I learned more of Courtesy and Manners than from all other individuals. One year I found myself trying to explain to Robert Arneson the obligation I felt in the circumstances. Bob Arneson, running out of energy and time, had embarked, as less physically demanding, on a painting series featuring large male Negro heads, many of them left, symbolically, in black & white. These confrontational faces crowded up to the picture plane, leaving no room for the viewer to slip past. These faces seemed to be saying: I'm here, undealt with. Deal with me, or else. . . . I called him up, see if I could squeeze him into my survey of California painting done for the Butler. We worked that out, and I told Arneson a bit about the debt I felt toward Fortenbery as (an admittedly Falstaffian) father-figure from RAILROAD days, how it was sort of like Joan putting her swimcoach squarely between Goya and Rembrandt in her celebrated "influences" painting—or perhaps a little like his own inclusion of the King in a pantheon that counted

Good Spelling, 1972:
Robert Arneson
and Sandra
Shannonhouse

Bacon, Pollock, Guston and so on. Arneson's response was (remembering that Bob caught maybe ½ of what was said to him), "Well probably every artist has his own Gardenberry." When Jane came home I told her what said Arneson, and she said, "Yes? and I suppose every Hamlet has his Fortinbras?" So I was on the point of saying, "We read in the learned Martha Stewart that 'No omelet's made with corn & squash,'" but Jane doesn't care for Martha Stewart, and, the seconds ticking away, I settled for "every Roger Berry has his Corten trash!!!" thus bringing to mind that delightful wine-grapes-growing sculptor whose big *Ashanti,* fashioned from welded & fused scraps of Corten, graces a curve of our hillside road. *Es costumbre,* in Roger's work for a piece to true in to some aspect of the Earth's passage thru Time/Space, and the Pilot Hill installation is situated so the piece casts a linear shadow due east at the moment of the equinox. The sculpture is cantilevered just enough to avoid the stiffness a strict up & down treatment would impart and, seen sideways, there is a visual surprise: a pair of quasi-minimalist boxes—they are parallelograms, actually—self-commenting; the one hovers in the air, the "soulbrother" box remaining shadow-anchored to the ground so they're balanced one above the other in perfect poise; as in the best metals sculpture gravity is challenged and the very precariousness is permanently exciting. All this side-show, this gratifying balancing act, is at right angles to the "proper" or frontal aspect, which recapitulates, with steely economy, the especially lovely lineaments of an abstract, heart-shaped female face. Berry's piece is the Ashanti doll fetish writ large in Corten. Women of the tribe carry these hand-held carved black discs in their purses against the occasion when they may see something discomfiting, like a jeepload of teen-aged soldiers with automatic weapons, or the "goodwill" visit of a U.S. vice president to a client State, or a woman stoned for breaking *Sharia,* or an embassy bombing, or the "suicide" of a political prisoner, or any other situation that gives Evil a leg up. All they need do is pull out the little amulet and contemplate its

sweet face. Then, magic, magic, the evil vibrations are nullified.

Roger Berry's big steel version of the elegantly simple West African fetish reduces formal matters to a single rolling plane activated by a small "mouth" at bottom-center—i.e., just where the mouth ought to be. Seen *a dos,* the image repeats itself, only upside down now, as if to indicate a differently predicated Space/Time: different folks, different symmetries.

Will Roger Berry's piece prove apotropaic? I hope so. I incline to believe that all art activity, whatever the medium, conserves an evil-averting component, as one legacy from the caves. Conspicuously, outdoor art, art in public places, stands a beneficent watch over its community. Consider Michael Todd's big Circle piece sited so perfectly overlooking Folsom Lake. Among other things the circle represents Woman (and there is in fact a reclining female figure—sort of an AbEx odalisque—which is how to read the concatenation of far from fully referential welded elements that pour down & across from upper-middle right—her head—to lower left—her feet). The *very purpose* of a sculpture like this is to make fruitful the land, replenish the waters, clear the air, protect against fire. It is meant to serve as a giant lens to focus divine energies on this needy earth below. In an essay on Mike's work I had occasion to mention what Frank O'Hara once told David Smith: "When I see one of your sculptures I don't want to have one, I want to *be* one!" When Mike & I were signing catalogs one day, I told him: "Michael, when I see your big circle pieces, I don't want to be one, I want to have one!" A few months later a flatbed showed up with *Daimaru XVII.*

A large Michael Todd can sustain multiple meanings. The primary one, as I started to suggest above, is that of Woman & the Cosmos. We have already noted the loosely figurative presence of the woman in her circle. Indeed, the circle *is* the Woman in a Voulkos plate, in a Thiebaud pie dish, in a Hassel Smith geometric orb, in a Julia Couzens painterly orb, in a Roger Berry female fetish. By

means of that universal, precious circle, we define Time & Space, relying on the rotation of the earth, the orbits of the planets and the chaste moonplate to tell us where & when we are. The advent of an age of digital technology is not going to change the perception that Todd's Circle = Woman = 28-day clock. Does 28-day clock really equal P——y? Not necessarily? Consult your watches ye docent band. The big hand's at 7? little hand at 5? What's that look like, to you? Oh! It's a piece of pie on a plate. Well, OK. But if, dear docents, you're having big problems with this one, go ahead & bring in that galleries' favorite, Monsieur Salvador Dalí. If memory persists there're a goodly number of melted watches (= P——ies) in the *Persistence of Memory* period (ca. late-'39) of Dalí's oeuvre. He had 'em on his mind, dear docent, and so do you, if yer halfway human—which, doubtless, you are.

Now I don't want to get far away from Michael Todd here, I've pal'd around with Mike in the various art capitals of our small world, here and abroad. Finding all those pudenda in his art instead of Zen dialogues between Emptiness & Fullness (or whatever) will embarrass Mike a good deal less than my telling you that, aside from Carlos Villa back when Carlos was speaking to anybody, Michael Todd enjoys the most impressive surplus of Friends. The guy has friends to squander, wherever he's spent a little time; I was thinking about this when I finally opened the Eva Hesse catalog from her recent show & noticed the group photograph of Hesse & her friends by Peter Hujar. Here came Joe Raffaele a little late, looking for a seat; Joseph was in graduate school with Hesse; he dedicated a painting to her, at her untimely death. The artist herself is front & center. She is sitting on Michael Todd's lap! "What gives?" I telephoned Michael at his Los Angles studio, well knowing that, like revenge, gossip is best tasted cold. It developed that Mike & Eva were together 7 months in 1965–66. "I don't see a whole lot of mutual influence," I said. The silence on the line meant that I was stupid and anybody was stupid who thought that 2 artists could spend night & day

39

Michael Todd, *Black Iris,* 1991

with each other, and nothing would rub off after more than half a year (fig. 39).

If you don't understand a work of art *before you see it,* you are unlikely to "get it" after. Most of the time abstract metal sculpture is about the figure (or about bodyparts). Either that or it's about a tree. I glanced over to the far side of the pool where two abstract "statues" regard each other, the Michael Todd conceived in swelling graceful curves and compact of copper tubing, slag plus air, which it "nets," and water, which it emits—for it is a fountain, like Woman. The other piece, made of heavy welded steelplate, juts manfully in defense of his position; William Wareham, himself short cocky & combative, answers Todd's lithe arabesques with

bristling thrusting Male energy; its arm-akimbo stance is pleasingly "at rest" but "come too close & catch an elbow" is the figure's attitude. As a pair, they remind a bit of Richbourg's chorus girl/halfback confrontation.

Flanking the main house-entry is another Male/Female duo, larger than life wooden abstract figures each painted in a flat monochrome primary color reminiscent of California production pottery, like Bauer or Vernon; they are cheerful and gently humorous guardians, from the hand of Robert Bagnasco Murray, who was wont to provide, for each Pilot Hill Annual, a strange, hand-held emblematic abstract-heraldic fetish of his own curious imagining, to be carried by an honoree, as in a religious processional. Murray's outside sentinels are echoed inside the house at the hearth by large Peter VandenBerge busts on either side of the fireplace (figs. 40, 41). They too are male/female—more or less! And Peter's sweet presence—and none sweeter, nor more surely present—is re-echoed thru-out that big room to a baker's dozen of large masks and ancestor figures from Africa, Mexico & Oceania (whom I claim & adopt as my own progenitors, if they'll have me—and they seem so far to've brought me luck and good guidance as to the Future). So I reverence these ancestors from all over, which is what you're supposed to do, after all. They are honored by me and when visitors come & hang their hat on a Sepik River mud man's head I take it off and am sorely tempted to sail it into the pool. Since our family is not devoid of an ancestor here and there, my motivation for bringing New Guinea elders into my living room is somewhat different from those Morgan-Huntington-Frick chaps, who, lacking progenitors of their own, bought other people's—all those Blue Boys & Pinkies and the like. I'm in a different spot. Because, after all, it's a wise child who can claim to know its own parent. And because, above all, I have to act on the belief that all humanity is one flesh & spirit.

Now I must immediately climb down from the above profundity and report that another denizen of my living room is Clayton Bailey's famous robot, "T.T." (fig. 42)—famous for failing to awaken a sense of humor in certain feminists. Fashioned from recombinant found metals and polished to a stainless steel silver glow, this *kore*-like figure is presented frontally, with her arms extended as if holding an invisible tray. T.T. is fully obedient to the body's bi-lateral symmetry and a neo-classical spirit presides, i.e., the whole is a sum of beautifully articulated parts. Her boobs are big, her bimbo brain is small. Bailey knows how to alleviate the static aspect of the pose thru careful part to part adjustments; he rests the torso (it's a coffee pot from a diner) on pipe-stem legs with petite feet that nevertheless keep her fully ponderated. There's a slight edge of potential movement to this piece as though she could be easily toppled (a push-over? No); or perhaps it's that the large conical breasts make her seem to precede her self. In other words, tho' poised & apparently stable, T.T. is also on the cusp of moving; in a word, she is *life-like* beyond all expectation. A very skillful sculptor achieved this balanced imbalance. Because Clayton Bailey is so funny, his formal strength often passes the viewer by.

Now I have Benjamin Franklin in front of me, as droll a fellow as was, and we are willing to bet the reader that I can fully expound Clayton Bailey's entire career in just two words. You doubt it? OK. Make the commitment in your mind . . . alright, if I succeed just put a check in the mails: c/o Pilot Hill, CA 95664. I trust you in this. If I fail you, bill me $100, right? Very well, here goes!

SERIOUSLY

LACKING

See, I did it. So pay.

What makes Clayton Bailey so funny, anyway? Any account of why we laugh must be inclusive, it must satisfy every case. Aristotle gave the first and still the simplest definition. We laugh, he said, at deformity. Every time. Bailey often addresses the question of a better America. Consider his moldmade (so as to reach a large public) Gang-Uzi with its firing mechanism turned so the

41

Peter VandenBerge,

Figure, 1982

40

Peter VandenBerge,

Leger, 1982

42

Clayton Bailey,
*"T. T." Robot
Secretary*, 1982

shooter shoots himself. This deformity of function triggers a laugh (sorry!). T.T., of course, is a Galatea transformed not from marble to flesh but from flesh to metals assemblage. Within the sculpture every part once existed as something else, those fingers were bullet cartridges. 'S funny. Bailey's jests, spoofs, hoaxes, parodies, travesties and so forth are basically unproblematic and fly the banner of Humor, requiring us merely to laugh along with him, rather than *at* something or someone, as happens when Humor shades over into Satire. Satire aims to harm, it's cruel, often *ad hominem,* feels no ruth for its target. Consider a favorite small ceramic, *Criminal Brain,* a still-life vignette from Clayton's Mad Scientist's Laboratory series. It's just a brain + hypodermic needle on a lab tray. Great art? Maybe, maybe not, but it's funnier'n hell. It only asks us to share a laugh at the expense of an absurd juvenile genre of B-minus gothic movies and perhaps to laugh at our own silly fondness for such garbage, our appetite for junk.

But what if I changed matters around a trifle? Revealed to Reader & World the results of new DNA testing that indicates that the "Criminal Brain" is in actuality the brain of Alfred Frankenstein, a conclusion supported by a search of Betty Bailey's receipts drawer, where a bill of sale turned up including the cryptic notation: "Dr. Franksstine's brain's, 75¢" (this slip apparently from a thrift store in Daly City, Nov. 1970).

This all might be fun if the Baileys countenanced it, & I don't know that they would. And it would turn humor, which is kind, into satire, which is not.

Our culture does not lack for theorists of laughter. Meredith comes to mind, and, from the next century Arthur Koestler, but I should have to give 2nd place, after Aristotle, to Henri Bergson, whose notion of the *élan vital* was of such significance to Matisse & his Fauve followers. About laughter, Bergson says, it comes about in either of two ways. We laugh when the human being (whose true self is characterized by naturalness, spontaneity, freedom, flexibility) becomes mechanical,

stiff, rigid, rote, repetitive. Or, such is our instinctive antipathy to the mechanical, we laugh every time the machine breaks down; we laugh at mechanical failure. As when the gang shooter shoots himself. "Perpetrate a hoax" was one of the maxims Steve Kaltenbach loosed on the artworld back in the '60s. Applications of both Bergson's & Aristotle's accounts of why we laugh are legion, *hic ubique* (as Bill Allan wouldn't put it) in Clayton Bailey's pseudo-scientific hoaxes, fake anthropologies, hybrid monstrosities, functionless robots, cups that don't pour, etc. I particularly like his little robot light switches (of mold-pressed clay). They fit around your ordinary wall-switch and all you have to do to activate these *ushabti* to turn on the light is to get up, walk over there & switch on the light, just as you ordinarily do. Thank you, Clayton, and on behalf of the readers—who shouldn't try to read this in the halfway-dark, please be thanked again. And while thanks are being passed around, thanks to Tom Albright (or "Son of Frankenstein" as I was wont to call him). Albright's *Art in the San Francisco Bay Area* was written well above the speed limit, with Death in the rearview mirror ("Objects may be closer than they appear"). For the most part he'd spent his life as a bugabear, scold, and Tommy-jeerer to most of the Friends gathered in this book; he disparaged, he sarcasticized, he undercut, he had reservations about pretty nearly everybody whose name wasn't Clyfford Still. He was doubtful about Diebenkorn. He was severe on David Park (who'd taken his paintings in the Still manner to the Berkeley Dump & staged an *auto-da-fé*). But in his book . . . ah, in his book. In his book Albright abandoned the role of Doubting Thomas, and gave a generally fair play overview of what had passed here since 1945. On the cover of his book Albright, dying of cancer aged 49 years, put not Clyfford Still but David Park (dead of cancer . . . at 49 years).

One of the best things Albright did in his book was not by way of restitution (because Tom had been supportive of Clayton right along—and, to a

degree, even his boss Al Frankenstein had been friendly enough, for a fellow with a felonious little mind). What Tom did was to open his chapter on Personal Myth with Bailey, thus placing Clayton very high indeed. So I want to admit that this clarified matters for me. Critical opinion, one aspect of it anyway, has to do with consensus. For years I'd been saying on radio air, in private conversation, and especially to visitors from the East Coast: this guy's funnier'n 3 kittens with a ball of twine, you've got to see him! But it took the reinforcement from All-dull (as I useta call him) before I was ready to look my New York guest in her contacts & say, "Yeah, the fella made this Marilyn Monroebot, he's a standard-bearer out here." Albright was always good at reducing whomever New York was inflating at a given moment down to life-size. The triumph of materialism and the scientific worldview, with their alienating consequences for Man, have left our culture more than ever in need of jokers like Bailey or Dave Gilhooly, that we may not lose sight of the Absurd. You already owe me that C-note, gambling reader, so I will let you have Jane's emendation for free:

SERIOUSLY

LARKING

■

The largest frog ever born in nearby Auburn CA was a certain David Gilhooly. He weighed less than 16 lb., but not much. We remember that Gargantua, except in appetite, was much bigger than the future U.C. Davis student. Remember, too tho', that Gargamelle was 11 months in berthing Gargantua, which gave the latter an unfair advantage over Gilhooly. So that Dave, as I eyeball it today, cannot go more than around ± 300 lb. despite a lifetime of gobbling cookies, scarfing up pizza, snacking on candy bars and 6 or 7 nights a week devouring those 1 a.m. Dagwoods. A reader now asks, is he fat? He is not fat, reader. *I* am fat—or starting to get there. Dave Gilhooly is a very big customer, and it's all muscle. Sculpture toting, kiln lifting muscle.

■

There are self portrait aspects to all kinds of art and it is fair inference that such is the case with FrogFred, a creature has yet to pass up a glazed donut. Does the artist actually think of himself as "You horrid disgusting Frog!!!" as the Princess in the Tale addresses him? It's a good question. Most of us spent our teen-age years waiting to grow into a handsome shining Prince. Dismissing the thought that, after all, I had Irish, not Italian antecedents, I waited in the mirror (the real mirror, not the mirror of art) for my plain nose to grow long, noble, Roman. To no avail. Perhaps, fair reader, you were luckier as you checked each evening to see if your breasts had as yet taken on the shape & semblance of Marilyn Monroe's? No, it's not unfair to infer that FrogFred who is D. G.'s alterfroggo or Froggerego stared back from the mirror Gilhooly stared into.

FrogFred is Gilhooly's Everyman or Everyfrog, and he indeed seems to have a share in every human or ranid vice, flaw, folly, self-deception. Let the virtues take care of themselves, I guess his attitude is; they are not to be found in Dave's alternative FrogWorld. He doesn't *limit* his attention to frogs, of course. Take the orangey-yaller *Cat*, the very emblem of sloth, who stretched out before the hearth 30 years ago & hasn't moved since (unless to raid the icebox or pantry while all are retired for the night). In our household when that *Linzertorte* disappears from the pantry overnite, we know whom to blame. "It was the Cat!"

Egypt. How many lessons still to be learned. A good number of artists have attempted a *My Egypt*. But who better than Gilhooly has nailed it down and sent it up in all its ludicrous glory? The grand Victorian Age with all its obsessions & possessions crowded into one boat. Who but Gilhooly could master such a complex trope, or hope to govern so multitudinous a crew? History, anthropology, psychology, sociology, the history of art itself, all must beware of Gilhooly's great cudgel. When the Whitney mounted its big clay survey in '86, the artists were Voulkos, John Mason, Ken Price, Arneson, Richard Shaw and Gilhooly, all West Coast, by the

bye. I thot they had it about right, but there were some objections to the undignified FrogFred, purveyor of trompe l'oeil donuts & candies. These (mostly N.Y.) complainants lacked the advantage of knowing Jane's mother, then long sunk in Alzheimer's, but still capable of spotting a powdered jelly donut when it appeared, unaccountably, right there on the mantel.

It would be perfectly correct to stress Arneson's central role in David Gilhooly's development but he absorbed conceptual influence from his teacher, Wiley, and his friends Kaltenbach (fig. 43) & Nauman; not to mention what he got by way of example from his grad school pal Mr. P. VandenBerge (figs. 44, 45). Thiebaud is in there too, helping to sanction Gilhooly's mistrust of New York abstraction. Davis was one feisty place. The point is, Gilhooly took whatever he needed from whatever source. By the time he'd finished graduate school he was already a "finished" master. Then & now Gilhooly has never trucked in subtleties. His approach to ceramics is utterly straightforward: glazes generously poured from the commercial jar; formal invention tied to a narrative expression unusually acute for a clay artist. (This formfinding at the service of storytelling carried over to D. G.'s graphics—which are superbly realized & enjoy the squirmy comic exuberance of a latter-day Thomas Rowlandson or even Hogarth.) When, rarely, Dave has occasion to throw a plate—perhaps for a support to a 2-foot-high Dagwood burger (fig. 46), the result is a brusque, no-nonsense utilitarian platter. There's as little *yin* to be found chez David as in the art of his Master, Bob Arneson.

Gilhooly's update of the moralizing medieval beastfable in which animals take on human feelings and motivations is still undervalued even out here on native ground. It's a grand conceit: A Frog Drowning in Chocolate Vegetables. When you start putting chocolate on your turnips & rutabagas, things have come to a pretty pass. Or how 'bout the Captain of the Yale Surfing Team? There's no surfing the 2-foot waves of Long Island

Instructions for the installation of Stephen Kaltenbach's artwork in the Tokyo Bienalle.

1. Get an _expert_ _translator_ to translate these instructions.

2. _Accuratly_ translate the following message into a. Japanese b. Chinese c. Russian d. French e. German f. Spanish. The message is: Expose your self.

3. A stencil of this sentence should be cut in each of the languages listed above and English.

4. The English stencil should look like This:

EXPOSE YOUR SELF.

5. Stencil the message once in each language on the walls of my space in the Museum.

6. The message should be placed five feet above the floor and should be executed with black spray paint.

7. The message should be stenciled in black on as many public restroom walls as possible through-out Tokyo just before the opening of the show. One stencil (one language) per rest room.

8. This drawing is to be exhibited and returned to me at the closing of the exhibit.

Stephen Kaltenbach
april, 1970

Stephen Kaltenbach,
Expose Your Self.,
April 1970

44

Peter VandenBerge,
Radish, ca. 1970s

45

Peter VandenBerge,
Pregnant Woman,
1982

46

David Gilhooly,

Dagwood Sandwich,

ca. 1980

Sound, I fear, even where amphibians rule. The picture Gilhooly draws for us is of an America given over to watching junk TV while craving junk food, just getting in a little slothful down time before the next bout of lust, greed, envy, rage and the pride that goeth before a fall. All is vanity in this America, and vexation of spirit. He is his own protagonist; perhaps out of politeness Dave bears the onus himself—or shunts it to Fred or one of Fred's close kin. But it's clear he regards us—hypocrite writer, hypocrite reader—as equally compromised. We junked our own situation. Then too there's that very shitty sculpture *The King of the Pit Goes to the Irish Potato Famine.* The King (again there's a self-portrait aspect) rides in a fertility barrow cushioned by very life-like ceramic 'taters. The King himself seems composed entirely of brown ceramic turds, again highly convincing: the fertility wheel is of white clay decorated with vegetables in relief. "King of Pit" here clearly means "King of Shit," and the piece as a whole takes him (& us) all the way back to the crib, where & when we had not much to do save play with that marvelous stuff we created out of our very own body, play with it, rub & smear it on the wall (now that got Mommie/Daddy's attention fast!). In short the piece—unique in D. G.'s oeuvre so far as I know it—takes us to the neo-Freudian argument that the creative artist's path begins in infancy with the messing around with one's own feces, the pride and also joy of our young being. How interested our dear parents were in our achievement, right on up thru potty training! "You can do it, li'l Johnnie! good boy! good boy!" How interested our dear art dealers will eventually be in this the stuff of our own creative effort. How much fun we are going to have simply by denying the parents, dealers, our apparently so valuable Product.

Such speculations, intriguing tho' they be, must be taken *cum salis grano.* We assure the reader, we will never take up arms against shit and deny its importance to Life & to Art. We agree that the chord the public feels between itself and the here's-mud-in-yer-eye pictures of Andrew

Wyeth is in essence a pile of shit. We accept the metaphorical equivalence of shit & money. We promise to regard bankers as "constipated." We will keep in mind always the role shit plays in the ceramic art of Robert Arneson. And, remembering that all art in some ways comes down to self-portraiture, we will be on the lookout in all abstract painting for telltale signs of brown.

And we will certainly thank Freud (for late thanks are better than none) for demonstrating that the very small apparent disparity in ages between St. Anne & St. Mary in Leonardo's painting can be accounted for by the fact that the artist was raised by in effect 2 mothers (i.e., his father's wife and his father's mistress). This was most brilliant. But it does not explain at all why other little boys who grow up with two moms do not turn out to be little Leonardos. Nor does thinking along these lines explain why more Sierra Foothills babies the weight of a shot-put do not grow up fit to take on the Gargantuan task of reproving folly in an America that probably doesn't deserve its artists, an ignorant country and a shallow, a game show America, where Gargamelle is taken to be a half sister to Gamera, a complacent Philistine land that fears not its Davids. Where Bob Arneson turned his art against the war in Vietnam, David Gilhooly (totally undraftable) simply moved to Canada for a few years.

There's one more thing with regard to the popularity & public accessibility of Gilhooly's Frogs.

The first time Jim Albertson & Lulu Stanley visited Pilot Hill we were looking at various Gilhoolys and with my best pedantry I was going all out to tie Gilhooly's success to the adolescent girl's craze for throw-frogs on her counterpane or pillow; just as in the tale of the princess who lost her golden ball in the well. The pubescent girl will have to kiss the ugly bunchy old frog CROAGK CROAGK in order for this droopy penis & scrotum configuration to make a second magical metamorphosis into a tall standing Prince. Jim & Louise listened carefully, calm & commentless. Some months later to my lasting embarrassment I learned that Jim a couple years prior had painted the episode. In *The Liberated One* (1974) Albertson represents the nude young girl masturbating beside a pond as 3 frogs look on. On her knee a 4th frog is turning into an erect penis. Out of chagrin & by way of compensation to Jim I bought the painting and the drawing study that goes with it. Much later I acquired Jim's 1997 watercolor *Early Work,* which depicts the infant-artist (he wears only a red beret) busily painting the walls alongside his changing table. Finger painting, that is, with his own poop. Looks like the kid has talent, too, but so far he's none too original. *Mona Lisa*, Munch's *The Scream*. The thought comes to mind: could mild-mannered James Albertson be the serial docent killer they're all talking about??? Naaaaaa.

■ THE READER NEEDS A BREAK RIGHT NOW, to rest up & gain perspective. So we'll go to those initial questions I laid out & half-promised to answer. You can e-mail me your request: jjfitzgibbon@hotmail.com.

Meanwhile, the phonelines are open. We'll take this call from Marius, in Epicurean, GA. Hi! you're on the air.

HI, JOHN, LUV YR SHOW!

Thanx.

READ SOMEPLACE YER FAVRIT N.Y. ARTISTS ARE WARHOL & LICHTENSTEIN? Right, they're the top ironists.

WHO D'YA THINK WOULD WIN, TAG TEAM, THEM AGAINST BAILEY + GILHOOLY? Wellll, if the bout took place in Tashkent or someplace, no N.Y. publicity apparatus, no magazine hype . . . I'd have to back the locals. Gilhooly, ya know, the guy is a second Gargantua, swat those cannonballs like they were face-flies, like somebody's throwing plums at him. Gilhooly would crush poor Andy. Warhol's a trueheart, tho', had a nervous breakdown in America, 12 yrs. old.

KIDS CAN BE CRUEL.

Thass right. I would have just gritted the teeth & run for Studentbody President…

THINK I UNDERSTAND. . . .

OK, thanx for the call. I do have to go with Dave & Clayton. The newyorkers are a good crew but they aren't reddy for the Crockett-Rocket, Blow'em at the Moon.

Good reader, I wasn't kidding Marius the Epicurean. I do think our locals are the equal of their locals. New York art isn't just ballyhoo, but home-team sportsflacking does come into it. I'm with you, reader. I loved the outsize Warhol *Mao*. So poorly painted! Such a fine deconstruction of the hollow cultism of a communist Big Brother regime. Yet I thot Mao Tse Toad funnier & in the long-term more damaging. All right, reader, lemme take another call . . . this is from Scott . . . in Stoic, Nebraska. Hello, Scott . . . oops! G'bye, Scott. Our e-mails are in and tallied . . . an' it seems the question with the most votes how to be funnier'n

Bailey & Bob Colescott combined?? Which surprised me a little. I woulda thot people mighta wanted to learn something about Love. Maybe the readers have concluded: this guy isn't going to know anything about Love. So. How to outfunny the comedians? Take a deep breath, reader. Well, I'd do it with this can of nitrous oxide. You may exhale, laughing.

So we move away, for the time being, from the topic of America, and take up the subject of Love. So many works of art, as I read them, are love-poems of sorts. Do I need to make the expected disclaimer here, that I know nothing, really about the topic—except that Love & Hate occupy either end of the same stick. Other than that, all's I know is what I read in the newspapers.

About 10 years ago now I read in the Sacramento newspaper a tale of true love, something that occurred in one of the smallish valley towns, Manteca it was or Merced or Modesto, one of those towns served by Hiway 99. It seems that a Mexican boy of 13, and small for his age, as Mexican boys often are, not a beautiful boy either, as young Mexican lads sometimes are, this teenager it seems had fallen in love, his first love in fact, with Donna. Who lived a few blocks away in another neighborhood. The youngsters had met in middleschool. Had they kissed? I tend to think not. But the boy loved, that is certain. And the girl liked back, but the boy liked more. For Donna, her features not yet made, her hair a bit mousy, life had to be taken one cautious step at a time. She suffered a defective heart, one that could betray her with the least shock. This meant he had to go over to her house to play, and that's what they did, the parents tolerating the visits for a while, the young boy was rather "nice." I believe the Chicano lad lived with his *abuelo;* he pretty much fended for himself. Then Donna's mother & father decided to terminate the relationship. Donna, after all, was a sick girl. The least disturbance . . . it was the best thing for their little girl. They didn't consider racial prejudice entered into it but let's face it, the Mexican thing might add a complication that who needed

in a situation like this, already desperate. Without a heart transplant, the girl would soon be dead. The boy was forbidden but he learned of the situation, and was able to send flowers he'd picked and messages. Somehow, somehow Love enabled him to make the necessary complex arrangements for himself at the hospital, where he duly burst his heart. Donna received her friend's heart compatibly. The operation "took." Donna lived several years more. Then the transferred heart also failed, the young woman died. At his grandson's funeral the *abuelo* had said, "He was a good boy."

The other love story I read in the newspapers dates from the era perhaps a dozen years back. It involves a young Arab man, studying in London, who seduced an Irish maid—literally a maid, for the young woman worked as a room cleaner in a West End hotel. After a few months Bridget became pregnant, and despite all the promises she had heard found herself utterly, cleanly abandoned. After going thru the matter with a priest the girl decided to take the baby to term and to remain working at the hotel as long as possible. She was in despair, but she was young, something would turn up, God would provide. Imagine her astonishment, her relief, her very joy when, as the end of the 2nd trimester passed, the delinquent lover reappeared, bearing expensive presents to go with his apologies, protestations, and reaffirmation of their Love. How could he have let her down, let their child down, so shamefully? She would meet his family, they would marry today week in the homeland. Here was her ticket, he would follow the day after tomorrow after concluding business here. Never again would they be apart, Allah willing. And here! rich gifts for the trip: new shoes, a beautiful maternity dress, a stylish hat, so the milliner assured him, and look! a new traveling case for the trip.

A terrible lie makes a terrible act the more despicable. *Arbeit macht Frei.* Baggage inspection procedures at El Al were as comprehensive then as they are at all airlines these days. The Israelis took their time, even for a fully booked flight to Amman with impatient travellers standing in line.

The Israeli inspectors played their hunches. Bridget was called back for another look at her new case. The false bottom contained a clock, some wiring, and sufficient *plastique* to blow an airplane to Gehenna and gone.

A hard act to follow, these real life tales of Love, Death & Birth. Of all the paintings at Pilot Hill that could fall under the rubric of Love-Poems only Judith Linhares's can be said to deliver the message without irony, undercutting, or reservation of any kind. Judy's view of the human situation argues for Kindness (above all), Domestic Harmony, Play (there are few scenes of Work, considering its weight in our lives), and the important role taken by animals, birds, tiny children (and oldsters?? No!) in preserving our Humanity. I've left out flowers, stars, clouds, insects (the interesting ones), grass, sky—but you have the idea; Judy's not a fan of streets (she does have a burning-car N.Y. genre piece in uncharacteristic sour color). She is not a fan of subways (Judy prefers caves). She is a fan of lovers though, and when she depicts a couple, as in *Red Planet* (1984) (fig. 47), she will typically spiritualize them by treating their bodies in blue outline, as transparent, then, and in this case seen against a passionate (not angry, not Mars-militant) fiery-red backdrop. Semi-circular palings define a stage-like space not unlike the set for the last act of *Siegfried*, while at left a Tree of Life is cut off top & bottom thus flattening the whole image and holding it to the picture plane. The catenary curve of the red orb looms—for Love is a planet entire. Finally a spider advances…but hold on, that's a daddy longlegs, not an arachnid, there's no real menace. *Eve's Dream*, the companion piece also from 1984 (fig. 48), is one of the out & out loveliest of a career full of beautiful paintings. "Eve" is recumbent in a dream bubble, sleeps in a sacred grove. The Life-tree at left is barked this time with ellipsoid pudenda. Another magical tree harbors a symbolic hand plucking an "apple" (it's "borrowed" from the Van Eyck *Temptation*). A Death's Head nestles half-hidden in the tree foliage. But this presence is not so much threatening or alarming as it is emblematic of the facts of

47

Judith Linhares, *Red
Planet*, 1984

48

Judith Linhares, *Eve's
Dream*, 1984

Existence: Life terminates in Death. The beauty of being in Love, the meaningfulness of it, Love's spiritual essence, is not challenged (the way it is in Jim Nutt's art or Roger Herman's (fig. 49)—and many a more). In the upper left-hand corner a handsome Cambodian prince enters Eve's Dream (I suspect Judith borrowed the image from a bronze head my mother brought back from a S.E. Asian trip in the late '40s; the daddy longlegs, too, I think came from one of her Pilot Hill visits; at one point we were overrun with them, piggy-backed in from Papua). Color in Linhares is inward, ruminative, memory-steeped (seldom wandering outward toward Observation). Rich. Elegiac. Musical in a haunting name-that-melody sort of way. Not Florentine, then, but Venetian. Radiant? Yes, but with a soft lights-turned-low glow. Arche-typal I was going to say, but can color be "Jun-gian"? (And yet of all the expressionists Klee is the one who phones in from the depths. Who else is on the line? Early Blue Rider—and possibly, since his name turns up: Ryder.) What I'm saying here is she free-associates her color arrangements, drawing on Nature but not going into it. Put another way, hers is a meditated Nature, a nature digested. Her inner resources are huge by now, and the cave keeps expanding. It's a magic realm down there, a sunlit underworld; the Elysian Fields would perhaps pin a name on it. To define her art would be to find words for the special Mood Linhares creates for the schematic figures-in-landscape that are now her stock-in-trade, like *Monarch* from her recent show at Thorp (repro-duced in Whitney Chadwick's catalog for same). The words I found were the same Matisse found in Baudelaire: *luxe,* that is, meaning plush; and *calme,* meaning calm, and *volupté,* meaning—No! not *volupté* for Judy. Something else for Judy, something much more passive-erotic, some Word encompassing enough to embody her Mood of wise-relaxation, of (if this phrase isn't off-putting) dharma-enlightenment. I'm not sure, but this Word may be . . . *tendresse — luxe, calme et ten-dresse.* Hers is an Arcadia ruled by kindness.

The Elysian Fields, I like that. Matters were not always so elevated. Or subterranean, rather. I first saw Linhares works at the old Paule Anglim gallery near North Beach. This was near something else, too. Namely the fancy pseudo-Victorian law office of Mel Belli, a corny old soul (so sue me) whose penchant for hi-profile cases kept him in the public eye and in his buddy Herb Caen's column in the *Chron.* To get to Paule Anglim (yet another gem of an art dealer) you had to walk past the velvet-swagged windows of Belli's place next door; these were full of memorabilia from famous criminal cases + elephant hooves, spittoons, gold nuggets, gay nineties posters, cable-car models, girlie pix, a pack-rat accumulation of whatever'd caught Belli's eye while cruising Tokyo or Leningrad; it had all ended up in this cabinet of curiosities: a heteroge-nous clutter you couldn't help (because all collec-tions are revealing and more or less fascinating) spending a few minutes with, before turning into Anglim, where perhaps that afternoon Michael Palmer would be reading Duncan to the Joan Mitchells on the walls and to the "crowd" of 13 or 17 invited hearers—there's Peter Selz, there's Jay DeFeo, and that's . . . Richard Avedon.

It was always a grand satisfaction to pass so immediately from the Ridiculous to the Sublime, and in this context I first met up with Judith Lin-hares's tiny love-poems, executed in black-and-white gouache, and often merely a few inches high like our example. I suppose a work could be more charming per square inch, but you tell me how? Do we have enough to go on here? The Woman calling out to heaven & earth for satisfaction, the former a patterned rain of stars, the latter a springy field of Fauve-like plants enlisting Bergson's afore-mentioned *élan vital* (fig. 50). There's a shooting star to wish on plus a crescent moon's cosmic female force as a counterweight to the skeleton-lover's long better-to-see-you-with telescope (a phallic instrument that extends & contracts). The geometries of the rug and the near golden section-ing of the horizontal space provide a sense of har-monious order, and Yes! reader, that carpet will fly!

49

Roger Herman,
*Untitled (Study for
Auditorium)*, 1984

50

Judith Linhares,
*Death and the
Maiden*, 1980

And the spade? Offers a stabilizing vertical as well as encourages you & me to delve, good pursuer-peruser of these pages.

Seeing these tender "poems" for the first time, and knowing nada about the painter, I was nonetheless inwardly aware that they had to demarcate something new and authentic afoot for Judith. And that they would lead somewhere; they looked like distillate of a long process of self-certification & I had that bet-all-you-got feeling that one day this painter will be hailed as a major figure. So in case you've just, in 2022, picked up this none-too-slender volume for the 1st time, please have the courtesy to acknowledge that sometimes yer elders were keerect. True, I was rather surprised when Judith raised the scale of her paintings so dramatically and began slinging oil around. But the failure of the imagination is attributable to the fact that I had my critic's beret on. If I'd had on my artist's cap, I might well have foreseen her move; while, if I'd been warming my noggin with my art historian's bowler, I'd've been all a-wonder over this or any other artistic innovation. Dr. Samuel Johnson defined Wonder as the effect of novelty on ignorance.

One aspect of Linhares's career that has interested me *ab origine* is the extent to which she owes something to David Park. There's surely something to this supposal. But it's nothing to do with skipping preliminary drawing in order to approach the canvas or paper directly with laden brush, freely replenished. Park's figuration has neo-classical sources and owes something too to Picassoid synthetic cubism of the '30s. His figures are drawn in the paint, where Judy's are daubed in the paint and remain "paint people." But there is a fundamental sameness of *rôle*. Both artists believe in the humanity of their protagonists. Each painter grants redeeming value to human behavior. People are perceived as potentially Good. Park's nude couples standing around in Nature at the Oakland Museum are the parents of Linhares's nude couples just standing there taking in the butterflies, in *Monarch.* This is why Linhares is properly the heiress of David Park. They share a commitment to human possibility. So that's the link; it's not a matter of both artists using gouache; Park didn't seek out the medium until his last year, basically, when he could no longer stand up in the studio. Our *Por-*

trait of a Young Man (1960) (fig. 51), was practically the last painting Park made, propped up in bed with his drawing board on his knees. R.D., I recall, was spending as much of his time as possible visiting his sick friend. He urged me several times to go and see Park. It would cheer him to know that somebody, even just a kid like me, greatly admired his work. I told R.D. that I was teaching school all day and working the railroad swingshift; I had no time. Dick gave me his "look." He was right & we both knew it. I really should have gone.

Did this *Young Man* start out as a portrait of Diebenkorn, and then get idealized & universalized, so as to stand for Man. Man facing his death, that is? I raised this speculation with R.D. He didn't say NO. In any case the bold drawing bespeaks urgency, while the two primaries enforce a primary message: Death and transfiguration are on the horizon. It should not be an embarrassment to admit to the reader that for more than 40 years now whenever I have required reassurance that it is not a crime to be enrolled in the human race, I have been able to turn to this David Park and be restored. When he painted this picture—and most of his others in the short period of his mature achievement—David Park surely had Nobility and Goodness riding on his brush. Can I temper that sentiment with a little irony?

I'd rather not.

The death of his friend hit Richard Diebenkorn very, very hard. A situation we'll have to revisit because my purpose here was to establish that Judith Linhares's figure paintings are the legitimate descendents of David Park's, and that this linkage was less a matter of formal templates than of shared outlook on the still open question, Whither Humanity?

Are there many more of these love-poems, as I call 'em? Yes, practically nothing but. All the rest, however are somewhat undermined, qualified, conditional, and invaded by doubt. Indeed some of these love songs are jaundiced beyond recognition. But not to lose heart. One way of showing TrueLove is by showing what it isn't. Take Jim

51

David Park, *Portrait of a Young Man,* 1960

99

Nutt's savagely unsympathetic *G .G.* (GoldenGirl?) (1968), one of Jim's better known early paintings, the *ne plus ultra* of de-idealized Sourhearts of Sigh & Cry (fig. 52). My overall reaction is the same as when I first saw it in a show I got to take to South America 30 years ago: the artist doth protest a bit much. The Brazilian art world didn't much take to the Chicago contingent (Nutt, Nilsson, Wirsum), but that same year Nutt (and Wiley) showed up in the U.S. pavilion at Venice and when the Chicagoans were brought down to São Paulo the year following (1973), Brazilian resistance was over; the artworld is a consensus world, O reader. Jane & I made many friends on that trip and one of the closest, Casimiro do Mendonca, art critic of *O Estado São Paulo,* visited us in Pilot Hill one Fall; he wanted to look at the Pomo baskets for a show he was curating on feather art the world over. We picked him up in S.F. on a Sunday morning, stood at the back for the matinee performance of *Turandot* with the role of the Prince enacted by Luciano Pavarotti, and drove the 2½ hours to Pilot Hill, talking the whole excited way of art and flicker feathers & pileated woodpeckers, and friends fine feathered as well. Just around the big curve before you reach the house we startled a band of wild turkeys, and it was a sight. "Mon Dieu. Jean, tu vives comme Prince!"

"Cher Casimiro, Non! Seulement comme Duc!"

It's difficult to sustain a friendship thru correspondence alone and by the beginning of the '90s we'd stopped communicating. The Summer of '97, tho', found us in Venice for the Bob Colescott show Mimi Roberts organized for the Biennale (fig. 53). I went directly to the Brazilian pavilion. A young guy was messing with brochures. Casimiro do Mendonca? Hay ees Death. Roberto Pontual? Hay ees Death. I named a couple more friends. Everybody is Death. "Muito obrigado," said Jane, using up 40% of her Portuguese. We walked on, Jane going a little ahead so's she could wait for me at the little bridge.

"Very too bad," she said as I caught her up.

"About Casimiro?"

"Yes, and all the others."

"They shouldna played Russian Roulette with their dicks," I said—immediately regretting it.

"UNFAIR, Unfair, unfair," Jane said in diminuendo. "They didn't know. How could they have known? By the time they knew. . . . Why! You're angry at them for dying!"

I acknowledged the bitter truth with a nod. I had blamed the victims. Casimiro!! I'm so sorry. We walked on thru the Gardens, each knowing the other's thoughts.

"Casimiro, what a beautiful man," my wife said.

To cover my confusion at the confirmation of my friend's death and to hide my deep feeling of loss, I made a jest that set my all-time record for jokes in the worst taste conceivable: "At least y'don't hafta line up to buy a standing-room ticket at the Opera anymore." Jane said nothing. She took my arm & we continued in the direction of the American pavilion. I was ready to bet half of Italy there would be a few laughs awaiting us there.

Nor did Colescott disappoint. But I had started to talk some about the art of that funnyman of a different stripe, Jim Nutt. Some love-poems are jaundiced, I said. And was there ever a Sally so sallow as this poor creature of Jim's? A poison Venus, discharging black, yellow & green bile! How Jim's wiry, tensile line brings to absolute life every wriggling inch of the figure-contour. The enthusiasm Nutt brings to his indictment of perfidious Sally is always a source of amazement to this viewer. It's the over-kill, of course, the exaggeration, that make his art so funny. There are usually nice touches: in this painting, for instance, the employ of the Bluebird of Happiness as bellybutton! The words—like "thump thump," like "hair"—that Jim adds along with the tiny decals (of a bra, a pussycat, etc.) do not carry much weight overall; the real story here is incredibly virtuosic use of line, line at the service of shape-invention. I have the feeling Nutt could draw the same figure a hundred times and deliver 200 separate linear formulations for a hand & fingers. Why does he make the female figure so repellant? That's his business, of course, but let me point out that where an aesthetic response is concerned you

52

Jim Nutt, *G. G.*,

1968

53

Robert Colescott,

Life Class, 1987

get the same mileage from Disgust as you get from Desire. Attraction/repulsion is one hiway in Art.

Manuel Neri's untitled golden girl (fig. 54) makes for a nice comparison with Nutt's *G. G.:* Manuel's figure is passive, "Venetian," beautiful, poetic, inviting. Nutt's is hyperactive, "Florentine," ugly as Sin, slangy/obscene, repulsive . . . Nutt's woman's obsessive writhing and unpleasant odors are presented in a harsh, unflattering light; while Neri offers us a perfumy painterly lady relaxed and happy in her indolence and awash in healthy sunlight and sumptuous flesh tones. Manuel Neri's untitled golden girl makes for a nice comparison with Nutt's *G. G.*

The small 1967 acrylic & cut-out metal on glass *Peanut Head* (fig. 55) gives the answer: Matisse. What was the question? Why, the familiar one: which pre-1950 artist—Picasso, Matisse, Duchamp & mebbe Mondrian—lies behind the achievement of any post-1950 painter, like Jim Nutt? Matisse, then, with maybe a side-bar of the great Pablo. Matisse because of Nutt's employ of flat unmodulated color and, especially, his practice of cutting directly into sheet metal. It took Henri Matisse 40 years to reconcile himself to the idea that he'd better treat the world to a few collages (the problem was that the cut & paste medium had been the brainchild of that ole D——t Murderer Señor P. Picasso; and H. M. was 40 yrs. in figuring how he could do it better; the solution being he could cut directly into color, draw with his scissors, let Pablo catch up to that!). It took Jim Nutt about 40 minutes to realize he could shear into flat metal and let other artists take the hindmost. He didn't do all that much with the idea—in the '60s before Jim took up golf ideas were spilling off him like a guy caught in a lightning storm—but he did a few (Bob Arneson bought the companion piece to *P. Nut*). Our painting by the way, should be titled *Shithead* or, better, *Shit & Pee Nutt;* I think the painting will answer to that call—but make it early, before Jim heads out to the links, before six, I mean.

This is one yugly painting, our *Peanut Head,* none yuglier. Lookit that shitbrown, that pissyellow, the toe-jam I-ball, the earwax, the cooties.

54

Manuel Neri, *Nude,*
1988

55

Jim Nutt, *Peanut Head*, 1967

(Want some exclamation marks¿¿¿¿ Here are a few!!!!!!!!!!!!!!!!!!!!!!!!!) What fun Jim Nutt had at home in Chicago, and a Broad in California as well.

Here in Sacramento Jim Nutt achieved a marvelous drawing in colored pencil called *Back yer Government / Keepin' my eyes wide Open,* which featured a meat Venus de Milo, seen from the rear, plus borrowings from Picasso's anti-Franco studies for *Guernica.* This drawing was directed not at American governmental quasi-fascism but at pie-in-the-Sky Art Departmental Utopian blather, as Nutt saw it "poor traits of gravy" that merely served to cover up sexual hanky panky ranky & the usual "California" dopey, far-out, starry-eyed self-deceptions.

Also weighing in on the matter was Gladys Nilsson's cautionary *Trip/Dyck,* not a triptych at all but a watercolor of a guy with triple dicks—he's also "Hung" or draped with blondes & brunettes. At left & right bottom Gladys Nilsson/Jim Nutt figures commenting on the action with What-can-you-do¿ shrugs. These little "paint-people" observers-within-the painting are a device as it were, that both Nutts use; I believe it was taken from a local primitive called Alex Maldonado.

After a time, in the course of human events Jim Nutt himself fell into the very "California" lures he decried. *Así es la Vida.* To his credit, when I remonstrated with him for this hypocrisy, he ceased his animadversions on me & my department. And Gladys put the matter to rest with her charming diptych: *He Is a Dip Dyck but They Are a Pair.*

Gladys Nilsson, her husband & their friend Karl Wirsum were each very successful teachers. Women students in particular sought out Nilsson to find out how you become a great Female Artist. "Sweetie," they would be told, "art is made by PEOPLE!" Nonetheless it's obvious that Nilsson's pictorial concerns give onto a woman's world: the domestic, dances, dreams. Her formal treatment of these matters: the lapidary brilliance of her color, her schematic "paint people," clearly had some influence at the beginning, on Judith Linhares and, at the beginning, on M. Louise Stanley. These artists, in turn, influenced a wide

array of "circle" painters, and that influencing still goes on.

Like Linhares, Gladys Nilsson's semi-Surrealist Expressionism projects a mood of sweet & gentle kindness. We have a captivating powder-room scene of women brushing their hair, adjusting their makeup, & in "picturebubbles" discussing the evening's dance strategies. Here we're at a far remove from Jim Nutt's brand of humor, his bitterly salacious provocations, his cloacal obscenities the equal of anything we might encounter in Swift or Rabelais for that matter or to bring it up to date, in David Mamet. Gladys is on an altogether different plane. Her good-sized acrylic *Pynk Rabbit* (i.e., a Mother-of-Many) (fig. 56) is harassed half way to distraction by her clamorous brood

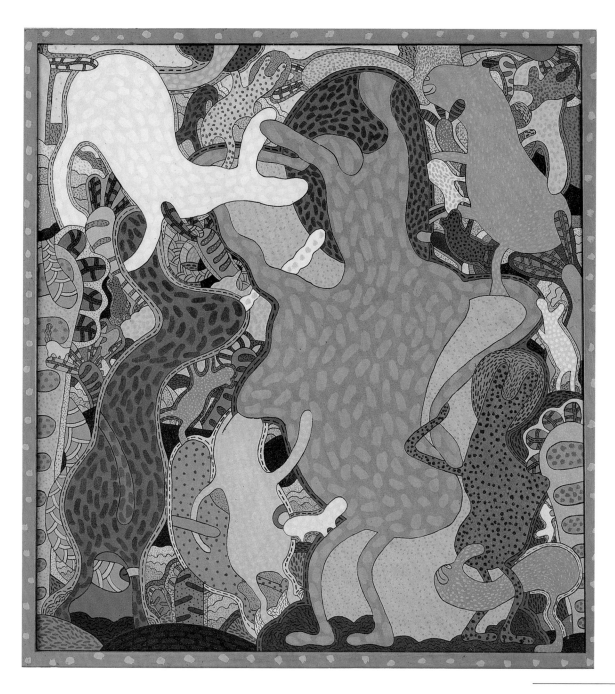

56

Gladys Nilsson,
Pynk Rabbit 1970

who are conceived in roller coaster bio-morphic shapes that seemingly won't quit poking pulling sucking grabbing pinching at their stressed-out yet clearly complicit Mom; this Rabbit lady long ago sacrificed the spring in her bosoms & bottom to the overwhelming onslaught of all these kids; but it was all in the good cause of Motherhood.

Both the Nutts are superior at shape invention, the reader will grant, and that goes double for their best friend, Karl Wirsum by name. Wirsum is a low, skulking fellow with the demeanor of a docent kil——No! no! reader, I'm just testing t'see if you're awake. Karl is not low, nor does he skulk,

and many of his best friends are docents. Like most all the Hairy Who artists, Karl Wirsum took a strong interest in the art of institutionalized persons as well as in the extraordinary sculptural traditions of so-called traditional societies. In startling works like *Beer Did Lay Dee* (fig. 57) and *Tearesa's Torso* from 30 years ago, Wirsum went further than his colleagues in exploiting the obsessive rhythms and quadrilateral symmetries of certain Sepik River shields or Congo Basin masks. And like Jim Nutt he chose to execute his ideas in unusual & even incongruous materials—inks plus crayon on cardboard in the present instances—in

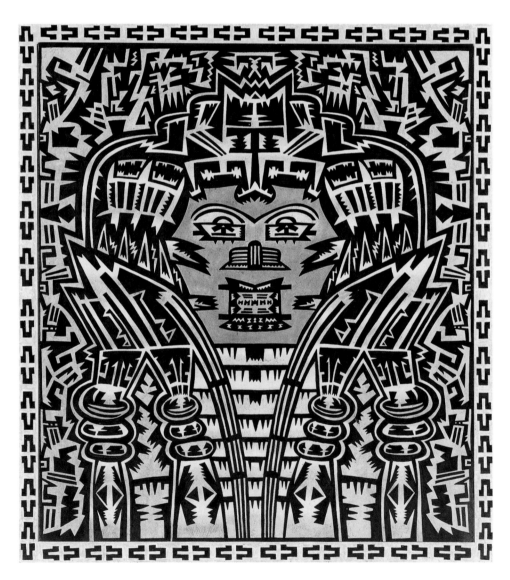

order to secure his work a little distance from the art of the artschools. *T.'s Torso* is seen perspectivally, from below. So the knees read in the round & large, the face and coiffure flattened & small. The flesh-color breasts, like rockets ready to fire, are pulled laterally in the plane, while pulsing diagonals & chevrons direct the eye straight into the flesh-colored vagina (yes, they hav'em in Chicago, too). That vagina, in Wirsum's manic expression, is very apparently a jailblock. Ouch! (which is a critical epithet we reserve for those occasions when something hits us). Once again Bergson helps us to see the fun in this: a person turned to a machine.

Have we drifted away here from the discussion of love-poems or would it be better to say we've looked at Chicago-style love poetry? Where we learn, from Jim & Karl, what to watch out for? Every art center has its own ethos. Chicagoans seem wary of New York sophistication, suspicious of California glamour. What is elsewhere condemned as "ugly" turns beautiful when you put on Chicago lenses. Something like that.

Jane & I were having Sunday brunch at quite a nice eating spot not far from the Museum of Contemporary Art one breezy Chicago a.m., waiting for the museum to open. A lot of "regulars" were in there, folding their way thru the *Tribune*. The place was a home away from home, very pleasant feeling all around. I was on the point of asking a lady at the next booth if I could take a look at her sports page, when the door opened to admit the ugliest fellow I think I'd ever seen. About our age and wearing a fine camel's hair coat over his barrel body, this man's neck & face were all over warts & carbuncles. He looked sort of like Mayor Daley Sr. afflicted with plague. He could have stepped right out of a painting by Ivan Le Lorraine Albright. Jane & I looked down at our plates and kinda held our breath as the incomer started to waddle his way thru the restaurant on his way to what turned out to be his table. Took him about 5 minutes to get there, too, because the whole progress he was interrupted by pals & wellwishers & gossip gatherers & buddies from

way back. Jane looked at me. We were the interlopers. This ugly guy was in his space, Chicago, U.S.A. Long may it wave. You can't be laid-back, reader, when the wind is trying to blow a hole in you on the finest day of the year. The lady next us left, so I snitched her sports section and read as follows:

WINDY CITY STAKES

> 6 furlongs, Purse: 3.12 million marbles
> (For Chicago-breds + horses that have influenced area artlife)

(A) LEON GOLUB 5/2
> Been campaigning in N.Y./Europe. Should handle these

JIM NUTT 3–1
> Throw out recent sub-par. Ready 4 smasher

PETER SAUL 7/2
> Californian invader showed way in FrumkinStks (fig. 58)

H. C. WESTERMANN 9/2
> Will be out gunning for top ones

GLADYS NILSSON 12–1
> Early speed; may try to steal it

ED PASCHKE 7/2
> May be placing too low

ROGER BROWN 5–1
> Long idle, could get up for part

(A) NANCY SPERO 5/2
> Entry holds powerful hand

IRVING PETLIN 15–1
> European invader best chance play of race (fig. 59)

KARL WIRSUM 15–1
> Watch tote board; can nail'em in the Drive

SUELLEN ROCCA 50–1
> Been facing printmakers

Note: Nutt & Nilsson will be uncoupled for betting purposes

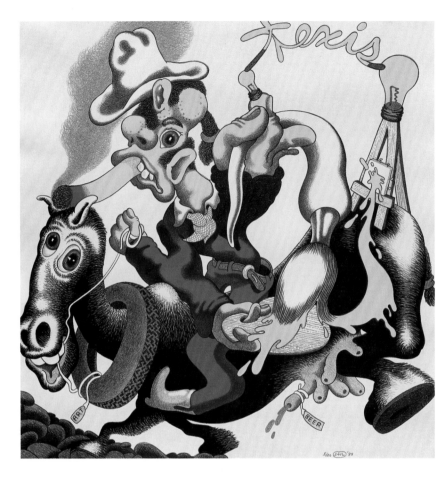

58

Peter Saul, *"Texis,"*
1985

59

Irving Petlin,
Soldier's Dream,
1990

Time now for me to answer one of those preliminary questions I raised in order to keep the reader staying up late & hoping (because y'never know when). So let's make Now When and tell you the truth about how you can be more generous than Wm. T. Wiley? All right, reader, don't spread this around: CANNOT BE DONE IN THIS LIFETIME.

OK, we go on to more paintings from Pilot Hill that may be classified as love-songs *manqués.* Roger Herman will fill our bill. We have a little painting that qualifies as a love-poem for contemporary consumption. I say "little" and it in fact is Herman's economy size, smaller than the regular size of the same subject, which in turn is smaller than the Giant version (which is in the Michener coll., Austin). The apparent subject here is 3 girls in bra & panties sitting/standing around watching TV. But Herman showed me one of those flip-books that gave rise to this scenario: a nondescript man is seated in a nondescript room watching TV in his shorts & undershirt. Two pornogirls arrive, put the man into black bra & panties. They all watch (porno) TV. This paradigm of modern Love isn't even frigging consummated! Herman puts the drizzly paint down in short fudgy strokes, not trying to enlist any of the paint handling skills he's built up during a long career. The colors of choice here, a bituminous gray black along with a dirty, acrid yellow, are the pictorial equivalent of ashes & urine. Haven't we returned to roughly the territory occupied by Nutt's goldengirl?

What about Herman's big painting, tho', the 10-foot-high *Staircase for W* (fig. 60)? It's still a poem about Love but more factors are at work. As his starting point Roger took the staircase plan for the house Ludwig Wittgenstein designed for his sister during his convalescence at home after he had suffered a severe nervous breakdown. What would usually happen to W. is that he'd fall in love with one of his Cambridge students, things wouldn't work out (the way they have a bad tendency not to), the philosopher would break down, & off he'd go to Scotland, where he

60

Roger Herman,
Staircase for W.,
1983

could rent a beach hut for a month & talk it over with the birds. This time it was worse & he had returned to the Continent. Part of his recuperation was busying himself with the house project. He was a cultured man, he was richer than he was cultured, and he was smarter than he was rich. Turning architect posed no real problem. No greater than that faced for instance by his brother Paul, who'd lost his right arm in the Great War & had to commission (from Ravel, from Prokofiev, etc.) piano concerti he could go out & concertize. So W. had his house built. It was acclaimed as the most lucid house in Europe. It was abhorred as the most lucid house in Europe. As functional as a post office. Intolerable. As matters stood, at least to my undergraduate satisfaction, Wittgenstein had established that the realm of the spiritual deserved to be exposed as nothing more than wish fulfillment that accompanies our dreams, daydreams rather.

Herman sets out to discover what residue of the Spiritual remains in W.'s house, and of course it all comes flooding back in because W.'s failure in love was like all such failures a spiritual failure, and not even the smartest man in a century can expel the metaphysical from Time/Space, be it even in the most lucid space in all Creation. So Roger restored the connotative realm to the denotative, which it fits like a glove or like a Love; and he used W.'s staircase to get from one level to the next.

Altho' *Staircase for W.* is stated in the same ashes & urine volcanic crust as the small painting of the 3 TV Watchers in Hell—as I am inclined to title that untitled work —you can see, here & there, leaking thru the surface skin a brighter, more joyous & even lyrical painting that once existed on this huge canvas until Roger painted it out. That original picture was undoubtedly a true love-poem. The painting out, blackening, the covering up of pictorial love-poems goes back, in our day, to the Spanish Elegy series of Robert Motherwell's. The Herman painting, with its grim skeletal patterning, its drab as Auschwitz garb, its mephitic sulfurous sullenness, is one of more than a handful of Pilot Hill paintings to ask the question: how can you have a good Love in a bad society?

John Ford's big paintings (and he can cope with a big canvas, hundreds can't) aim at correcting that society. How? Well, that answer will suggest itself once we get the Revolution going & start turning over everything. Meanwhile here's an Explosion painting (fig. 64). KerBlam, KA-BOOM. John had something of a following among (male) painters of his generation (Roger Herman & I were introduced by John); artists were drawn to John's combative energy, the sense he projected that art could do something about the status quo. Ford was pleased to maintain that he was self-taught, and so he probably was in matters of holding a brush. For his art history tho', he imbibed it without a chaser from the front row of my classroom (always a good signal; it's the sullen ones who go to the back). John would cross his legs, hit on the girls, badger the teacher, & tell his homies he was there because the slides were good. He seldom missed a class. In 1975 my friend Marcia Tucker put Ford & Don Hazlitt in the Whitney Biennial. Go to New York, young men—that was my advice. Abstract painting was not in full flower in our area. Then Roger Clisby was organizing a California Abstraction show for the Crocker and, Hazlitt already having moved to N.Y., I suggested that Roger fill the "youngest artist" berth with John Ford (who never found out about the collusion; he'd have been sore). Buoyed by the chance to show alongside R.D., Bischoff, Hassel Smith, Mark di Suvero, Mike Todd, Voulkos, Garabedian & the like, John now debated 2 courses: follow Roger Herman to Los Angeles; follow Don Hazlitt to New York. My advice was the same. In N.Y. Don Hazlitt's large blossoming "love-poems" like the one illustrated here (fig. 62) could not survive in the new punishing environment. They shrank, like wool socks in a tumbled hot water wash. Don had to redefine himself within a tiny format. This he managed to do thanks partly to friendship with Richard Tuttle and permissions granted him by his teacher in Sacramento days, Mr. James Nutt. Soon enough he

61

John Ford, *Requiem
for Phil Ochs,* 1976

62

Don Hazlitt,
Untitled (detail),
1974

found gallery representation, a part-time teaching gig (at Columbia) and even patrons (Herbie Vogel the postal clerk & his ladywife the librarian). Beyond this there gradually developed interest in his work in several European centers. Don didn't "make it" in the biggest way but he did "hang in there" and he continues to create beautiful small paintings and reliefs that marry high taste with "low" materials (fig. 63).

John Ford did not walk in the same luck, if that's the word. He made few adjustments to his art. What passed in California for confidence New York took as pugnacious. Work as a best boy grip for an outfit filming commercials paid the bills, but sapped him for his art. And there were money matters after all. Worst of all John, long committed to an esthetic of heroic abstractions, completely waffled in the face of a sudden N.Y. shift towards neo-expressionist figuration just as John Ford was getting situated. John, wavering, now offered some abstract representational "landscapes." They were OK, but they didn't really take. Meanwhile a retreat to California was closed to him by certain alimony troubles. John moved to Ireland. Roots. But he was soon deracinated back to Manhattan. Then Ireland again. And back. It's a merry life, if y'don't weaken, John! We used to say to each other when we got a chance to meet.

The day of the funeral was pouring down rain. A few nights back John Ford had stepped into the street outside his favorite bar and been struck by a car pulling out from the curb. The driver was a good friend. John fell backward, his head struck the kerb. Some hours later he died in the hospital.

Bill Bourke who collects Ford's work and whom I've known these 50 years took a cab way downtown with me but we had the wrong Catholic church. We ran for the right one and walked in soaked as the long service was ending. Drunken clergy, far too lengthy ritual, hardly time available for those who wanted to talk about the John they remembered. A Catholic disaster, Bill Rees admitted. I am not a Catholic, but a whole roster of my school friends seems to be. Rees had arrived on

time for the long service. An insurance man who tries his hand at poetry, he had come prepared with a pencil & paper. I love Bill Rees and his whole family, and after 50 years of friendship the only bad thing I can remember about him is that in college his room looked like a Catholic gift shop. Bill pulled out his notebook & read us the start of his poem on John Ford. It was pretty good, too.

Later, back in the hotel we were reminiscing about Ford, about how it took luck as well as talent, about self-sabotage, and so forth. I confessed that I could never decide if *Requiem for Phil Ochs* (fig. 61), where Van Gogh meets Pollock (3 suicides, then), belonged to the love-poem category or if it were more a Hymn to Death. Bill Bourke said, "What did categories amount to? It was enough to know that John Ford was an Irish/American Love/Death Painter/Poet."

"Who never lived in the luck," I added. And Rees brought to mind what Mark Twain said about the composer of *Tristan und Isolde:* "Wagner's music is better than it sounds."

On the flight home I was still thinking about how convenient and a half it was that the news of Phil Ochs's suicide should have come over the air just as John was finishing this work of many months in which a Pollock-like all-over field is conflated with the crows taking off above Vincent's cornfield and with the starry stars themselves. Why was I there on that particular afternoon when the news came on my airwaves (KPFA)? Of course I often watched Ford paint . . . it was kinda like watching the toilet flush in this airplane, I thot. Whoosh! it just whirlpools down & outta there, he just pours his personality into the canvas, it's an unfillable hole for him . . . and the whole time it looks like he is afraid . . . he'll lose control. . . his whole personality will slip in there . . . he won't be able to hold it back . . . hmmm, I remembered how R. D. did it . . . lots of passion but way more reserve . . . in Ford the brush didn't think much, not much reflection . . . you just followed the brush where it led . . . that's John's strength & his weakness, I thot; the paintings are compelling BUT. . . .

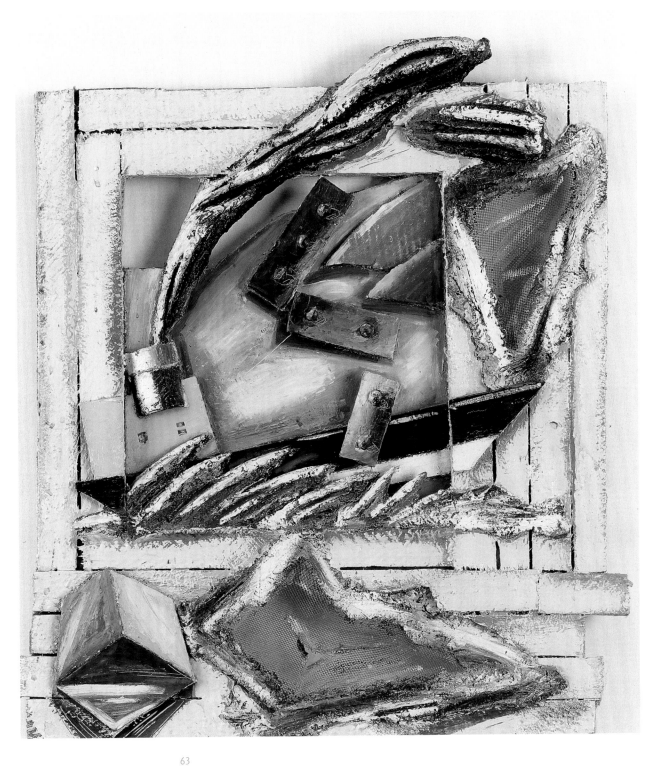

63

Don Hazlitt, *Sinking
Ship*, 1984

64

John Ford, *"High Velocity #15,"* from the Explosion Series (detail), 1978

I dozed away & woke as we were in the landing descent. "Where Have all the Flowers Gone" was going thru my head or was that Leonard Cohen? Mia Todd, Mike's chanteuse daughter, reminded me a little of Leonard Cohen. Where have all the '60s gone . . . Ford had been a stalwart of the Pilot Hill—lonnnnggtyum agohoh—Annual . . . what was the relation between Luck and Accident? . . . between Accident and Coincidence? . . . Bbbbmmmmmttdddybbmmm . . .we were on the ground in golden California.

Jane picked me up. "Pete Seeger wrote that flower song, dummy."

"Dumbell," I corrected her. "Pete Seeger, he was early. Phil Ochs, he came later. 'Universal Soldier' was his?"

"Right."

"Thank you." For no reason whatever Jane swerved into the next lane. The way she drives. But my brain jolted back onto circuit. "That's the California connection," I said. "The California Art connexion."

"What is?"

"I'm sure it wouldn't interest anybody outside a small circle of friends."

Often I do think of my school & college chums and their families. But do you share this assessment, thoughtful reader? That it's all over by the last year in high school? The test cheaters have announced themselves. And the dirty players, sports & other games. The brave have identified themselves, also the lazy and the gutless. The generous & the kind are known, so are the behind-your-backers. The wait to see what Cindy will do-ers are all in a row, also the rank pullers, the politicians-born, together with the borrowers 'til Thursday, promise; the parents won't let mes, the whole crew? Is it all decided by Graduation? Haven't the ambitious come out? The brutal, the innocent, the easily compromised, the good scouts & the bad? This is not the (we'll get there later) *Nicomachean Ethics,* reader, I'm just soliciting your views. Take us, reader, you & me. Will I walk the last mile with you? Or is it the other way round? I'm minded of a performance piece done years back at the Berkeley Art Museum by my very

dear friend Howard Fried. Afterwards, Howard announced he would walk the last mile with anyone who wished to accompany him. So a little band set off & walked & walked. After 10 miles only the intrepid few were still on track. At milestone 12, down to two + Howard. They'd set off after 9 p.m.—it was now the wee hour. At mile 15 it became just Howard against this other guy, and on they walked & walked & walked. Finally, in San Leandro, at mile 23, Howard Fried cried Uncle. Was it that the other fellow had imposed his will? Not really. The point had been made. Common sense intervened. So I dunno, reader dear, if either of us is destined to go that final 5K feet together. You don't, do you, harbor unexpressed feelings about docents??

A reader requests that I fill her in on why I admire Damien Hirst? Well, of course the work speaks for itself. The cows in formaldehyde recall my *Slaughtered Beef* (1973) brought off at Pilot Hill by a dozen artists, including Kaprow, Jimi Suzuki, Jack Ogden, Irv Marcus, Terry Allen, the late Nate Shiner, Pomeroy, Steve Tamarabuchi, and Peter Saul. Each artist was attended by a "Veronica" who toweled & gave drink to her artist thru-out the course of the Event , which began with Bread & Wine served at a long table beside the creek. Mounted Sheriffs arrived and put the artists under arrest. We were required to push, haul & shove 3 motorcycles up the steep winding roadway, while the spectators lined up above the road harassed & vilified the criminals, threw stuff, kicked the bike wheels, shouted insults & fired off pistols and shotguns. Even tho' I knew pretty much what was happening I was sort of terrified. A mass psychology was dominating the crowd by the time we reached the imagery at the top on this day when the sky kept threatening rainstorm every minute & every minute held off. "Crucify them!" "Death to the artists!" It was a mind-numbing cacophony. Just as we got to the imagery, the sun sliced through, illuminating the 3 large crosses I had erected. The center cross held a huge slaughtered beef. Where you'd find INRI I had carved MAKE

Slaughtered Beef, 1973: Veronica Rest Stop—Jack Ogden, Nate Shiner, Allan Kaprow, Jim Pomeroy

Slaughtered Beef, 1972: Jimi Suzuki, John Fitz Gibbon, Terry Allen, and Peter Saul

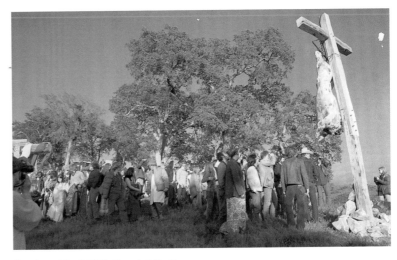

Slaughtered Beef, 1972: Crowd at the Cross

ART. Suspended from the cross of the Good Thief was an upside-down black motorcycle, a Norton [Simon]. BUY ART was carved above. The Bad Thief's cross wore a huge block of ice that encased a brilliant yellow Bullock's oriole and a black typewriter; nailed to the outstretched hands at either side were open copies of Al Elsen's *Purposes of Art* and *The History of Art* by Peter Janson. Above you read: TALK ART. In Brueghel's version of the crucifixion the executioners didn't use a cross but rather a wheel atop a pole; the body of the criminal was bound to the wheel. In Jimi Suzuki's 3 paintings of *Friday 13th at Fitz Gibbon's* he uses the pole wheels, conflating them with the motorcycle wheels we got so chummy with (fig. 65). Suzuki adds to his view of an almost rainy day at Pilot Hill his familiar rendering of Mount Fuji as well as, out for a cruise on Folsom Lake, the liner that brought Jim to the America this dear friend has been scrupulous to observe for us native inhabitants. My *Slaughtered Beef* was done in homage to Rembrandt's two versions, the better of which is in the Louvre. The greatest painter of the Old Testament understood that the Ox & Ass in the stable represent the interface between the Old Bible & the New. The greatest painter of the New Testament understood that the so-called Painter-Evangelist, St. Luke, has as his medallion the flying Ox. The greatest painter of them all understood that in our legacy from Greece the satyr Marsyas, flayed alive in the marketplace for daring to best the orthodox God of Music in a jam session, is the true emblem, in the final analysis, of the great artist, the artist who makes no concessions. Suzuki is not Rembrandt and, last time I checked, I wasn't either, but Jimi did understand what I was getting at, which I explained, and the proof is in the painting.

It's tempting to call Suzuki a Little Master if that epithet may be applied without pejoration. It can be frightening how good his ear is for what's going on in the artworld, at a given moment. The large 1964 2nd-generation AbEx painting here (fig. 66) is an absolutely textbook "period piece." 'S not a love-poem so much as a Birth story, or

even a *How to Get Preggers* manual. The painting reads left to right and bottom to top, the way most Occidental painting works. Blue and red are set in opposition in 2 relatively uninflected large fields. Quasi-scientific imagery based loosely on female reproductive tracts are casually drawn in white or black: there's an ovary plus a fallopian tube leading to a pelvic shape. Are those seeds? Yes. The drawing with paint is accomplished, firm, spare; the wild, elastic quality brings de Kooning to mind but Suzuki is somewhat more stately, poised, takes no risks. He knows where he's going with the painting at all times. It is, as I suggested above, a neo-scholastic essay in how an Abstract Expressionist vocabulary of forms can carry information & convey content perhaps more roundedly than realism itself. Those AbEx fathers include Gorky/Miro-esque bio-morphic sweeping shapes at left, then a Barnett Newman "elevator door" "zip" down the middle, then on to the red zone with its (late) Hofmann-esque black cubes; finally at upper right these geometries break into story; one tit sticks up from a torso on its back; two large opposed circumflexes stand in for buttocks.

What Suzuki accomplishes here is a sort of macro-version of the female reproductive system (which should be called the human reproduction, or simply the reproductive system, the reader need not remind us where we came from). Jane points out that a micro-version of the female goods (abstracted to about the same degree as in the Suzuki) has for the last couple millennia existed thru-out South Asia in the form of golden apotropaic pendants. They are worn by women not just from S. Asia, she says, meaning (certainly) that Jane has and wears one. A scholar-collector-connoisseur like Mr. Suzuki would likely be possessed of such charms, don't I agree? "I agree with you, Jane—for maybe the first time this millennium." In fact, tho', I have misgivings. Jimi was only 29 when he made the painting. He may not yet have been aware of the ling-ling-o as these pretty talismans are called so melodiously. I'll

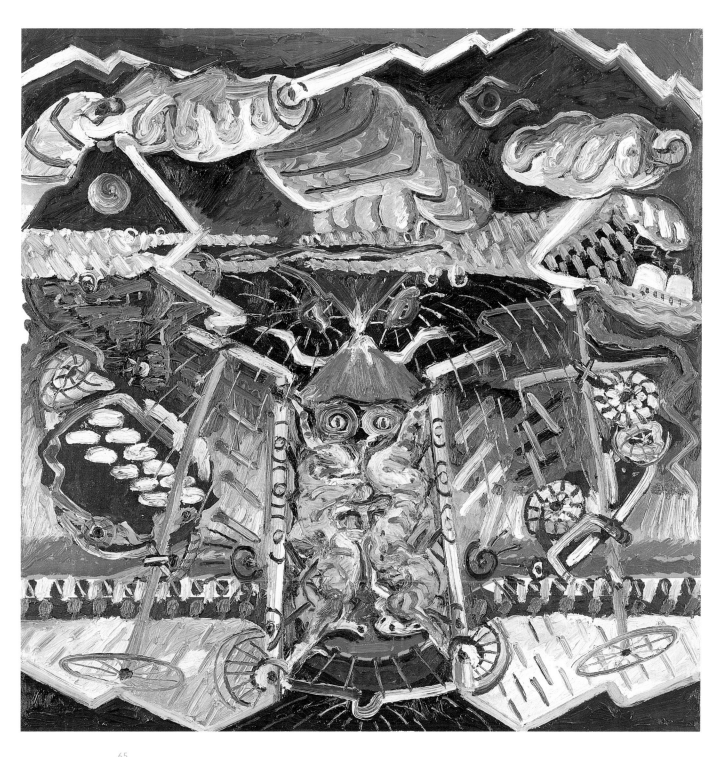

65

Jimi Suzuki, *Friday
13th at Fitz
Gibbon's*, 1974

66

Jimi Suzuki, *Untitled (Abstract)*, 1964

make a note to ask Bead Woman of the Year about it, Jane's daughter, and mine. Those readers who know Jane, and have come to the usual conclusion that she is perfect, ought to ask themselves if it's so damn hifalutin of her to be always working the conversation to where she can mention her children's achievements? (something I myself've refrained from—except where the Wittenborn Prize is concerned, I grant you; but it won't happen again, I promise).

So be advised, good reader. Try to let this long document profit you. Never forget that while you & I are zonked out in front of the set watching the Breeder's Cup all day, or the interminable Hockey & NBA play-offs or the Arturo Gatti/Irish Mickey Ward donnybrook, behind our back half the population is scurrying around collecting beads. These bead-ladies are of every shape, age, and degree of footwear. Even now these bead collectors are collecting just below the glass ceiling. When the break-thru (and it may well be here in Pilot Hill) finally comes, you will learn, faithful reader, what it can cost a man to be ignorant of beads in his own household and America herself will have to find out how to flourish under Capitalism with a Beady Face.

Think I have forgotten about Damien Hirst? Not so. Just want to interpolate a few words about the *Bore* (fig. 67). Not me, unkind reader, Ken Little's piece of that name. Ken makes beautifully nuanced generic portraits of animals, life-sized and to the very life. So what? Well, they're made on an armature, which he covers with sometimes hundreds of mostly women's (and a few children's) shoes from the thrift store. The genius of this is simply untellable. To say that *Bore* (1982) has a staggering

fetish power is to way understate the matter. This is a piece I so hated at first sight that I knew I had to go back and buy it. It had changed galleries in the interim. I paid more. There are penalties for disregarding the law of Hate at First Sight. Which, stated simply, is BUY IT before the streetlight changes.

One year, before they stopped awarding the big prizes, Ken Little received the National Endowment's $25,000 grant. James Albertson was on the same short list. Ken spent the money on producing a *catalogue raisonné*. Albertson put twelve-five up his left arm and twelve-five up the right.

Are Damien Hirst's kine to be preferred over Ken Little's boar? Tusk, tusk, reader. In any case I do think Hirst the artist is terrific. But I pity Damien the guy. Now the reader shall judge if gossip is really best savored cold. More than 50 years ago, before I met Jane, Damien's mother-in-law was my high-school steady. Of so mercurial a disposition was this blond damsel that proximity to her would raise the thermometer on the coldest day. For one so young she definitely enjoyed that special "mother-in-law" tendency toward interference in matters not entirely germane to her own business. An attractive girl of Finnish descent, she was almost entirely given over to partying in an era when the intransitive verb "to party" was as yet unborn. She was a good dancer and a pretty good sport, all told (moreover she would most certainly tell all). The main problem was that she was never happy unless she had something to be unhappy about. As far as I could tell she never drew a happy breath. I don't think I have ever known a person more difficult to satisfy emotionally. This was curious, but ultimately wearing. Quite possibly I just didn't measure up to some inner standard she maintained, I can't say. I hear tell that she graduated to become a good cook, a dedicated gardener, a friend to all cats, and eventually a loving grandmother. Additionally, she was known on land & sea as the organizer of grand galas associated with a noted annual yacht race down San Diego way. And (of course) she threw a

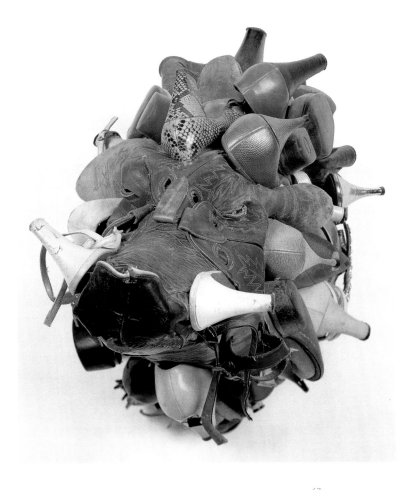

67

Ken D. Little, *Bore,* 1982

great annual party on the day the swallows return to San Juan Capistrano. At any rate, when we were young I received the deluxe seminar in Jealousy from this lady plus the Advanced Placement tutorial in how to nag, nag, nag. The benefit of hindsight enables me to locate her physical type as uncannily similar to Dürer's *Eifersucht* print, but that is neither here nor there. I would be happy to learn that equanimity had settled at last on a person I so truly valued. People don't change very much, though. I'd be surprised if Mr. Hirst does not give thanks that the continental United States of America enjoy the breadth that they do, and thanks too to the wide Atlantic.

No doubt Aristotle wants to clamber back aboard this excursus, nor can we say him nay since without somebody's help we may have a hard time with the comparison we intend to draw ■

119

between Philip Morsberger's *A Guiding Hand* (fig. 68) and Robert Yarber's Study for *Bad Bellboy* (fig. 69). Each piece was worked over for years and years. Remembering that we have to understand the painting before we look at it, we can say that these love-poems each will fall somewhere on the pole that leads from the little Chicano's truelove demonstration and the Arab who was ready to murder his pregnant lover along with a planeload of people, which registered zero on the lovescale. Obviously the Morsberger will show us the way toward Love as the husband tenderly guides the wife past the demons that her psyche has raised in her way. Together they can make their way thru a field of chaos & dangerous disorder. Meanwhile the plunging eccentric perspective tells us that something bad is going on in Yarber's painting, or has gone on, or will go on between this nasty, stunted couple. The way the space is squeezed

tells us that matters are unnatural, distortion rules here. Color is livid, like a wound. Dirt is about to go down. Truelove has been trashed yet again, as in the small Roger Herman; spiritual sickness is the diagnosis for both paintings.

Aristotle is semi-relevant here. In his *Ethics* he maintained that virtue lies between two extremes. Generosity, for instance. You can be too generous, like Wm. T. Wiley; or not nearly generous enough, like X—— or Y—— or, now that I think of it, like Z——, the stingy bugger. Find a mean between two extremes, between underdoing it and overdoing it, that's the advice Aristotle gives. More on him later.

Hassel Smith was all over the artmap with his paintings, and always with a verbal justification— after the fact. Where Diebenkorn's tri-partite career made ineluctable sense, where Bischoff knew just where he was going, Smith rattled

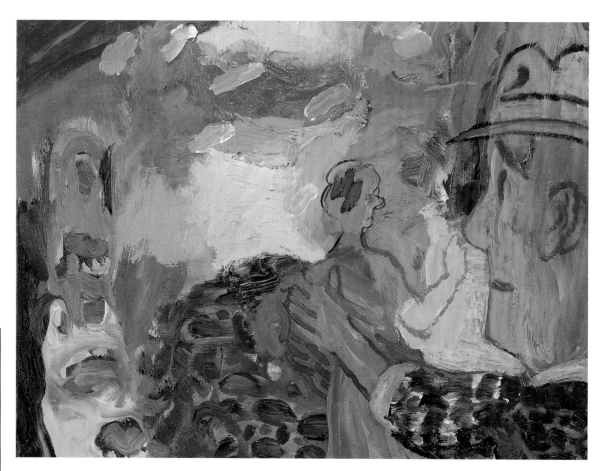

around like a pinball. The first entry I have for him in my library is the catalog for a group show from 1939, which I found, dog-eared & tatty, in a used bookstore early in 2002. For a time, at the beginning, Hassel did sorta Provincetown/modren landscapes & fishing boats, work that was going royally nowhere. Clyfford Still entered his life and Smith was an instant convert—or was he? David Park dumped his paintings in the Still manner; R. D. despised Still—yet produced work that clearly owed him some debt; Bischoff took Still's program all too seriously. But *Smith,* supposedly a Still follower and by every account an acolyte, *Smith* did Abstract Expressionist paintings that displayed qualities never seen in Still: wit, irony, lyrical color, scintillating brush moves. And he was modest, too in & out of the work. Sure they were lightweight, but reader they were funny, a virtue never seen in Still. You won't find this in histories of the period

but in 1952, shortly after Park's apostasy, Hassel Smith did some Bay Area Figure Paintings in the new David Park manner, and these were to die for. I recall a small painting, *Woman with a Snood,* which beat Park at his own game. These paintings disappeared from his oeuvre and years later when he had a SFMOMA retrospective, he began the show with 1953, with paintings that had returned to baiting (as I see it) the dour *chef d'école.*

As Bay Area Figuration ran its course, Smith, in a sudden reversal, began travestying the movement with cartoonish figures that sent up the dignified account of human nature you could extrapolate, for example, from our Bischoff, our Park. Hassel's AbEx paintings often had titles tied to sexual behavior (e.g., *And When She Came Home He Was Smoking a Pipe*) and they always supplied plenty of abstracted boobs, bottoms, gams, & hair patches; but now this became explicit in a mocking sardonic

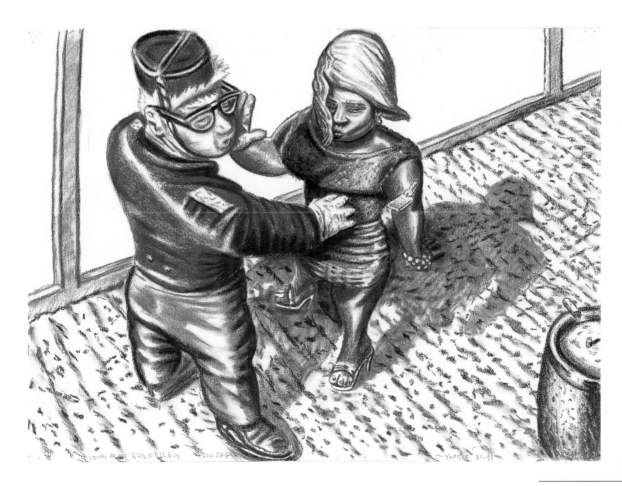

69

Robert Yarber,
Study for *Bad Bell Boy,* 1981–1991

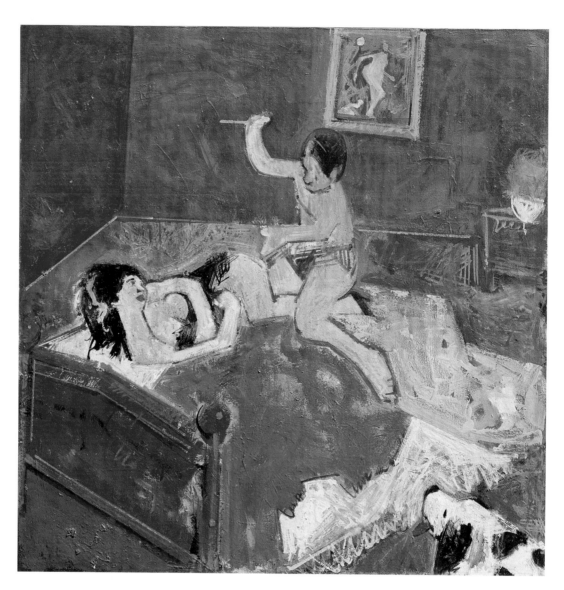

Hassel Smith, *Rape
of Lucretia*, 1963

figuration that stressed the teasing femme fatale role of women who use their charms to manipulate hang-dog men (they are often Hassel: balding, pot-bellied self-caricatures). In all the silliness (but what first-rate silliness it is!!) the men are hapless, more or less at the mercy of the fully sexed, know-ing sirens. This is exactly the case in our *Rape of Lucretia* (1963), Smith's undoubted masterwork in this figurative-comic vein (fig. 70). No one is being raped here. You'll recall from Plutarch the tale of Lucretia, a Roman matron so virtuous & obedient that, raped by a neighbor, she takes her own life to spare her husband embarrassment. Come on! Such

women, if any there be, are not denizens of the world according to Hassel Smith. The attacker here is a green boy uncertain of the situation, which will be controlled, doubt not, by the grown woman in black négligée. This is one of Smith's most beautiful paintings, the space somewhat torqued & tilted in a way that makes us recall the painter's obligatory apprenticeship to Picasso's '30s interiors. Richly inflected color is brushed on with absolute authority: flesh-pink/spirit-blue/blood-passion red/visceral-fecal mauve. We access the spatial coordinates thru the diagonal *repoussoir* of the spaniel, lower-right corner.

Within a handful of years Smith had played himself out on the theme of the natural conflict of the sexes and there ensued for precisely no reason at all Smith's abstract geometric period of hard-edge (but not pristine) canvases. These were never small & never too large & since they do not appear to be supported by preliminary drawings I think he worked out the compositions as he went along. Whatever the case, a feeling of spontaneity is maintained. The more I see of this series, the more significant they come to seem. More than 2 decades of them. And barely known. The reader should guard against the temptation to see them as a response to clean-edge theoretical paintings in New York. In other words, the Smiths have nothing to do with Ellsworth Kelly or the Park Place crowd scamming out the pictorial codes. The new work had everything to do with staying within hailing distance of Diebenkorn's & then Bischoff's returns to abstract painting. That simple. Smith wanted, and got, his own idiom.

High-keyed *Bop City* (1978), is one of the finest paintings in that clean neo-classical idiom (fig. 71). Bright, bent primary & secondary notes spill out of Red Norvo's trumpet, Joe Henderson's sax and carom right left upside down thru the afterhours fog before slipping back & re-uniting on Hassel's memory-canvas. Architectonic magic, jigsaw bliss. Play it back to me Hassel. One more time.

Despite the fact that Smith "influenced," personally, 3 generations of California painters in informal, "pick-up" seminars & whiskey-klatches, his clean-edged (yet obviously hand-worked) geometric paintings attracted no imitators (unless you count Charlie Strong, born to follow). Eventually he abandoned them himself, having used up the paradoxes posed by a brush-worked hard-edge abstraction. The last phase of his art featured a return to a propulsive swept-along brand of sometimes monochromatic AbEx paintings, love-poems from an old man's quiet corner. They enjoy a certain lyrical conviction, but the jury's still out.

Lucretia, on the other hand is still paying dividends, amounting as it does to Bad Painting before

71

Hassel Smith, *Bop City,* 1978

the letter. Fifteen years is damn sure before the letter. Marcia Tucker's 1978 *"Bad" Painting* was a show of idiosyncratic figuration that, due to the indefatigable curator, managed to cover most of the U.S.A., for once. The title was a worthy (for once) provocation. Included from Our Gang were Linhares, J. Brown, Pat Siler, Garabedian, Ed Carrillo, and Albertson. Add Colescott to the list of Bad Painters. He was in an early show at the New Museum, consequently N.Y. critics, those busy dears, sometimes lump Bob in. There are other things to be concerned about in New York, better you should believe.

A number of sources for Albertson's paintings suggest themselves: Children's book illustration, Sunday Supplement fashion illustrations, commix (overground & under) (fig. 72). In other words, just the same sources any average kid would encounter—and in the order specified. Add to these, of course, the Art of the Museums. What about Lucretia? I'll take a guess. Yes. Consider Jim's *Venus & Amor* (1977). Here we know we're in

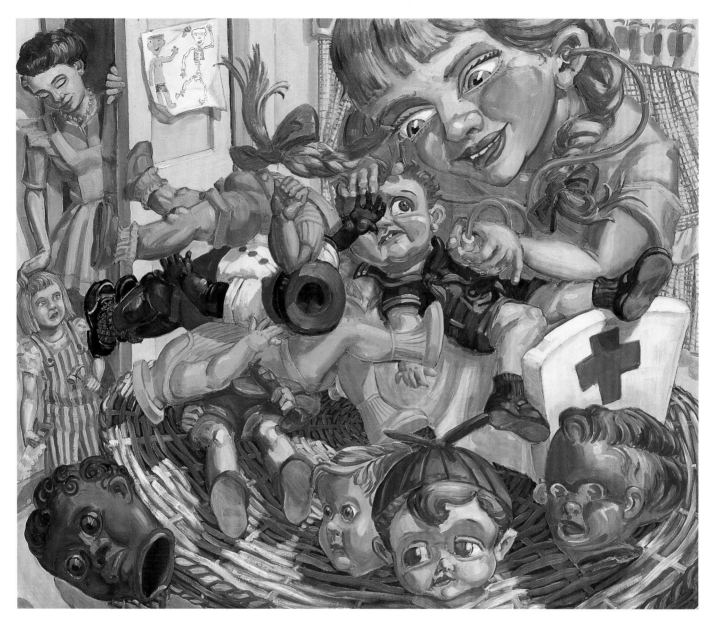

72

James Albertson,
Doll Doctor,
1993–1994

Antiquity (the little temple in background). But the situation's the same in both the Smith & the Albertson: a fledgling youth is in the power of a Woman old (and Wise) enough to be his Mother. Bob Colescott has some nice images along the same score. You tell me, fair reader: Are men really the wimps our artists make them out? I dunno, myself. All's I know's what I read in the comic strips.

"Jane!¿! I possibly could handle one more cheeseburger, if yer still on yer feet¿"

One year *Art in America* arrived at my postbox with a cover story on the Boucher exhibition at the Met. In her essay, Lisa Liebmann occasioned to mention 3 or 4 current painters who have a rococo "edge" to their work. I checked the gas and drove straight to Oakland, where Albertson was "living" on Murder Ave., corner of Robbery Lane. "You're in like kin, Jimmie," said I, showing him the article and my best toldja so smile. Albertson was nodding out. "Nugh, nuh," was all he could get out. Nonetheless, God saved him out that he might

124

make great paintings, for all great paintings honor God, including (especially including) the blasphemous ones—Jim has made a few of those. Nowadays Jim teaches in prisons—which are a good fit for him. Because Jim doesn't draw a line. If you visit his house you will have to step over street people there to pick up their check, because Jim is letting them use his place as a mail drop. Or if you have to call home. . . . For me it's a tickling irony that I've been able to introduce Jim to some of the high mucky-mucks that I've always pal'd around with. I do often think of my school & college chums and their families. Over the years they have filled their houses with the art of my friends, and this they've done . . . I'm not sure why; but their trust in me has been heartening because, as the reader may readily credit, I have the habit, not entirely unique to me, of telling people what they want to hear about me, and if I see they want *drek,* then I give them *drek* and they, because they've had a good look in the mirror, go away satisfied. But my school & college friends have the skinny on me. They were there when we formed our basic selves in interplay with each other. These friends, together with the art friends collected here, have proved the blessing of a life full of luck and advantage. Anyway, numerous classmates have become Type-2 art critics by stepping up to BUY ART. The pattern is always the same: Buddy X informs Spouse X that he has purchased X works of prime California art. Wife takes to bed faster'n you can say Elizabeth Barrett Browning. Her Mother was right. A few months later, the peripeteia . . . Spouse becomes chief connoisseur, initiate, & supporter (of Jim Albertson in especial) and now has to be restrained from art shopping by Husband and Family Doctor.

The above is the God's Truth, so help me, Jane. So that is our excuse for thinking of these longtime friends so much and for introducing them to the reader. When I got home from my recent college reunion trip, Jane asked me to give her a rehash:

"The Reeses? They're fine. JoAnne & Bill had an argument one night over the meaning of the Holy Trinity. . . . Billy Jr. bought a Garabedian. . ."

"From L.A. Louver?"

"No, at auction. . . ."

"And Teresa Bourke?"

"Teresa wasn't there. She's skiing in New Zealand. . . ."

"She fears the Serial Docent Killer?"

"I believe so, yes. . ."

"And Bill [Bourke]?"

"He's OK now . . . was hospitalized again recently for King Midas's Disease . . ."
"Everything Bill touches. . ."

"—turns to gold, yes. . ."

When you develop the kind of feeling we all have for Albertson's work, it's hard to stop at just one (fig. 73). We have maybe 25 oils in our family, in the Rees household, better'n 20; Bourke, around the same. And here comes very dear to us all Roger Hollander, King of Cody; he bought out the last 2 shows Jim had with Joe Chowning in S.F.

The theme of Jim Albertson's *Aristotle and Phyllis* (fig. 74) originated, not in Antiquity but as a Medieval invention. Aristotle's star pupil, Alexander, had been complaining to his young mistress, Phyllis, that his famous teacher was too severe on him.

"Aristotle's allus riding me, woan lighten up, allus ridin' me day & night."

"Let me but be with him for an hour, Alex you great big sweetie, and I promise you, I'LL RIDE HIM!!!"

So Alexander goes behind the tree there or perhaps into the little house—for Jim has set his version in the Midwest, it looks like, growing up in Wisconsin maybe. After an hour Alexander comes out and, yes, Phyllis is riding the famous teacher, using her bra as bit & reins. Alexander/Albertson just flips his copy of Aristotle's *Ethics* onto the ground in disgust. That's Jim, of course, as the young Swede athlete, lotta golden hair, wearing his varsity block letter 'A' —for Aristotle U., rah! rah! 'A' for Albertson as well. That's nowadays—Jim on all fours as Aristotle, still being ridden around by girls. The little girl just coming thru the yard? She's observing, learning how to do it from Phyllis. One day it'll be her turn. It's a

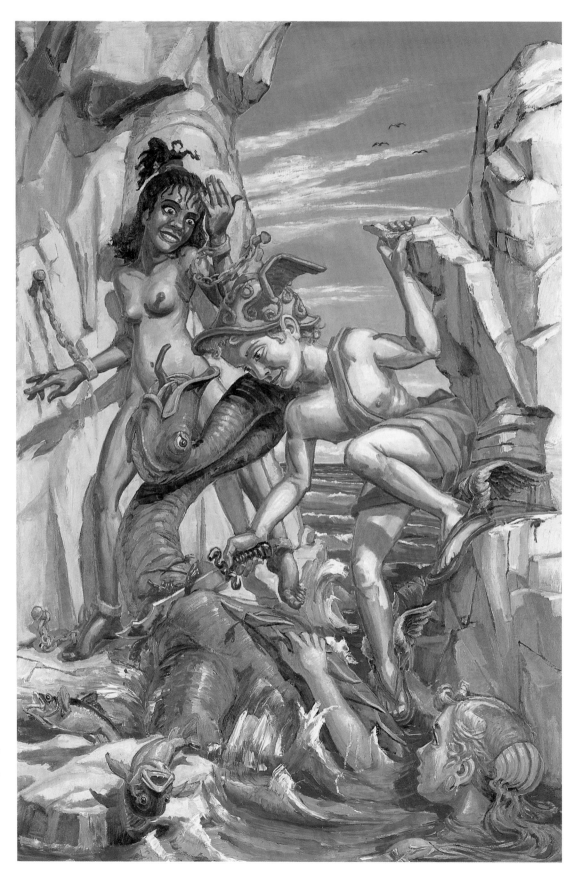

73

James Albertson,
*Perseus and
Andromeda*, 1990

74

James Albertson,
Aristotle and Phyllis,
1989

clever picture, and we've encountered the situation before: the smartest man in the world baffled by sex. In Roger Herman's *Staircase for W.*

What's good about Jim's treatment of this amusing theme is that he involved himself in the predicament; the joke's on him, and all other men, from 'A' to zed. As in every Albertson the handling is expressive over every inch of the painting, transcending mere *illustration du texte.* You can see how the long graceful strokes that describe the bodies are countered by short choppy strokes in the foliage & ground; the contrasting strokes work to define area against area; this is at the very heart of his expression and accounts for its superiority over all comers. Jim is not what we mean when we talk about "a great colorist" but he is great, in fact infallible, at deepening his expression thru color contrasts and he is masterly at allowing color-form to convey energy rather than relying on line.

What deserves he who gave the world so extraordinary a painting? All together now, readers: Give the lad an 'A'!!

Laydeez & Gennumin, you will now witness a death-defying (or at least sensibility defying) segue from an artist some people do not like (he's too scatological, too nasty, ugghh!) to an artist some don't like (because he's too hearts & flowery saccharine, yecchh!). Here goes . . .

◾

. . . Did I make it??????????? I left James Albertson's place beside the railroad tracks in Sacramento, CA, seems like seconds ago, & here I am, yes, here am I in the South of France somewhere, lost, and looking to find a lost chateau & if I get there maybe I can get un-lost long enough to find my way over to Cap d'Antibes and be the 37th visitor this year to bother Joseph Raffael and his Lannis.

◾

75

Joseph Raffael,
Water Painting #3,
ca. 1973

First off tho', a word about Raffael's *Water Painting #3* (1973) (fig. 75): "great."

Or rather: GREAT!!

Take a look at it. Great. If ever a painting less needed TALK ART art-talk. . . . Shall we just declare this painting the winner of the Pilot Hill handicap?[2]

Joseph's paintings shine from within. Ever see in the newspaper a photograph of an ugly bride? Me either. Brides shine from within. Leading us perhaps to Plotinus, his theory of the splendor of the divine. Or to other allied neo-platonic notions of God continuously sustaining this reality of ours thru his Will; by His very Breath giving Life to inherently inert & contingent matter. Too cloudy for you? Well, defending Joseph can be a hop, skip & a jump from cloud to cloud, I admit. Joseph doesn't mention God; he prefers to speak of the *chi,* or life-force flowing thru Nature. OK, Joseph, you are definitely tapping Something. Unlike his friend Bill Allan, Joseph is no naturalist. Raffael's nature has been to Hollywood. His brush glamorizes all it touches. Remember how often art comes down to self-portraiture. A tall, handsome Italian fellow, Raffael wants it all to look like him.

The Aquinas-based discussion of aesthetics well along into *Portrait of the Artist* may sometimes be brought to bear on a painting. This is one of them. Three things are requisite, the Latin says, *integritas:* the work of art must be One Thing, Whole; *consonantia:* there must be a harmony of parts; and *claritas:* the [painting] has to be radiant. It's impressive, if not utterly amazing that Raffael, a Pisces, should be able, first, to sweep into oneness so aqueous a congeries of splashing, burbling, sparkling, rippling bubbly small shapes; it's impressive. And second, to reconcile their natural disorder into pictorial harmony, each shape to each and every single shape to the sum-of-parts All. But yes, shades of Parmenides & Zeno his pal, the Many are One, the One is revealed as Many. And third, and hardest, the damn thing has to glow! Does Raffael bring it off? Does the Body have a Soul, reader? Answer me that.

Le Grand Meaulnes is the only novel of Henri Alain-Fournier killed at 36 in WW I. Either you regard it as a pretty good read, rather slow at times but on the whole worthy—this is probably most readers' estimate (and since you are a reader,

you may try it on for size). Or, if you are Simone de Beauvoir or John Fowles—Pilot Hill Annual People cite his *The Magus* as their book experience that most resonates with what they went through in the Events here—or, if you are Henri Peyre, who had the distinction of teaching me French (and who wrote on a paper of mine that my French was pretty fair, *"Ameliorez-le!"*; advice I failed to heed)—if you are any of those people, then it is the only novel for you. And if you are the present writer, then you pretty much based your art on what the book offered you, which is tantamount to saying the book was the chief basis for your life.

The story is set at a rural village school in the pre-automotive 1890s. The protagonist runs away from school, hitches enough rides that with dozing he has no idea where he may be. And now he's going up an unmarked long *allée,* which culminates in a chateau. Where he is taken for one of the performers—"Here! Get into costume!" Tomorrow is a fête day dedicated to the young boys & girls of the locale. The children rule. They pick the games, participate or not in the sailboat races & other contests. Even they choose the menu (this is France!). That'll be ice cream for me, make it a double. Does he meet the 17-year-old-daughter of the chatelaine? Is it love at first sight? Is this silly, or what? There are no lessons, no homework, no books. It's a happily regressive Arcadia. I loved this book. What does the boy say to Yvonne when they meet? "Tu es belle!" And this is actually a quote from Maeterlinck's *Pélleas et Mélisande!* Exhausted by the weekend, the boy again dozes off and again wakes up lost. Eventually he gets back to school and he spends most of the rest of the book trying to locate the chateau *"de mon étrange aventure."* Eventually the couple meets in Paris & there is a rivalry, a marriage & a child on the way but the infringements & complications of the adult world misdirect matters & responsibilities and mix-ups and misreadings take their toll so that, eventually . . . But why spoil it?

Joe Raffael was not a reader, reader. He will tell you that. He didn't read *Le Grand Meaulnes.* He did see the movie. An "experimental" French avant-garde director. The film is not great but it gives you an idea. When Joseph heard about the Events I was trying to do at the end of my road, he connected my Delta Ledge End house with the lost chateau. He had gotten lost himself a couple of times trying to find the place. Next thing I knew he had produced two collages, based on Peter Hujar photos of paintings he (Joe) had made back in 1957 on the Alain-Fournier film/book. They are very simple. In each collage Joseph placed the bottom photo face down and above it the gray/black rectangle of the photograph as you'd normally look at it. So two same-size rectangles, one above the other; in both cases the gray/black above the buff. Classy? Indeed they are. We don't go in for that New York classy stuff, but in Joseph's case an exception will be made.

■

I just picked up this little porcelain *Bob as a Shotglass* and I'm wondering if it'll break should I drop it—which I've no intention of doing. Ooooops!

Merely kidding, reader. That's what Arneson did when he handed it to me, he faked dropping it. Somehow I knew he was going to try some jest or other, so I didn't react.

"Quit clowning, Bob," I said. "Thass like dropping your own name."

He gave me a look.

"What if I tole you, Hey, Bob! Guess who I had lunch with lass week? John Fitz Gibbon!" This was too many for Arneson. We went on to something else.

Bob Arneson was a wonderful man. He took a measured stand against the wrongs of our era, and he expected the same commitment from you. Initially, I think, Jeanette helped him form a social conscience, but once he got well started his art deepened & grew steadily despite grave personal & medical trauma. In many ways he exemplified what I'm always saying about a major content of Art being Friendship. He told me one time that he was going to make me an urn for my ashes, but he ran out of time, I guess, or maybe I didn't ■

make the cut. Our Roy-pot here (fig. 76) is a good likeness of his friend & colleague. A puppy crawls out of De Forest's locks while Roy's Queensland Blue Heeler, who's run ahead a ways, turns his head back looking for Roy & snuffling thru his nose hah hah hah c'mon Roy hah hah hah. The Alice Street House signaled Bob's acceptance of the role of average American. As such his views would carry more weight. To the end he warned against egghead intellectuals. What'd I learn from Bob beside stuff like he could handle porcelain like Boehm if it came to that? Well, Jeanette used to offer early Sunday supper to sundry comers. You ate off Bob Bowls and when I came to the bottom of my goulash, I looked & it said: "Chew wif yer mouf Close."

"I bin Trine."

130

TEACHING TOM

Tom Rippon you lived above
The garage at Alice Street
As baby-sitter monoparent
Choice of Robert Arneson
Your personal fam'ly circumstance;
The Father it was, if I have it right
Told you Love it or leave same.
Do-nothing teenager, without
College grades or plans O thrice
Fallible America, How many Fathers
Walk blind in thee? Plenty, that's how

Tom Rippon you moved T B Nineward
Breaking loft-living record
Previously held by L O Pompili

(Thus saith learned gallery dealer
Johnny N). You had genes, Tom
Instead of credentials. What a
Mockery you made of the re-
Quirements world! How many credits
Did Auntie Ruth Rippon's genes
Add to. How many units of faith
Came your way from Bob. How many
Units of unqualified Love?

Your story shall be better known,
Tom Rippon. Of all the Arneson
Followers you did the least
Following. Instead you turned to
Of all people Jim Nutt for formal
Cues to go on. How ingenious your
Never-repeated inventions for nose
Ear & throat, for chin and eye and
Hand. Yes, and you made Porcelain
Your own. Jim Nutt in Porcelain!
Dig me Dresden, Thing-a-ma-Bob!

Now you ride the wide *ur*-trails of
Missoula, Sacred in the annals of Clay
America. I should pretty well think
Bob Arneson's proud, Tom Rippon Tom Rippon.
Tom Rippon, Tom Rippon, I should think he is
Proud.
(fig. 77)

Roy De Forest is a *sui generis* painter who yet
has roots in the North European tradition of
Expressionism that developed out of Matisse
(fig. 78). I bring up the name Heinrich Campen-
donk in my 1990 monograph (in which both
Roy's works in the present exhibition are dis-
cussed). Roy has written his own chapter in the
book of NorCal surrealism. Roy doesn't try, like
Miro, to return all the way to the tadpole draw-
ings of late infancy; judging from his work I
would estimate Roy's chronological age some-
what in the range 8–10 yrs. In other words he is
about a year or two younger than his next door
neighbor Clayton G. Bailey, Esq. Squire Bailey &

Squire De Forest are the only residents of the
winding road that leads from Crockett, CA, to Port
Costa, CA, in an area that is county-zoned for
Humor. These neighbors' relationship has been
marked by amity, altho' I recall a ticklish moment
when Bailey had those 17 ca. 1947 Studebakers
parked in their mutual driveway. For a time I was-
n't sure which way it'd go. All is comity & sweet
peace nowadays. Squire De Forest sez: "They
broke the mold when they made Clayton!"
Whereas Bailey, a noted jewel thief (& wanted for
docent harassment in the St. Louis region) told
interviewers recently: "Prove it! I'm not grassing on
me pal Roy." As the cops led Bailey to the Super-
copter he shouted something at Betty. Channel 3
reported it as "Build Kills for J-birds' Ponces!"
Channel 5 had "Good fences make Neighbors
senseless." And Channel 12: "Docent consensus
bills kiln labors." "Defense waivers *Bild und Dichter*"
is what the German interviewer got. I heard some-
thing different still, but why add to the confusion?

Besides a reader wishes to know . . . two
things? OK. How high do I rank De Forest as a
painter? And second, Who's playing Number-
One Son down New Mexico way? Why that'd be
Terry Allen, reader my reader. As to your 1st
question, just fill in the blank below, and I'll sign
it. OK?

IN MY OPINION, ROY DE FOREST IS BETTER THAN

_____ _____,

(THE NOTED NEW YORK ART STAR)

(signature)

78

Roy De Forest,
*Events in the Rabbit
Quarter,* 1977

■ PORTRAITS ARE EVERY BIT AS SIGNIFICANT as they were in the many centuries when they ranked just below History painting and just above Landscape, Still Life & Genre painting in the hierarchical scheme of the history of art. This is not at all because of the worth or dignity of the sitters. It is due to the fact that no 2 human beings are precisely alike. Does a good portrait affirm the crucial difference between all human beings? Or does it affirm the crucial sameness in all mankind? Sameness? Difference? Had there been a portrait tradi-

tion in medieval times, there needn't have been any debate over the question *universalia in relre in universalia.* Each fellow human is a rich repository of experience. Each great portrait extends our knowledge of humanity. Just because we now have quasi-scientific ways (mostly with a camera), of recording what someone looks like does not mean that portraits are obsolescent. I dare say that people will continue to be interested in other People for quite some time. Just a little while back there was a very large show of powerful N.Y. (and

some California) contemporary art from the collection of a powerful couple whose money came if I don't mistake from a pizza chain. It was held in a powerful museum that hopes to receive the art as a gift. Guess what? No portraits of Champ & Miaow (not actually their real names). Jane & I agreed that the powerful collection was weak. It looked like powerful stamp collecting to us. Jus' fillin' in the philatelic squares.

A lot of pretty good artists have wanted to paint me, if you can believe this. I always played impossible to get 'til Philip Pearlstein said one evening: "John, what about a portrait?" Then I thought: 10, 9, 8, 7, 6, 5, do I want to look like dead horsemeat? 4, 3, I just remembered how Philip painted his 2 attractive daughters (they shoulda sued for child

abuse), 2, then I recalled a couple of his portraits of artworld figures (guilty-lookin' if yer lucky; death warmed over if not),1, ZERO! I'll do it.

The painting that Philip realized made me look younger and better than I actually appeared (fig. 79). Not only that, the mask I brought him for lagniappe he, so to speak, gave back to me. What happened? Well, I tried to charm Philip, and I guess I succeeded but I'm not sure because I was charmed outta my Irish brogans the whole time. I conclude that Charm is not a one-way street.

In Pearlstein's world of 9-to-5 workaday paintings the moral nullity and soulless funk of an America out of touch with its own values & best hopes are relentlessly exposed. In his paintings of nudes in an entryway or antechamber of Hell,

Pearlstein again pulls out all the stops (is that the right simile for his work? Like a Bach organ concerto?). The shadows and the play of artificial spotlights—they are the most "alive" elements in the paintings; the nude models—often cut off in midface!—are the deadest. Humanizing use of pets? Are you kidding? These paintings are about a society so moribund, so passive, so afflicted with anomie that it is beyond salvation. A painting must have a little libido stirring in order to come off at all; the nudes are terminally unappetitive, so Philip vests all the sexiness in phallic/vaginal interplay among the artifacts & accessories. Not even Andy Warhol has portrayed with more finality an America that's dead & doesn't realize it.

I asked Philip (Andy's schoolmate back in Pittsburgh—they came east to tackle the Big Apple together) could his friend & mentee really draw? "Andy was the best draftsman in our class," said the winner of the National Scholastic 1st Prize. Well, Philip's always been modest . . . but! So the erstwhile roommates deliver the same message, Warhol by making trashy slipshod "portraits" of, ferChrissakes, *Liz,* which completely undercut the subject (perhaps Andy's masterwork along these lines is his *Leo Castelli*); and Philip Pearlstein by conferring ultimate Quality on a dramatis personae not merely incapable of acting but already sunk in a lassitude of Melvillean proportions.

What makes paintings still significant in an Age of Mechanical Reproduction is that the information even so practiced an observer as Pearlstein can provide is not the same information we would garner (to use Walter Benjamin's phrase) according to the model on which the exact natural sciences are based. The scientific model is not the only way experience can be construed. Experiences (still with Benjamin here) are "lived similarities." There is such a thing as "romantic observation" and (highly applicable to Pearlstein) "observation is based on self-immersion." Artist and object are interpenetrating, and the painter redelivers what he's taken into himself richer, more transcendent, and clothed in manna. A Pearlstein sort of fits over the exact paradigmatic scientific version like a visible Platonic cloak. Both are correct but the painting gives back "more" than the experimental result. That "more" is all important to the defense of Art, which has ever a metaphysical intuitional dimension. The reader who has packed along with me in prior publications knows the stress I place on the artist as gambler. Benjamin maintains that "the character type that learns by experience is the exact opposite of the gambler as type."

A reader now e-mails: What do I think of Bill Allan's designation—the one that Scott Shields so fancies—that the artist is a free-range chicken? What do I think of the facinorous William Allan, reader? I think he'll do well to keep his beak and comb a good free-range away from my pet weasel & his pal the Pilot Hill stoat. That's my thought for the day. Free-range, indeed.

Back now to a consideration of Pearlstein's portraiture. Imagine yourself in Philip's situation, reader. You're too busy to visit Pilot Hill or anywhere else, practically. All day all week all month all year you're in the studio piling up your legacy churning out these quite amazing *Nudes in Interior* one after another, like R. D. adding one Ocean Park to the one before. You're doing all this and part of your program is you've proscribed yourself from any psychologizing of the models' interiority. These are people with nothing going on inside them. They are like objects. They are cyphers merely. They're nude, the viewer should be able to pick up their Truth, or at least some of it. But no—you've forbidden yourself from prying. You don't even politely inquire.

Now however the day is over, the models have packed up and gone, and in comes your portrait sitter for the evening. And now you are not merely the supertalented observer from a distance. Now you are permitted to go on the inside, and you do, Philip, you do, with all your will & intelligence & insight & *Einfuhlung* & your imagination, all these qualities being more exemplary in you, Philip Pearlstein, than in other men. You bring a lot to the easel, Philip, my friend. Linda F. G. is a pretty tough

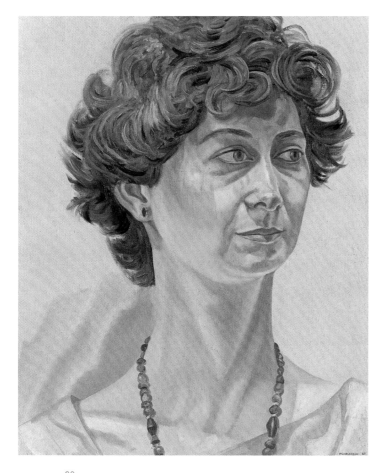

80

Philip Pearlstein,

Linda Fitz Gibbon,

1985

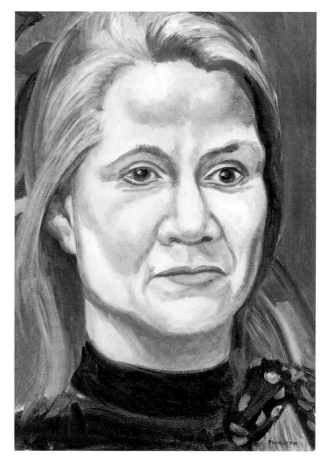

81

Philip Pearlstein,

Pinkerton F. G. Flad,

1988

picture, even for a Pearlstein (fig. 80). The sitter, a pretty enough girl in her mid-20s, was notably coy & ingratiating, + very capable of capitalizing on her petite qualities. Pearlstein renders a woman "Who could very well pass for forty-three/In the dusk with the light behind her." Because he elongates the neck, Linda seems to loom out of the picture space. That slight elongation and the averted glance Mannerize the painting. Everything here spells trouble.

A sparkling vivacious sexy strawberry blonde, Pinky (F. G. Flad) knows where she stands & doesn't hesitate to let the world know it too (fig. 81). Pinky skipped college in favor of reading. She

has her dad's eyes and during adolescence she addressed that person as if his first name were "SHUT UP!!" It surprised me a little that my mother did not rise from her grave on getting the news that her favorite grandchild was about to marry into a great American family; but perhaps it's just as well because she would in all certainty have erected for herself some largely invented eminence from which to sneer at the Beechers. Pinky liked Philip Pearlstein quite a bit. "Dad, he made me look ugly, he made me look old, but at least he didn't make me look like a BITCH!!"

The Hon. Kate Fitz Gibbon I promised the reader never to boast of more (fig. 82). I'll just say ■

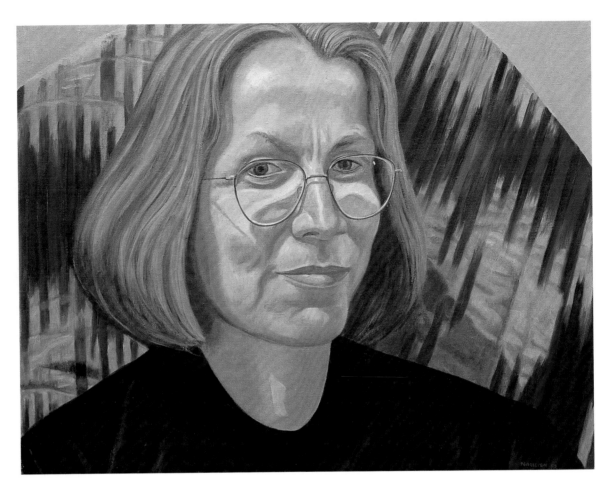

that the Hon. in her goes all the way down. Both my girls are big fans of Nancy Mitford. So you may imagine what it means to Kate to be an Hon. at last. She received her share of Jane's looks and Philip Pearlstein pretty well captures Kate's dedication and her commitment to bettering the situation in Central Asia where she went to live and learn after she dropped out of Cal.

The *grande dame* portrait of Mrs. Florence Beecher will not travel beyond the Butler. Pearlstein loosened his brushwork for the occasion of this donor portrait. Wet areas of pure color slide under, around, & over each other in virtuoso wavelets. Philip abandons here his practice of pinning every stitch down. It may be that the nonagenarian subject's failing eyesight was taken into account.

We're fortunate to have portraits of this caliber to accompany the collection. It'l probably scratch your curiosity in that itchy spot to get a gander at our mugs. Everyone in the family is pleased that Philip Pearlstein didn't turn me into the next stage before dogfood; everyone that is, except Getty the dachshund; Getty has reservations. Getty's opinion, for the record is: Arrf arrf arrf arrf arrf arrfff arf arf aarrff. And he adds: grrragh grarararaffgh. (Now that's art criticism for you!)

◼

In the history of art I guess you have to go pretty far afield to find more talented first-cousins than Leo Valledor and Carlos Villa. I tried, and I couldn't come up with such a tag-team. Italy is far afield and so is the 16th century. But the Carracci don't count. I'd always remembered that Ludovico

Carraci was Agostino and Annibale Carracci's *cugino* but no, he's their uncle. I checked. They were all, no Bologna, born within a few years, how the confusion. Leo was barely older than Carl, but he was the mentor, teaching what he was preaching in his own bodacious Tobeyesque field paintings—dark they were, and not too large (I have one here with the cheap housepaint falling off it). Dark & relatively small because AbEx painting in New York was mostly known out here thru black-and-white repros not much bigger than a postage stamp; you could read the values in such artrag illustrations but nothing of the color.

The energy of the young Carlos Villa was so dynamic that he triumphed, for a time anyway, over every obstacle: his youth, the poverty that had been his lot, his living outside the N.Y. World Art Capital, and, what would eventually loom over his later life, his outsider status of another color, namely that he is Filipino. Meantime Villa, studying with such as Bill Morehouse & Frank Lobdell, was taking on the coloration of a classic SFAI Abstract Expressionist, that color so often being Yellow, as in the case of the huge 1963 painting here (fig. 83), that it's conceivable that Villa is already signaling his interest, later to become absorption, in his Asian identity. A dull scabrous field of mustard is windowed by clumsy chunks of red & blue (edged with silver to keep these Kiklopean bursts of primaries tied to the plane). Here and there crude black-paint drawing offers a suggestion of depth or an intimation of body parts. It's a grand painting by an artist who understands the heroic ethos of Action Painting, an artist who is young, fresh, with nothing at stake, nothing to lose, and is throwing everything he's got in there. Doubts, which are the portion of every man, doubts about failed relationships, heart-gnawing doubts, doubts about America herself, as a place that offers the same entitlements to all who run & read, these doubts are not present in the 1963 painting. They dominate the entire untitled 1978 canvas where, as in the case of Roger's *Staircase for W.,* a beautiful lyrical

83

Carlos Villa, *Abstract*
(detail), 1963

love-poem has been covered up by ashen blacks and surface-holding chic depthless silver. A self-portrait in fashionable despair, with only a whisper now and again of the robin's-egg blue & crimson lipsticky wisteria and bougainvillea original life of the canvas. Often if an artist gives me a painting, as in the present instance, the painting will be a message about how burnt out he or she is. Because they think, He understands; I want him to know de trubble I seen, to be aware of my anguish. Well, don't give me that painting, Carlos. I already know how burnt out you are. Whaddya think I am!¿!¿

You hear, reader¿ Don't send me your painting about the black death of the soul. Send that painting to Jack Stuppin, the guy who does those scrumptious dessert-tray high-calorie fairy-tale landscapes *si charmants*. This guy doesn't have an anxiety in his head. He needs to get the bad news. Me, I alreddy got.

The bad news began to collect on the cousins after a while. Villa was bounced off New York in a couple of sojourns. Worse, the work didn't stick. He made nothing there but friends, which he had in practically unimaginable plentitude. He always had a job on the Westcoast, plus another army of friends. If Carlos had chosen, say, to invade Chicago in a pincers movement, he could have declared his Kingdom there & reigned forever and a day.

From the time Carlos realized that he'd have to take responsibility for the direction of his work, that he was no longer a kid (and a cute kid too), he began to wince at the restrictions posed by (even large) easel painting convention. He wiggled a little, offering unstretched canvases for a time. These were decorated in spiraling "slinky" ringlets, and were fetishized with chicken bones, feathers, blood, semen, hair, and other ritual objects that might work a spell. After a time these patterned canvases folded over [the artist's] body like a cloak; wearable art, in other words, in direct touch with the artist's heritage. I liked better a next step that featured stick figures dowelled out from the

canvas to make love as they hovered bird-like in air. This maneuver deconstructed lyrical abstraction into sites for sexual play; love-poems then where the lovers emerge to merge. The next time Villa left the canvas to enter the real world in front of it, the content was political—altho' sex was still a major issue. Carlos started doing installation/performance art with the aid of documentary photos, old newspaper accounts, memorabilia, ritual foods & substances + nude bodies (his).

He had begun to base his life and his art on political goals, his principal endeavor being to create consciousness about how Filipinos were oppressed & exploited as soon as they were brought to this country after the Spanish-American War. I was sobered by the seriousness of his approach. Villa had gone so far as to bring in elders from the community to tell their story of an America that doesn't know how. Not only were Filipinos brought over on an indentured-menial basis, there was a little codicil: their women & families stayed in the Islands. So the men were stranded here without access to women. A nice civics lesson, this. Whenever you ask yourself—or ask Mrs. Reader, How could the country of Beethoven have pursued a policy of *Judenrein¿*—start looking for your answers at home in California, where "enemy" Asians were put in camps & long before that "Ally" Asians were treated without Humanity, Theirs.

What happened to Leo Valledor¿ Had better New York luck than his cousin. Joined the prestigious Park Place group of abstract artists. Leo's large exaggeratedly "shaped" canvases (figs. 84, 85), clean-edged now and painted with every scruple, had a mild but authentic influence on the circle of Frank Stella. In the end, money woes and the pull of California brought Leo back to the Bay Area, where he eked out the bare necessities with a 1-class teaching gig here, another class over there, and odd jobs. That's an ironic locution when you think about it. Odd locution. . . . By the middle '80s life had become burdened by inertia and despair. There were a couple of gallery shows,

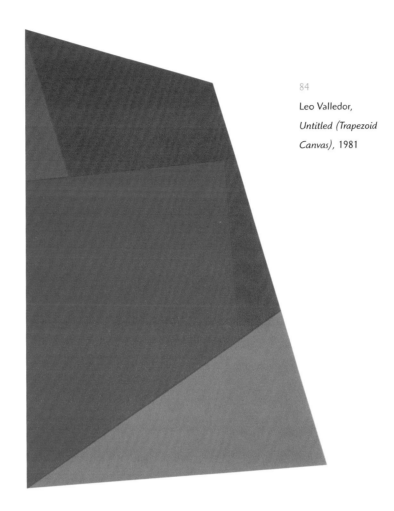

84

Leo Valledor,
*Untitled (Trapezoid
Canvas)*, 1981

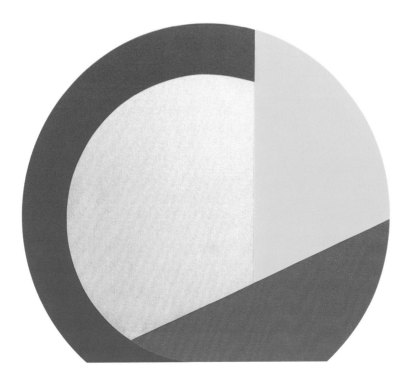

85

Leo Valledor,
*Untitled (Round
Canvas)*, ca. 1987

without pecuniary result. A pair of rich ladies had underbudgeted & went under with Leo's show. A final exhibition was upstaged by that major quake. A friend with a pickup helped him return the paintings to the studio, one sunny day. Took 3 trips, checking the sky. When matters got really tight, I would go to a friend or relative who had the money. Buy one of these. They are worthy. The friend would look at me as if I were asking instead of doing him a favor. You try explaining hard-edge painting to . . . to anybody! This got old for everyone involved. Five hundred 1980-dollars became the sum of money. That was for rent per month in the city-controlled artist loft building where Leo lived his Spartan existence. Better than the Spartans, actually. They didn't have an electric hot plate.

The reader probably knows better than I you can't rouse someone who's made a full commitment to Despair. No progress for this pilgrim, that was my final diagnosis. I was down, anyway to bartenders, nurses, casual acquaintances, ex-students ("Hey! Glad to run intya . . . I was yer favrit teacher. . . .").

It was depressing. I would look meaningfully at Valledor's saxophone. No way! No way he was going to hock that horn, the veteran of so many transcendent after-hours at the North Beach clubs successive to Bop City. The key to Valledor's play of colors in his pristine map of the human experience, purified of all that is contingent & can drag you down, is a word that, as Tom Albright was wont to remind us, was derived from a euphemism for sex. That word is jazz. Leo's art looked back not to Picasso, Matisse, or Duchamp, but to the Utopian project of neo-plasticism led, nay Embodied, by Piet Mondrian. We have small Valledors here in which the sun, author of our bodily & spiritual Being, is paid homage worthy of Egypt. . . . *North* Broadway Boogie-Woogie you could in justice call them. More than Leo Valledor, no one could exult (try this at home) over the fact that by the expedient of cutting off 3 corners of a lateral

rectangle, he would realize an unending series of 7-sided polygons: enough to fuel the rest of his kind of painter's working years.

Yet no one wished for these paintings on his or her walls. "I'm saving up to buy a Leo Valledor." This I never heard. Only 7–8 years before his untimely death in his loft, across the Boulevard from a hospital, this cherubic man (Did he wonder: Am I the Asian in the window?) was included in Henry Hopkins's *50 West Coast Artists*. You'll find him there, between Thiebaud and Voulkos. "It is the sparkle of my spirit," said Leo of his exquisite Albers-like Spring lyric, harmoniously compounded of Nature Sunlight & Spirit (green, yellow-gold, and very pale green-blue). A few years later the spark was out, the Spirit fled. An influenza evidently turned to Pneumonia. Leo too sick, too weak, too proud to cross the street. The Spartans, my readers, had comprehensive medical coverage.

One day not too long before the end I suggested to him, "Drive me back to Pilot Hill, Leo. You can tell me more stories about you and Carlos."

"How will I get back?" he wanted to know.

"You can have this truck," I said. "A gift, not a trade. Whaddya say?"

Generously I was offering Leo our utility pickup, sits around Pilot Hill waiting for a firewood run. Hunnerd'n six thousand miles . . . these damn Japanese trucks run forever. "You got to admit the price is right," said I continuing my pitch.

"Not that I wouldn't take it," said Leo, "but I can't afford it."

"You need a truck, Leo. What if that junior college job in Marin comes thru?"

"They filled it. Anyway, man, thanks for the truck but I can't afford it. Can't afford to register it. Can't afford to get insurance. Don't have any gas money to put in, and out there (he pointed at the lot) they want $30 a month in advance to park, no security, nothing."

"You're a pain in the ass, Leo. I'll walk over to work with you." Valledor worked 3 days a week,

all he could take, at a Winchell's Donut Shop, 3 blocks away. Imagine the pleasure this thoughtful 53-year-old man took, dear reader, in his Winchell's outfit, the striped apron over his white shirt with little black bow tie. Imagine, America, how this artist who reveled in the magic of geometry must have relished the little Winchell's cap he got to wear, and the bag of unsold donuts that got to go home with him. "You otta work more days, Leo," I would say. "And eat some vegetables."

Carlos Villa used to call me maybe once a week. I learned so much from him about art and heart. Those conversations would often amount to little more than wordplay, counter punching and puncturing the other guy's pun. Parm me, son? Pass the parmesan? (groan) Wm. T. Wiley is not the only artist who uses the humble pun as a way of indicating the Imagination is in gear. Most everybody out here is a practitioner of the ignoble art. So Carl & I would have these lickety-split conversations about nothing in particular and hang up refreshed & poised to look in our work-basket. I miss talking to Carlos and I would make a large bet that others feel the same. My number (note the changed area code) is 530-885-9294. "Aw yiu theah?"

Jim Melchert first introduced me to Carlos—they shared a studio in Berkeley. And Jim helped me to meet any number of the friends gathered here. First, tho', I had to meet Jim, and it wasn't that auspicious. Not long after he came out from New York (& immediately fell into lasting friendship with me), Peter Selz was spending some Berkeley Art Museum entertainment budget funds on throwing a huge party to welcome a visiting fireman, Eduardo Paolozzi I think it was, at Selz's Berkeley home. I got cosmically ancestrally drunk and was just standing there in the foyer when a very big fellow came up & hovered over me. "You're John Fitz Gibbon, are you?"

I should've said, "Yer in my space, amigo," but I was too drunk to talk, and I nodded I was.

"Well, I've heard you on the radio."

I shoulda said, "You & 20,000 other people with unimpaired reception," but I kept silent.

"I can see," he went on, "that you are an exceptionally smart chap—"

Here I was honor bound to interrupt with "Don't try & curry favor with the critics," but my tongue wouldn't un-blur.

"—but you talked about a piece of mine that's in the SFMOMA show you reviewed last week—"

I had been sarcastic all right at the expense of one of Melchert's hybrid metal/wood/clay constructions (fig. 86).

"—and I don't think you know a single thing about my art. So what I'm going to do is—"

Now at this point self-respect required me to at least say something like, "Well, hybridize this!" & punch him in the stomach but, catatonic, I could say nothing.

"—I'm going to invite you to my house on Sunday where we can look at some things & get to know one another, if you like."

By that time Jane had come up to my rescue or to pick up the pieces & she said, "Sure, what time, what address?"

Sunday we went over there and Mary Ann had baked & Jim had his say and I listened. Jane sez this could happen the more readily because we'd gone thru a similar education program.

So I say, "Jane, Jim is really very calculating!"

"And you're not, I spoze??" Anyway I like to admit when I learn from somebody. I learned from Melchert.

About Jim's work I've already had some say—in the hard to find *California A–Z,* also known as the Pilot Hill Bible (the Greek word *biblios* simply means book). The same is true of many others in this compendium—I've written my piece within the sacrosanct covers of *A–Z,* and the dedicated reader will necessarily await its soon republication—or my name isn't Stephen J. Kaltenbach (an improbable name I just made up). We'll see, readers, we'll see. All along our path together here readers have urged: "Give us some *A–Z!*" and I think I will oblige right now, with Frank Owen. My reasons? *(a)* I'm weakening, *(b)* the Owen painting is the same in both exhibitions, and *(c)* Frank will understand:

Frank Owen's paintings are big, complex, and demanding. They will not make peace with the viewer with a single look. Even after 10 considered sessions of looking an Owen won't yield up fully. You have to be around an Owen for a long time. A signal of aesthetic quality, no? I tried once to describe how Frank does it:

In the early '70s, Frank began opening the painting to illusionistic space, and color got pulled out like taffy until it became line-colored line—and started drawing with itself, exploring new space. This sense of line, once it got going, turned out to be plenty versatile and continues to this day to have a true signature character as well as providing the best contemporary update of Surrealist automatic drawing. It initiates itself anywhere; caroms; wheels around on itself; stutters in tight sinewy curves, which rarely glide into smooth arabesques, knits itself up into patches, brakes and accelerates, continually threads over old tracks; burrows under color and resurfaces; squeezes itself into a

ball and unravels; jams into a corner, only to rebound; drops in a plumb; coughs to life; flattens out tangent to an arc; impacts with a blob of red-orange; emerges as a vector, hell-bent for the edge; solos around an elastic form; bops and snakes its way past a guardian interior rectangle; hardens again; and from a casual trajectory, falls spent and dribbling into a violet pond.[3]

In our painting (fig. 87) Frank has withdrawn color; or rather he has made its role subtler, forcing us to *think* the painting more than, at first, we feel it. As we think the painting we come to realize that one of the many things it's *about* is friendship. That's Peter Saul down there in the center there! Hello, Peter! See Frank, in the middle distance? Saying: Hello, Peter! And Bruce! Hi! In the corner!

This friendship rebounds to me as well, and I have gone into it a bit in a long essay on Frank's work, only part of which (excerpted above) has been published. The piece ranged widely, wildly in my effort to keep up with Frank. At one point I tried to apply some of Benoit Mandelbrot's ideas about the fractal geometry of nature:

Much more than the question of Beauty connects Frank Owen's work to the study of fractals. In his book Mandelbrot points out that enormous effort has gone into the study of circles and waves, forms central to Owen's art. "The studies of circles and waves . . . form the very foundation of science. In comparison, 'wiggles' have been left almost totally untouched." Those "wiggles," comparable to the brisk jagged irregular jazzy rhythms that are Owen's standby, are the primary subject of fractal analysis of Nature. Put another way, fractals provide a sort of Natural Geometry of "wiggles." It should be said that there is a neutrality to the various forms of the fractal concepts of dimension, measure, and curve: they serve Escher as courteously as they do an Owen and they are equally obliging to the person who simply (what price Duchamp's 3 Standard Stoppages?) wants to measure the coastline between Big Sur and Ft. Bragg. The focus in Frank Owen's work on the step-by-step use of tools and templates is certainly consonant with

Mandelbrot's stress on algorithms that include a loop where he makes the point "that a very complex artifact can be made with a very simple tool (think of it as a sculptor's chisel), as long as the tool can be applied repeatedly." He goes on to say that the tool is a function from which further functions are generated, so that "one does not here deal with an operation that is performed once, then stops when completed, but with an operation that is performed then repeated, etc." This notion of iterated functions as "examples of treadmills or loops, each turn of which can deal with a fresh task" comes very, very close to Owen's own creative style. It answers the question, What is fresh, innovative, and important about these paintings?

A nice paradox is that Owen's rage to cover absolutely everything can often be expressed mathematically in short, sweet terms. Science, in the dictum of the physicist Steven Weinberg, is the search for the few simple principles that govern everything. This is a salient point for an art so epistemologically concerned as Owen's. For Owen, fractals, Mandelbrot sets, and mathematical topology generally can be quite illuminating, just as they can for Pollock, for certain periods of Hassel Smith, for very early and very late Kandinsky, for the Synchromists, for the Delaunays, for certain paintings by Signac, for a Central Asian ikat, for a Chaco Canyon bowl, for a Minoan octopus jar, etc., k.t.l. The study of fractals was in disrepute throughout most of this century. Mandelbrot brought it back. And thanks to the concomitant rise of computer graphics, fractals literally caught the eye of the scientific community and whoever else was staying open, looking. Stated mathematically, they seemed a little beside the point, somewhat useless; when they were "imaged" they turned out to be beautiful. Above all, computer graphics now gives us a window into fractals so that we can image dimensionalities which skirt around in the realms between line —a single dimension—and geometry—2 D, i.e., and between the flatness of 2-D figures and the solid world of 3-D objects. Frank Owen has always had a yen for 4-D reality and his paintings go as far as anyone's in the 100-year trek

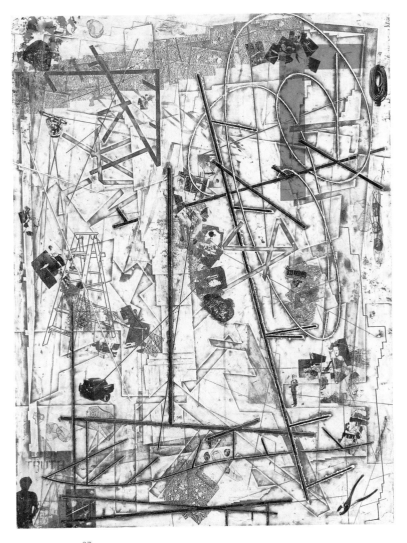

87

Frank Owen,
Untitled,
1988–1989

toward that dearly hankered-for mirage. In a typical Owen the sequence goes line-into-plane, the planes spin and form, perhaps, a drum, and like a chocolate grinder, the drum starts rotating and 1, 2, 3, 4, Frank has all the dimensions.[4]

It makes it easy on me that so little has appeared in print on Frank Owen. It must be a little hard on him, though, and it does make me wonder. In the profession he is known as an artist's artist. The hoopla hasn't followed him around, the curators and critics aren't holding hands and recording his moves. But the other strong painters have always been aware of what he's up to, collected his work in some cases, kept him ever in mind. A little hoopla at this stage might be nice. All the artists know how good Frank's work is. The sharpest collectors know how good. Certainly, I know how. And now you know.

The catalogue's written, let's have the retrospective![5]

■

Nice, huh? Well, the Crocker has *Certain Explanations* (1984), an even more fascinating Owen in the same vein, but as I say, plan to spend some time with it. And to encourage you to spend extra time here's a couple more paragraphs from that same unpublished piece on Frank:

Like Pollock and like Owen's tocayo, Stella, Owen doesn't depend on particularly appetitive color resources. Color always remains experiential, however. And heavily graded, down-keyed, dirtied secondaries and tertiaries are employed to convincing effect. The experience bodied-forth by the slow systole and diastole of Owen's color orchestration is just that—body experience, the dim consciousness we have of our innards, liver, kidneys, heart, lungs and colon. His color breathes rhythmically, but it transpires from the lungs, not the head. These paintings from the gut, so to speak, often come to be dominated by a single hue; a dull, sulphurous ocher, perhaps, or a molten, smoldering red-orange, the color of heartburn.

In paintings of the mid-'80s the disassociation of color and line pits an angry, strident, sweeping red against an hallucinatory urban hellscape of collapsing towers and falling fragmentary geometries. A lot of contemporary paintings are about hell, as many as in the Quattrocento, and a lot deal with a holocaust possibly to come. The drawings of Robert Arneson on this subject come graphically to mind. Like his friend, Frank Owen, Bob once lost a deal of work to a house-fire and had to start over. Owen's holocaustal paintings drove him from the city to the beautiful valley in upstate New York where he now lives and paints. In the most recent paintings I've seen quite new notes of Hudson-y color and harmony are sounded—a broken line may signify rabbit tracks in the snow, and the role of the geometries that structure the painting are given to the pattern made by standing, leaning and fallen maples, birches and spruce, rather than to burning beams and melting floors.

If color is used by Owen as a stand-in for bodily processes, line is the vehicle for mental operations. And we have seen that vehicle can travel, both forward and backward, in Time. Owen's concentration on mind-eye-hand interactions connects all the way to virtually the first images painted in the caves; the outlines of hands sprayed on the wall with a blowreed. And Owen's line can accelerate outward in Space because the mind is somehow "out-there" and can and does take flight toward the planets, the stars, and all the proliferating comets of the imagination. And if mind is cosmic, it also functions microcosmically and can picture in Owen's ramifying vivid filaments, like the neuro-transmission sites at the ends of ganglia feelers, the movement of neurons in the brain. Paintings like Ranger *(1986),* Hammersaw *(1983), or the Pollock-like* Gradient *(1988), resonate with what we know, and are concerned deeply with how we know, as well as why we know anything about the first two.[6]*

I first met Frank thru the agency of Jack Ogden, a pretty hard-knocking painter as Westcoast painters go—but one who's made little effort,

beyond a visiting sojourn at Madison, to move his art East of Reno. Jack has been overly cautious, played it fairly close to the vest. This painter, it is said, wore a tie to school every day the first year he taught at Sack State. Jack had for many years been a high school teacher. He wasn't about to go back! Too bad in a way, because high school teaching is fun, keeps you on the *qui vive,* calls for more commitment. The Sacramento area has way more than its share of 1st-rate art teachers. I taught at Berkeley High for ten years and did not miss a day. Musta liked it. I'd gone there myself, little snob that I was. I felt I owed the school something. With a couple of pals we set out to destroy the fraternity system. Wiped it out. Gone. Looked back in on the scene 10 years later. Back. "Totally" back, as the kids would say. Bad as ever. I thot I had done something in my life, but no, and I'd failed to apply John Cage's dictum to my own case. In '68 or so, when we were first teaching together, I tried to recruit Bill Allan to go on a march with me. Bill said: "I see more murder in Safeway every day than I do in Viet Nam." This is the kind of statement that allowed Eastern critics to surmise that Wiley et al. were a buncha "laid-back" yokels without a strong moral backbone. If he said that to me now? Well, after 35 years I've thot of an answer: "C'mon, Bill. Let's demonstrate together in Safeway!"

Along these same lines Jack Ogden was a help to me. At the time of the People's Park encounters near the Berkeley campus Jack did a couple of "drawings" on the reverse of shiny photographic paper, using rubber stamps, an ink pad, felt pen + watercolor. In these confrontations between the authorities and the student demonstrators the cops, of course, are no-nuthin' robot clones, but!! the student protesters include Fred & Wilma Flintstone, Dirty Dan McGrew, Olive Oyl & Popeye, Inky the Cat + Winky, Professor Waldo, and the Fox. In other words Odgen treats the "Good Guys" as virtually equally dehumanized. Touché, Jack. Yet I sometimes think that if Mario Savio hadn't stood on that police car, I might be railroading

tonight in the U.S. of A., trying to catch enuf sleep to teach school in the morning.

Next to Linhares, Ogden is the most indebted artist to David Park in the show. He's more cartoony than Park—because late Philip Guston comes into it, too. But his large riverbank composition (fig. 88), derived from a familiar Seurat, offers luxuriant paint application, a relaxed color-rich love-poem mood, the stretched out, leisurely horizontal planes demanding slow, slow, slow access to a deep space where perfumes play in air. This is true Venetian paint practise: passive, actionless eroticism, feeling completely dominates thinking, melodious color. Only the pruned branches in the trees framing the lovers admit a note of anxiety into this atmosphere of languid Arcadian dream.

Anxiety? Take that friend of Ogden and Suzuki's. Who really *wants* to face up to the tortured sardonic vision of Alberich America, which sold its birthright to pursue happiness and try to have a good love, sold that birthright in order to get ahead and get gold. Nobody can understand you, Irving Marcus. Why your colors must shriek so chalk-on-the-blackboard skreechy. Nobody wants to hear that people are stupid & learn nothing from experience. But your painful paintings do make that uncomfortable point. Consider the men & women working their way up the middle echelons of Morgan-Stanley, did they suppose that there would be no 2nd attempt to do them in? To poison them with gas, contaminate their water, Godzilla them from above or below? Irving, dogs have a tender place in NorCal art. Why in your painting (fig. 89) are they being misused by those cave-man cops to aid in their drug-bust? Irv, those German shepherds don't care if laid-back California artists smoke pot. Why do you always point to how our society abuses the natural order? Irv, your beautiful paintings are too tormented for me. Can't you make them a little user-friendly? I doan wanna think, OK?

Don't you go glassy-eyed when some collector is given free reign of terror over the reader & gets to tell same how we acquired every little piece, "found this in an antique store in Mesa, AZ, birthplace of

145

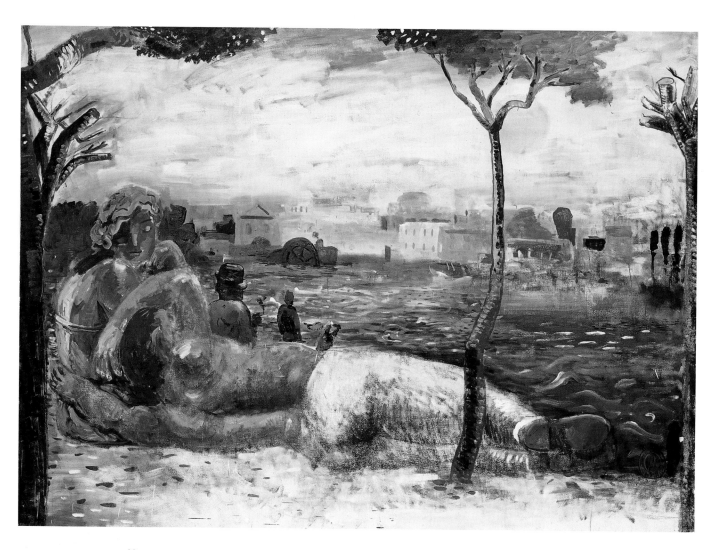

88

Jack Ogden,

Riverbank Lovers,

1984

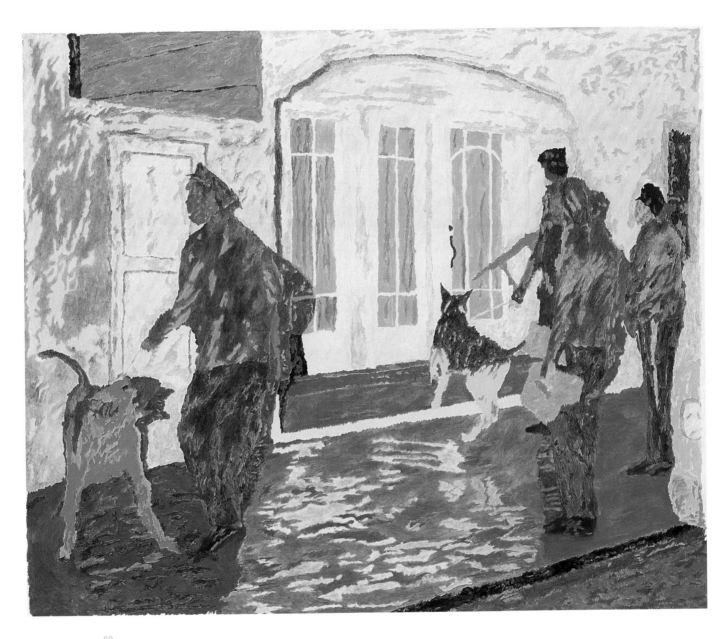

89

Irving Marcus, *House
Search*, 1969

90

Ken Waterstreet,
Luni Zuni, 1986

that's the other bidder keeps it rolling—somebody there knows what they're looking at. Two, Three, Three-five, Four thousand dollars. Do I have four-five, do I have 4,500 dollars? Erle knows what I think of this bowl, which probably changed hands originally for 2 dollars. Erle is looking straight ahead like I am not nudging him. Going once. Erle's paddle is flat on his knee. Going twice. Going three times to the good lady in Santa Fe!

"Erle, wha hoppen back there?" I said as we walked to the car.

"Pinkie put superglue on my trouser right here," he said, showing me a spot that looked sorta dark. I tended to believe Erle. Trust between relatives is a beautiful thing to see, reader. I knew Ken Waterstreet had painted a Zuni bowl (fig. 90), adding the way he does the drawings of his own children when they were small. So now I have two innocent eyes for the price of one. The Zuni are not innocent, reader, but as things go in this world they are relatively pure. Waterstreet is not pure but he has been a force for honesty and commitment around here since before I can remember.

You may judge from Bechtle's masterful *French Doors II* (1966) in the Crocker that marriage is the only subject for Art. Nearly so. Bob has the ability, surpassed in the exhibition only by his teacher, Diebenkorn, of allowing his feelings to descend into the deepest waters where the pressure would crush other heads like a balloon. From the Crocker painting we learn that people are inside and outside at the same time, and that having an inside is very serious business whether you know it or not. Where R. D. might paint a woman at table with a box or a vase in front of her, Bechtle will let you know that the box is a Ritz Crackers carton. He aims for the commonplace facts as well as the deep thoughts that well from within. Beat him, and you are a winner. Equal him and your name just might be Eduardo Carrillo.

This curious painter was a close friend for 30 years before his death, at 60, Summer of 1997. I never got near to plumbing his depths and I let myself believe I was helping him thru the decades. Truth was he was helping me the whole time, not

that Wayne Tybalt fella, one that did yer et ching, whaddya call it? Two boys meet 2 girls, thass right." Tell me I'm wrong, but I think most of us would like to be spared the story of how your Aunt Torquemada bought a Richard Shaw/Bob Hudson collaborative pot at a garage sale for $1.25. So basically the reader has been spared. Now, however, I break ranks with myself to tell the story of the one that got away. Jane & I collect Southwestern Pueblo art the way a Louise Stanley shelf of knick-knacks collects dust. One desideratum we lack is a Zuni pot. The Zuni found out, about 75 years ago that a lot more money for time expended could be obtained from tourists like us by producing jewelry. So they quit making pots & as the supply dwindled, up went the prices. So here I am in Butterfield's, S.F., sitting next to my son-in-law Erle who has his bid paddle on his knee. I was waiting for one item & one item only; it's a Zuni doughbowl, a shallow coiled pot decorated with characteristic geometric signs & motifs. From around 1890, I'd judge. Because I've seen the full sister to this outstanding pot in the storage area of the Hearst Anthropology Museum at Cal. So the bidding begins low & goes up by the 100s & now by the 500s, which is where I enter, waving my paddle, and the fancy hotel in Santa Fe

just when things were bad for me, but in a general way by showing me how to take my own life as seriously—and as joyfully as Ed took his. There are those, and I am one of them, who think that Ed drew energy for his paintings from the cosmic stream of grace, and if you get a look at the Crocker's *Testament of the Holy Spirit* (1974) take a peek at the rattlesnake ashtray on the table of this large Interior of Ed's rented house on Sacramento's 'H' Street, and you will see a spiritual spaceship for fair.

Now some people don't like to read about cosmic streams of grace and the like, and these readers heartily wish that artists would not be so adamant in debunking the worldview based on scientific rationalism. They find it hard to understand why Jim Pomeroy, one of the best of the younger American artists, should have done a piece that cast into doubt the reality of the moon landing. They don't get it, they don't get a lot of the art done in their time, and they won't get it either, if history provides an index for prediction. One time, on television, I saw one of the local newswomen interview Ed Carrillo at an opening at D. R. Wagner's gallery downtown. The newslady was wearing a girl's poplin raincoat and a pastel silk scarf; she looked very nice. Carrillo had on a serape over his white peon's pajamas. "Where do you get the ideas for these paintings?" he was asked. The lady meant that the paintings were strange.

"Well, I receive messages from outer space," Ed said. He was choking back laughter and turning away to hide it.

"Don't your friends think you're crazy when you tell them you get messages from outer space?" asked the not-so-dumb TV lady.

"Well," said Ed, "when I get messages from space *I* think I'm crazy." And he hid his face in his sombrero so as not to be caught laughing at another person.

Carrillo was hired away from Sack State by U. C. Santa Cruz where, as a gift to the community, he spent 8 months painting a mural in an unused entry off the enclosed shopping mall downtown.

The painting dealt searchingly and compassionately with the theme of conquered and Conquistador, with the fateful coming together of brown and white peoples, their cultures, and their myths. The thing to keep in mind about this mural is its quality. Many artists considered it one of the finest murals outside Mexico. What the manager of the Santa Cruz branch of Monterey Savings and Loan, which owns the mall, thought of Ed's work was that Ed's work was kind of a big mess, and quite conceivably a blight on the mall and people's shopping instincts, so one day while Ed was away working on a mural for the City of Los Angeles the bank manager, in order "to clean the place up," had Ed's work spray-painted out with glossy enamel, thus earning himself a place in the annals of banker taste. Which is interchangeable with newscaster taste. Nor can the issue of docent taste be finessed much longer. As to my taste, well I think the ruined mural to've been in a class with Ed's great admiration, Orozco. We have at Pilot Hill the maquette for Eduardo's Los Angeles mural, which is located just off Olvera St., across from the train station. The subject is Padre Hidalgo and his El Grito. It impressed Ed that I had known David Alfaro Siqueiros fairly well. Eduardo had as much truck with Paris/N.Y. formalism as this idol of his, which is to say hardly at all. There is evidence all over Mexico City of Orozco, Rivera, and, yes, Tamayo's dabbling with synthetic cubism. I once asked Siqueiros, "How come, you guys were all there, on the Paris scene, they all trafficked with cubism, you didn't. How come?" (This was for the radio.) Siqueiros smiled one of those boxer's smiles, which says, "That big punch you caught me with just now, it didn't hurt me." Then he told me why he was never a student cubist like the others: "Thaaay wonted to pennt an Opple!"

Whereas Siqueiros wished to paint human liberation. Ed was somewhat skeptical. Like Colescott, Ed recognized that things are pretty intertwined; the victimized are to a degree complicit and compromised (fig. 91). But, again like Colescott, Carrillo was

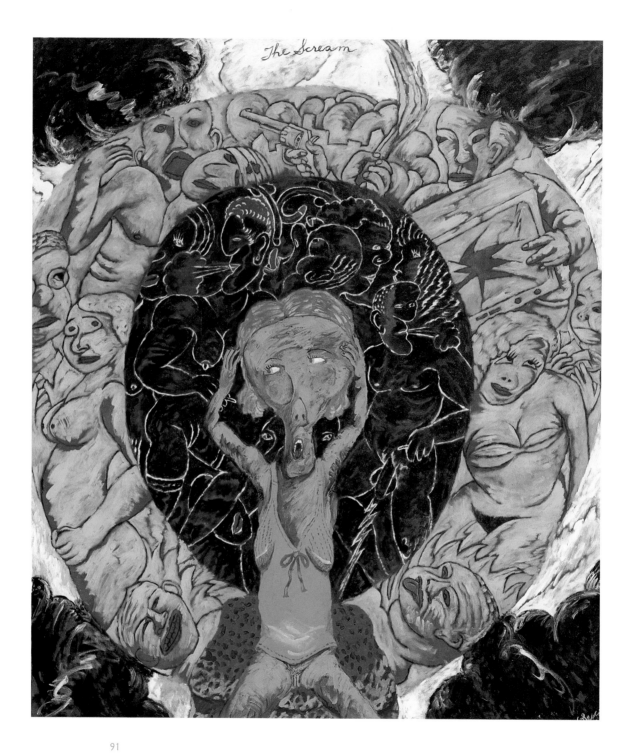

91

Robert Colescott,
The Scream
(Georgia O'Keeffe
in Los Angeles),
1992

ever mindful of the least of his people. On the other hand, Wiley appears to be mindful of the least and the best of ALL peoples. Go reader, go and calculate.

Carrillo's large *Testament* amounts to an essay in spiritualized light. So does the big painting here called *Down the Lane* (Ed suggested to me that a more accurate title would be *Surfing at the Mouth of the Jordan River*) (fig. 92). It's a different light here at the beach, but still thoroughly metaphysical. There's that looooong extended moment in mid-morning when the overcast is just promising to lift, just when the marine layer is shot thru with sunlight spread evenly like butter on toast. That's the gray-yellow moment Carrillo wants to capture: where the thin even haze has soaked out all the values & the whole scene swims in an atmospheric diffusion—or as in a colloidal dispersion. (I struggle to wrap words around it; let's merely say that Carrillo has made the evanescence of it sit still long enough to have its picture taken.)

Five figures, unclad for the beach, occupy this *épandu* Space/Light, plus a mountain bike, a 4 W-D off-road vehicle & the odd surfboard. The subject would have engaged David Park who, the more he empathized with you, the fewer clothes you wore in his pictures (*Cousin Emily* portrayed along with her baby-talk dog is wearing gloves, a hat & fur stole on her constitutional; Park's cousin is surely spiritual cousin to the Chinese ladies of so many pages ago). Compared to David Park, Carrillo is a decidedly wooden figure painter, but that is mostly a question of deliberate stylizations; Cézanne is far more wooden than any of the Impressionists (fig. 93). Anyway Carrillo's figures, as I mention in *A–Z,* enjoy a ligneous life, and that is not only no harm, it is worth repeating. Teresa & Bill Bourke's son, Dr. Sean Bourke, is the model for the young man on the right; the two women are both Alison. Carrillo has arranged the perspective so that the eye is brought in very low—we see thru the legs of these beach-goers and thus are drawn into their interactions. The more you stay with the painting the more convincingly are the figures locked in, the more persuasive Ed's evocation of one of those fog's about to lift mornings when the whole gang risks a shiver to be on the beach ahead of the rest of the world.

As to Alison, when she & Ed met I was among the most forward of his male buddies to warn the poor grown-up man against the possible machinations of this well-favored buxom blond siren (I dare say the reader knew I had it in me). Of course the 10 years they had together was a True Love fit, just the way it's spozed to be. Then Eduardo died a sudden and especially horrendous death from cancer. And subsequently something came out about Alison Keeler Carrillo, something different from the stuff like she was named Knitting Woman of the Year in *Family Circle* (which I think is the kitty's booties; Alison doesn't). I already knew she was well-educated—at the girls' auxiliary to Cincinnati Country Day and Sarah Lawrence. I could see moreover that Alison is even more beautiful than she is well educated. But now the whole world came to know that this grieving widow who was so smart, talented, and goodlookin' was also richer than she was anything else. Ed had surprised me with this information. It hardly made up for the loss of a man who was goldenhearted to a degree unprecedented in my knowing. But it did have its fairy-tale aspects, not the least of which was that Eduardo's life work would be protected & preserved in a museo.

So Eduardo Carrillo will have his legacy and eventually the world will come to know the paintings of an artist who died without a herald. Can this still be happening so late in our own day? The question is rhetorical, reader. But you'd at least like to know why I make such a fuss over a let's head for the beach genre exercise? Because, reader, it sums up the whole project of this Pilot Hill collection. We are promised in the Old Testament . . . "A Land?"

"Yes, Where?"

"Over Jordan?" That's good reading.

"What are we to do in this promised Land?"

"Well, the founding documents of our society announce certain entitlements."

"Which are?"

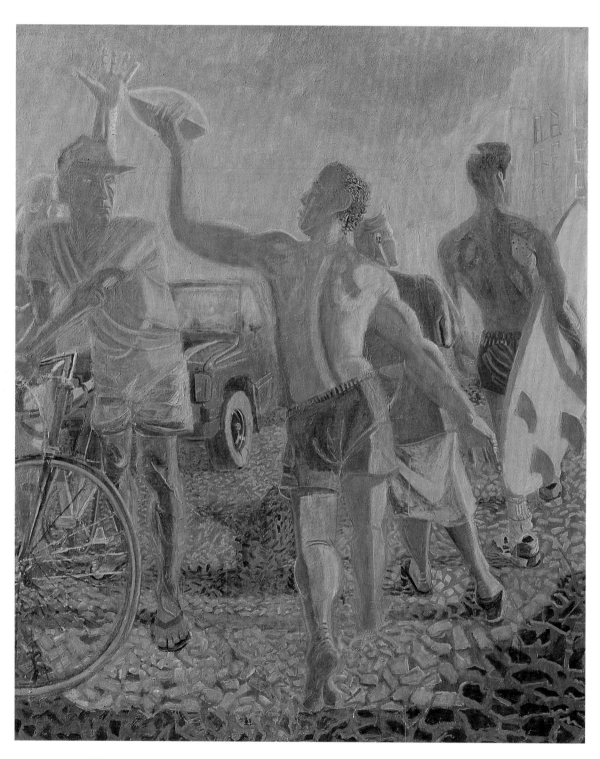

92

Eduardo Carrillo,

Down the Lane,

1991–1992

"Well, to begin with, we are free to live and —."

"Pursue Happiness."

"That's right."

"Surfin?"

"Yes, you otta try it, Kid Kansas."

"Pegging a football around?"

"All day, yes."

"Mountain biking?"

"Great sport."

"Surely not off-road cruising?"

"Have you tried it?"

"So Carrillo made an attempt to confer epic status on American leisure?"

"So I think."

"And the two Alisons?"

"Alison is all women, all women Alison."

"What did Alison want from Eduardo?"

"The same thing he wanted from her."

"Yes?"

"To have a good Love in a good Society."

As I was finishing my Socratic dialogue with my reader-interlocutor, Jane came back in; she had driven down to our gate to see what the clamor was about. "*A–Z* fans are down there demonstrating for parity."

"What does that mean?"

"You caved and gave them the Frank Owen section, now they want parity for women artists. You have to put in two women."

"That is parity?"

"Yes."

"Well, alright [no one is more agreeable than yours truly] go ahead & give them the Lulu Stanley, it's the same piece—and they can have the Julia Couzens—her drawing's from the same Mortal Lessons series, they're close. And while you're gone I shall tell the reader a story."

"Is it one I've heard?"

"You have heard all my stories, Jane."

Fifty years ago and more I was a humble tenor in the chorus standing in the corridor wings of the Berkeley H.S. auditorium. The dress rehearsal for Victor Herbert's *The Red Mill* was going forward (I had one solo line!). So I'm standing there and a

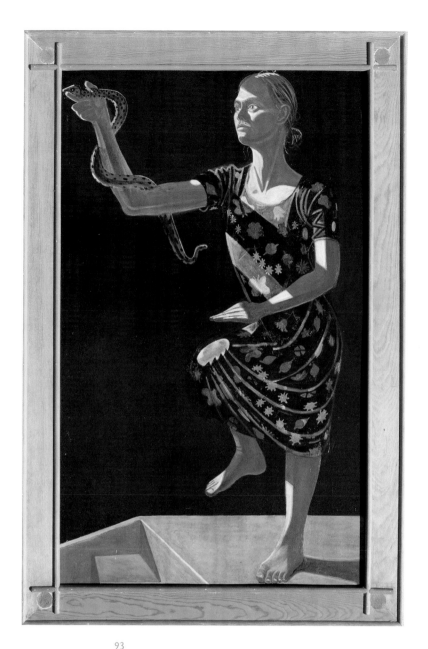

93

Eduardo Carrillo,
*Woman with the
Snake,* 1975

girl in pink tutu with white stockings rushes in from stage left and leans against the wall opposite me. This was the prima ballerina. I stared. The girl shifted one foot and looked me a look of utter candor.

Nowadays, I suppose, I'd have gone over & said, "Whut's cool, bitch?" Or perhaps: "Less go, ho!" But believe it or not in those days the custom was to get an introduction. I learned the girl's name and that she was a member of one of those "Greek" clubs that knew nothing of Greece. We were introduced the next day after school by a girl I knew who was in this "Adelphian" sorority. "Hello, I'm Jane," said the girl calmly. "Me Tarzan." This elicited my first laugh from Jane.

Jane was far the most beautiful girl I'd seen in this or any prior lives. In our circle and beyond she was legendary for her extraordinary beauty and as I soon enough came to discover perhaps equally famous for the honesty, veracity & reliability of her platinum-bar character. But the extreme susceptibility of the world in general to her looks, you hadda be there. Nowhere was the Jane effect more pronounced than Los Angeles, CA. We'd go down there, my father would take us to various clubs where he cut a figure, like the Coconut Grove at the Ambassador, with its long approach to the extended awning so ideal for autograph hunters, amateur (maybe they were pros?) paparazzi & like pests. We would start up this gauntlet, some look-out would yell "Grace! GRACE!" and celebrity-seekers would rush up to the ropes from where they were camped out in the bushes or from their blanket on the lawns. Jane signed many a Grace Kelly/my best to you en route to seeing Liberace or Sinatra. One more? OK, I remember the time we all went to Perinos, on Wilshire Blvd., the place to be for supper Saturday nite. We all meaning Jane, me, and Lael Leslie. The latter was doing some modeling for UCLA visiting prof. E. Bischoff. Nineteenhundred-sixtythree. We decided on an excursion to the track for the day. I began poorly and continued poorly, putting us all in a bad frame of mind. So

the women wanted to go and I had to say, "Please! Let's stay for the feature"—because I wanted to watch the Hollywood Gold Cup. We walked down to the paddock to watch them saddle the horses for the Cup. My last $20 bill was in my shirt pocket. In those days still a sum of money. I looked over the *Racing Form* thinking to myself, Anything can win this race. . . . What a bunchta pigs dese is. Lael admired the conformation of the number 8 horse. "That's Cadiz," I said, glancing at my program. "Shipped in from New Zealand. He's by far the longest price in the field. But he will relish the added distance here." The Gold Cup is Hollywood Park's longest horse race. This Cadiz continues to look good to me as I walked to the betting window. Horses from Down Under often are undersupported when they invade the States. I was sold & I knew it. "Number 8," I said to the pari-mutuel clerk, "$10 to Win." We watched the race from the Turf Club railing, ready to make a fast move on the parking area. But the New Zealand horse, reserved early under a tight hold, was allowed to kick back rounding the far turn . . . his big run carried him to the leaders at the head of the stretch and he swept by them like they were anchored, going on to win by daylite.

At Perinos that evening there was talk that some longshot, from Chile, was it? Had run off with the Hollywood Gold Cup, paid a hunnerd t'one. "That'd be Cadiz," I said. "From New Zealand. He paid 35–1—" We were shown to a good banquette. They keep the dining lights way up in that restaurant because people go there so they can see the other people who have gone to see their friends. Wait! Do I have that right? What was sure is everyone was looking at Jane & Lael. Who are these women? That one is under contract to Paramount. I'm sure. There was speculation at every table in that well-lit room as to the identity of this young woman who (there could be no doubting it) was one of the major studios' new superstar, the one they were said to be keeping under wraps while she had her teeth

capped. I think Jane enjoyed being a movie star for one evening; she was, let it be said, better looking than the far from flawless Kelly, 7 days in the week. When the bill came for the 1st-rate meal it came in the form of complimentary liqueurs; and the invitation to come back any time soon.

Jane is (you can verify this from Diebenkorn's portrait of her—fig. 94) the most self-sufficient girl/woman/grandmother I know. Nothing and no one has ever turned her head—for which I am deeply grateful (unless you count the aforementioned "Tarzan" fellow, and she couldn't help *that*, seeing as how he is God's own incalculably generous Gift to women).

The gift of women to our collection has been greater in quality than in number. We are proud that a dozen years ago we spotted two able women artists practically in our own backyard: Lulu Stanley, the Baedeker's woman whose European Tours are so valued by her sister travellers, was already building a career. Julia Couzens was barely started on hers. Now both artists crop up in everyone's thinking in Northern California. Louise wears the mask of Comedy—Julia of Tragedy. This is what we had to say then:

A brainy new talent, M. Louise Stanley's witty send-ups of Hollywood antiquity are steeped in unjudgmental laughter. She is both censorious and forgiving of foibles which are hers as well. There is some contrast here with Eric Fischl's concern with Roman/American decadence. He indicts it, with anguish and trauma. She sends it up and teases it down with giggles and irony. A blessing on both their studios. Here (fig. 95) she hangs the figure group on the picture plane like the tired, faded purpureal curtains themselves. Few painters today have so natural a command of narrative and she sets herself a true test here by putting these passive, neurasthenic people into believable interaction. The landscape is a mere backdrop, beautifully realized and always reminding me, anyway, of the dismissive landscape foils-for-action of the 19th-century

94

Richard Diebenkorn,
Portrait of Jane,
1961

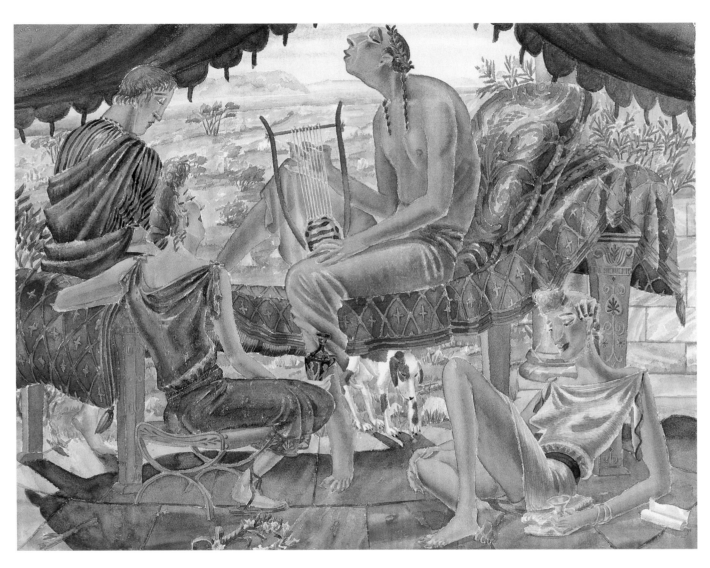

95

M. Louise Stanley,

Orpheus, 1981

California painter Charles Christian Nahl. Neo neo-classicism is the pictorial manner here. That truly funny pooch is a triumph of foreshortening and serves to flip our eye toward the deep space. Those depleted purple-passion drapes are the key to the mood of the listeners. This Orpheus is too interested in dramatizing his loss of Eurydice ever to get off his duff and go look for her. He's putting all his feelings into his musical art, where they're safer. His creator is a charmer, but Louise has steel beneath.

For Stanley watercolor isn't the spontaneous medium of simple suggestive washes it is for many, especially the plein-air *artists; nor is it the matter of fact rendering of the photo-realists. Spontaneous in her first inspiration, she then modifies the composition through careful thought, and slowly builds up the washes from light to dark, with an emphasis on solidity and structure. The trick in this kind of re-work in watercolor is keeping the painting luminous, which she does very well, as in our example.*

Louise Stanley's versatile line and faultless color phrasing remind once again of what we require from a new artist in the big leagues: Talent, talent, talent. Not to mention, Brains, brains, brains.[7]

■

Julia Couzens is a new artist, or at least a newly graduated from an M.F.A. program. I thought it would be nice to borrow a work from someone's M.F.A. exhibition. It turned out to be Julia.

The large drawing here [fig. 96] has autobiographical overtones for Julia was hit by a car in a crosswalk a year ago and had to go under the knife a couple of times in order to get her leg back in function. You can see, though, that this incision is elsewhere, closer to the heart and to the loins. In a very general way the message is about the vulnerability of the body. But there is much more. I like the execution of the drawing, cautious but confident. I have seen drawings of Couzens's in the past which were accomplished but, to my eye, facile. Now there is belief behind every mark. It mounts up. She likes

the struggle; she is combative, she likes to win. Good signs.

This drawing tells me things I don't know. And I am always ready to learn from art. The piece is perversely masochistic in a way that jibes with experience. Julia is widely read in both Jung and Freud. She is interested in the question of hysteria and its source. That's why no head. The body is doing the thinking. What is it thinking about? There are ambiguities in the drawing; the figure is phallic. A provocative touch. I like the morbid sexuality of the drawing, which tries, and succeeds, to be different from other artists' morbid sexuality. It is fresh. It rings true, "à l'Acéphale."

Julia Couzens is a good draughtswoman. This is a spelling I always use to designate an artist who is devoted to Duchamp ("He was so handsome!") Duchamp wasn't such a good draftsman but he was the greatest draughtsman.

Julia Couzens is just over 40. She is married to a lawyer who has done good work for freedom of expression. When I first knew her, more than 10 years ago, Julia, like several artists here—for instance, my dear friend Lewis Stein, when he was a student, hardly spoke a word. Talent in art is in many ways compensatory. Art historians do not really understand this. Intelligence is vested in the hands, and in the silent eye. Now, Julia can go on and on. An opinionated artist. She may have picked it up from me. Her teacher Roy De Forest used to chide Julia about it being time to go to color. I used to chide her to put some humor in her art. We chide to our strengths. As a teacher next year down at Scripps in Claremont Colleges, Julia will get her chance to chide students. I am betting that she will.[8]

In paintings and wall installations of the past few years Couzens has finally digested Roy's advice about color. Looks like *my* advice will continue to be superfluous. An artist who can sound the authentic note of tragic passion in her work does not *need* a sense of humor.

■

157

96

Julia Couzens,
Mortal Lessons, 1990

PILOT HILL DISTAFF STAKES

7 Furlongs, Purse: All the marbles
(Fillies & Mares)

JOAN BROWN 6/5
 Holds class edge. Victor over colts in last

JUDITH LINHARES 3–1
 Best threatens top one

JULIA COUZENS 8–1
 Improving filly steps up again

LOUISE STANLEY 9/2
 Be there or thereabouts

GLADYS NILSSON 7/2
 Early foot, dangerous on front end.

MARILYN LEVINE 4–1
 Don't let her fool you, chance for part
 (fig. 97)

JUNE FELTER 15–1
 Some efforts give outside chance

IRENE PIJOAN 12–1
 Well-bred filly rounding to form

VIOLA FREY 3–1
 Beat Cheaper in thrift store handicap
 (fig. 98)

ELLEN VAN FLEET 20–1
 Would need very best

DONNA BILLICK 25–1
 Veteran campaigner always poses a threat

LINDA FITZ GIBBON 20–1
 Yet to face this kind

MIRIAM MORRIS 30–1
 Went to knees at start, lost all chance

MICHAELE LECOMPTE 40–1
 Must come from behind

JOAN MOMENT 50–1
 Figures to bring up rear

97

Marilyn Levine, *Bag,*
late 1980s

98

Viola Frey, *Plate,*
1992

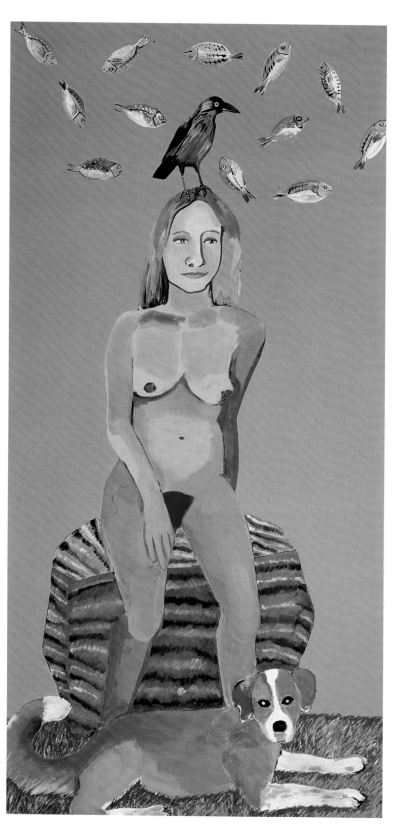

99

Joan Brown, *Sara as
Eve with Fish and
Bird*, 1970

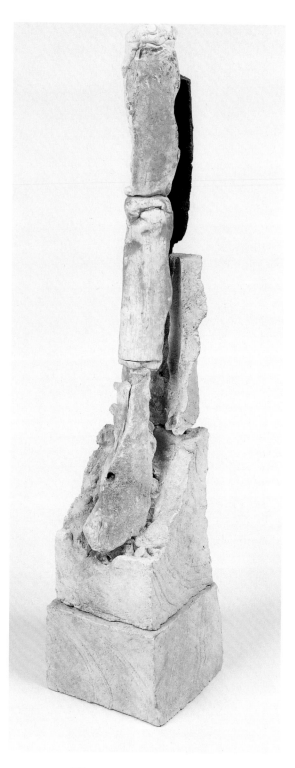

100

Stephen DeStaebler,
Pale Red Leg,
1996–1998

Joan Brown was an artist of remarkable vision taste authority imagination talent and independence. These qualities in her required no commas they ran all together. Like, say, Garabedian, Joan had drawing chops all her own; like, say, Bill Allan she was handy with the brush; unlike Bill Allan she thot fish could stand in for Penises and penises could stand up for fish (fig. 99). Joan was chic *soignée* elegant a good dancer teacher cook mom swimmer dog & cat fancier + pal. Joan was my friend and she had husbands lovers boyfriends mentors students up down & across this collection without my (yet) having heard one word of reproach *contra* Joan. Beautiful she was not, but she was cute enough for three. And she was effortlessly sexy. Give her a 10? I'll give Joan a 100.

There.

It's hard to know where to find a useful female role model for a younger clay artist like Linda F. G. Joan Brown was, like Gladys Nilsson, more a people-ist than anything else. Linda seems drawn to the crude forceful manipulative strength of her admirations Viola Frey and Annabeth Rosen. And she seems drawn to the deep identification with humanity that the art of her admirations Steve DeStaebler (fig. 100) & Arthur Gonzalez put on offer. Not to mention the empathy for human suffering at stake in the work she has around her from the hand of Joe Mariscal (fig. 101) or Glenn Takai. In other words, she seems taken, in her BUY ART persona, by the very dimensions not at all apparent in her own art. And this makes perfect sense. I also find in her art very inconsequential inheritances from such teachers as Brady, Vanden-Berge, Kaltenbach, Allan, Melchert. So we are left with what is Linda Fitz Gibbon about Linda Fitz Gibbon. And that, for my money, turns out to be very consequential indeed. First off, she handles clay with a rollicking rococo virtuosic freedom that makes it seem like Linda could throw handfuls of clay in the air and they would fix themselves there by their own volition. The resultant forms are answerable to each other in a magical reciprocal flow that cannot be admired enough. These forms

101

Joe Mariscal,
Inmate, 1984

102

Linda S. Fitz Gibbon,

*Do You Like My
Hat? Autumn,* 2000

are, moreover, appetitive, somehow edible, definitely confectionery. And the color! Never less than ravishing. *Trompe l'oeil* art is a low art by and large but Linda gives the genre new life and a sort of decorative dignity. She can, at all events, reproduce any surface quality or texture, as in the turban-squash turban of her Arcimboldo-derived figure of *Autumn* (fig. 102). What she may someday prove able to do is to withdraw her art from the world of decoy & deception and redirect it to the oceanic or sky-ey realm of representation & recreation of the spiritual & metaphysical Truth that underlies (or overhangs) the apparently solid material plane of existence. As in Raffael's *Water* painting or the Bill Allan Sky painting. How can I be sure Linda F. G. will one day occupy a high step on the art ladder? Reader, reader, she has Talent to spare. And Ambition will out, reader, relentless Ambition will out.

Thanks to his inviting me over, I had a look at Allan's Sky painting here—*Four Second Show* (fig. 103)—5 or 6 days before he finished the painting & turned it over to me, and I saw that in less'n a week the painting had utterly changed from a radiant & joyful symphonic paean to American Beauty, all flesh pinks sumptuously spread out against the close of Day to its present doleful threnody to the approaching Night and Pessimism Triumphant. Allan like his friend Carlos Villa wanted to assure himself that I understood the permeating sadness of the human situation.

Yes, faithful reader? Can you turn your TV down? — OK, shoot. — Thass right, I did forget her. — Oh, very well, just a few then.

Miriam Morris stands rival (as I've always seen it) to Linda Fitz Gibbon. They're of an age, they each developed their very different art in the same artistic milieu. But whereas humor in Linda's art is gentle, sometimes mildly self-mocking and seldom amounts to more than an arch cleverness, Miriam can deliver heartfelt rage against the Father who prefers bimbo stepmothers [to her], against the Man born to scorn [Miriam], the Man (a false backsliding lunkhead) who prefers [to her modest charms] the Playmate type of sex-pot. In short,

because it is based, to a degree, in Truth, Miriam Morris's anger against hypocritical Men who spurn Women can feed her art forever—or at least thru a long career. Unhappiness is not without its dividends, at least in art. Forced to a choice, that Old Adam is going to go on preferring M/M (Marilyn Monroe) to M/M (Miriam Morris)—a.k.a. O/O (Olive Oyl) as she often identifies herself.

One serious impediment Morris faces is that unlike L. F. G.'s her sensibility is essentially literary, not sculptural at all. She uses clay as a storytelling material, not as a locus or nexus of forms. How to correct this I dunno. For it seems that Miriam, despite an intelligence as high as anybody's, is nevertheless, a certified Slow Learner. Morris is among that amazing cadre of artists who are entirely self-taught (and who don't stop to think that they have only their teacher to blame for whatever deficiencies in their art). Turns out, tho', that Miriam spent day & night for seven years in company with a noted Type-ABC art critic, and Miriam is pleased to admit that from this person she learned Absolutely Nothing. This argues delinquent learning capacity. Nevertheless her raunchy sardonic pieces, like *Bull Eyeing Europa* (fig. 104), with its polite nod toward Mel Ramos, provide a gulp of fresh air.

Linda & Miriam, reader. BUY ART.

That's what I did, reader, with Bill Allan's Sky painting which, as I intimated, has a certain self-portrait character. For our human makeup consists of breath & matter, spirit & flesh. So in this sky-blue-pink painting darker more saturated blues have overcome the saliency of the flesh-toned

104

*Miriam Morris, Bull
Eyeing Europa, 1999*

"original" painting seen in Bill's studio. It's Bill in a mood more somber, brooding, closed in. The delphinium blue snatches & patches have merged and come near to taking over the 2nd painting, darkening & graying out in the process. Sometimes as in one of the Crocker's Sky paintings, Bill will slip a horizontal nude into the painting disguised as a cirrostratus cloud formation (& vice versa). Just as in R. D.'s Berkeley series the abstract landscape is often a body, so in Bill A., the body is sometimes a cloud. Most of the time tho' these weather reports from Allan are about his own

transparency. Indeed Bill has a legendary capacity for being "not-there" in Nature. I have written previously about William Allan's quite remarkable "ability to hear the grace notes from the noumenal world." It was true then, it's true now, 20 years on. Shoot, 30 years back I was able to recognize Allan's famous *Shadow Repair for the Western Man* as deliberately "evocative of Gary Snyder's enthusiasm for lonely, holy places in the mountains." It's been a long trek from that 1st *Art in America* article, hasn't it, reader Bill? I don't share your intoxication with fishing (fig. 105), tho' I have a

son who does, but I think we share a belief in the role of Friendship as a content in Art. You & Hudson & Wiley provide one of the best instances of this proposition. Also I know we share an interest in childhood play as a source and resource for keeping the best things alive in us until the end, which as the Chinese ladies believed is most certainly coming sooner than we may think! You've always been a poet (which I am not), but I was so happy to find from your Grady vignettes that you are also a fabulous fabulist! Jane joins me in telling you how honored we are that you should contribute to this catalog. Thanks so much, dear Bill.

One thing I wonder is whether Grady's childhood or our Santa Fe granddaughters' childhood is any more magical than yours or mine? You'll agree that Xmas-tree lights have improved in quality & quantity since we were boys. Yet I harbor a great fondness for your painting of the kids Keds & a Xmas string of lights floating together in the dream reaches of *Traveling in Strange Circles* (1973), your painting at SFMOMA. I know it would have been a

selfish wish to have the painting here to look at, so I contented myself with wishing to BE SFMOMA ITSELF in order to have the painting at my permanent disposal.

Now . . . should I do it? Should I reveal the truth about Wm. Allan . . . tell this ancient bit of gossip? I'm pretty sure it will cause yer eyes to bulge. You do want to hear it? Even though gossip requires you to believe about another person stuff that you know damn well *you* wouldn't do in a thousand years? Very well, I'll tell on Bill. I'll tell the reader how Wm. Allan got to be so transparent that he and Nature are one. You won't misuse this information? Use it against Bill with some Federal Bureaucracy?

OK, then. Here's the skinny. Allan is not what he seems. You're aware of all the books: "Born, Everett, Washington, 1936." False, all false. First of all, William Allan is not his name. William Allan is two names, two first names. Reminds me of my schoolmate Bradford Standish . . . or was it Standish Bradford? Anyway, two last names. One didn't know if to call him "Stan" or "Hey! Brad

■

babes!" Anyhow, William Allan or William Allen, as you will see it spelled, those aren't real names. Bill was born in Otpag, a Native Canadian village on Lake Ontario, came to this country aged 2 years, bearing the name W. A. Otpag, later Anglicized to Ottpage, and still later dropped altogether, with results you know, if you've paid attention.

Now here's the crucial part: the birthdate. Bill wasn't born in 1936; his true date of birth is 29 February 1736. So Bill is a man of the 18th century. This explains a lot, no? Fr'instance it explains certain spelling errors Bill Allan persists in. What's clear is Bill spent nearly 200 years fishing, hunting & trapping in an American wilderness that had as yet to see its first candy bar wrapper. He was just 40 when the Independence Declaration was proclaimed. He participated in most of Young America's defining moments, & the entire time he was working toward an America that lived up to its own standards. The whole time he worked alongside other artists, going West with the Hudson River painters, always carrying his Thoreau & later his signed copy of *Leaves of Grass*. He loved hunting & painting with Homer and also doing (disguised this time as one of the rich friends) private trout stream watercolors with Sargent; Bill did some pretty nice American cubist paintings in the Santa Fe area and a few decades later, working now in a decorative brand of AbEx and using the name W. Allan, he was included in the Carnegie International. Sometimes people saw him & forgot, sometimes Bill was totally transparent, as you might be yourself, reader, if you skipped meals for 200 years. Bill appeared to Hudson & Wiley as a slightly older schoolmate, capable of giving answers, and when Wiley, a natural-born intellectual, asked Bill what he thot of crossing the Bay & taking some philosophy courses & a little history maybe, Allan poured cold water on the Berkeley idea: "I'm gonna stay right here at SFAI & become an artist!" That was an important answer.

Bill Allan will be in his late 60s when his next birthday rolls up. I often go to him with a question myself because his answers are wise. But I won't go to Bill with the question I've nursed all these pages & all these years because I know he'll sidestep. (Here I have to apologize to the invaluable readers for luring them with promises of nonexistent gossip—offering instead a flight of fancy & now planning to ditch them on the dangerous precipice of this question, which Allan will take fishing with him but not attempt to answer, a question that even Wiley set aside early on as an insoluble enigma & went on to other existential issues. The question I'm sticking the reader with is—stated as largely as I can—what is the role of sex from cradle to grave?????? In 10 Events here at Pilot Hill I tried and, to my dissatisfaction, failed to answer the question myself—tho' in the *Unicorn Hunt*, done for Bruce Nauman & others, I think the results were close.) Good reader, clamber down from that cliff & tell us, How you can have a good Love in a bad society? "You don't know? What! Yes, I heard you: 'Ask the docent.'"

Nathan Oliviera (fig. 106), like his pal Manuel Neri, is one of the great diagnosticians of the topic. Nate's tiny oil here (fig. 107), less than a foot high, portrays a couple uncoupling after sex. A filmy cream-colored impasto conveys both the extreme spirituality & the lingering pleasure of this dying moment when the senses decay to a long-drawn-out plane of pure feeling. Intellection is in abeyance, a passive passion rules. Of the woman's body, at lower-left corner, we see only her bent knees & black triangle. The man seems to slump & turn his head away. Above this primal scene floats a . . . magic hooked-rug? celestial eye? labyrinth? . . . one more p———y? Whatever, the painting's a triumph *in petto*.

Did I save the best for the last? I tend to do so. By the early '80s when his brushstroking began to reach equivalence with his erstwhile teacher's (Bischoff), it was hard not to see Colescott coming. It was hard not to see that History painting was back, and that the guy bringing it was not called R. B. Kitaj. (Altho' it could be argued that Colescott looked & thot about Kitaj's strategy of

Unicorn Hunt, 1975: Unicorn Pavilion, Melinda Barbera, Death and Maiden

106

Nathan Oliviera,
Standing Nude,
1982

Unicorn Hunt, 1975: Bruce Nauman

compartmentalizing the canvas into sizeable precincts that could load-bear separate story lines. But then the same argument leads as easily toward Duccio di Buoninsegna or Giovanni di Paolo.) In any case History painting was back, Bob Colescott brought it, and his serio-comic version of the genre (ever more serious than comic as the years go down) gave Bob's art an immediate built-in advantage over all other art rationales of what-soever stamp, origin, or venue. Period. The reason for History painting's pre-eminence for so many centuries did not go away, reader. They are still in place. It still matters that America has a Destiny, and that we had a Past, which must be exorcised. It is still a question whether you can have a good love in a sound-bite Society where everything is for sale. Of course, if paintings were not for sale, I wouldn't be able to tell you that we have, in the

107

Nathan Oliviera,

Couple, 1968

family, 17 Colescotts most all of 'em large. Of these my two favorites are—but oh heck, I like all of 'em!

I'll say a couple of words about the little still life with Bob's army boot stomping on Wayne's birthday cake.

VERY FUNNY.

Blondes Have More Fun (fig. 108) is dominated by the nictitating joint-smoking lurid & compromised Sex-Goddess of the title. The wink this tricktress spends on the viewer is intended to draw us into the jumbled jungle of a dozen or so figures who enact confused scenarios of Birth, Love, and Death (I particularly laughed at the His and Her skeletons in the graveyard, she still wearing her bra; Bob indicates here that the struggle—and passion—between Man & Woman continues on after Death; nice idée). The word *tricktress* is invented for this writing occasion, and costs you no extra. The spirit of Bosch & Brueghel lives in this encompassing critique of human follies, out the window there, that is Hell on the urban horizon. Again, I particularly responded to the episode at lower right where a man wearing a Sepik River mask is putting one over on that poor nekkid tribal woman; O dat Purity ob demb traditional societies. When Bob reads this he is going to ask me if I think there can be a good Love in a so-called primitive society? And I am going to twist out of that one and say, "Lemme think about it! It is all very complicated."

In our painting don't miss the snippet of American flag, the authority fist with the dollar sign cuff-flink, the white p——y for sale, the use of upside down & arbitrarily cut off figures to convey moral obloquy, the supine yet potentially ebullient situation of the black underclass. Above all, don't overlook the great beauty of this fair-minded, politically balanced painter's reading of an America he only wants to live up to its historical word. What a colorist. What a draftsman! What a joker! What a friend. And what a rememberer of stuff mainstream America wishes it could sweep under the rug or into the closet with Unca Cholley.

Tap, tap tap tap tap tap and, further onomatopoeia, tap tap tap tap tap tap to your liking, tap tap tap tap. Hey children what's that sow-wun¿¿¿ Evaboddie look what's goin' dow wun!!!

Dear me, dear me, that dear real ME appears to be back. Not that aged hippie, Sierra Foothills '60s warmed-over Voice he does. Please spare us!

"Actually, no sir. Checking, merely to ascertain whether you are wide awake. You have been standing for some instants now in front of Mr. Peter Voulkos —" ME trailed off respectfully as is his wont when he is in his manservant Voice.

"Some instants!!! You mean . . . all that's been passing thru my head took place—"

"'—in the twinkling of an eye' as Mr. G. F. Handel might be moved to say. If I may recommend, sir? Do not mention the plate Mr. Voulkos promised you. It would be in bad form, I fear."

"Not to worry about me, ME," I said. I made ready to greet Pete, but PETER VOULKOS SPOKE FIRST.

"Hey, John! I still owe ya a plate!"

This made me feel so good! Pete had remembered. In fact it was the first thing on his mind. Even ME was grinning through his stiff upper lip. We all chatted a bit. It developed that the great Niu Guini ancestor figure had somehow "disappeared." Ann Voulkos was apologetic but not flustered. I looked over her head at the Bischoffs. I barely recollected her from the Pot Shop days & daze. Still one cute lady I could not help noticing.

Voulkos didn't have a plate at the ready just now. Soon he would. "Well," I said, "we'll be in Berkeley after Xmas, visiting the grandkids. We'll come by the Dome or phone ya first."

In January I called Peter twice & was put off. A couple of weeks later we were again chez Pinkie & Erle in Berkeley. Peter Voulkos said he was packing for a workshop trip to Ohio, be reunited with old pals. Deal with the plate on his return. "OK, Pete," I said.

After Pete's death I waited 6 mos. and called Heaven, see if Peter Voulkos was registered. "That's P as in Picasso, V as in Valledor, O as in Oldenburg—" I'd had to call the main switchboard; they

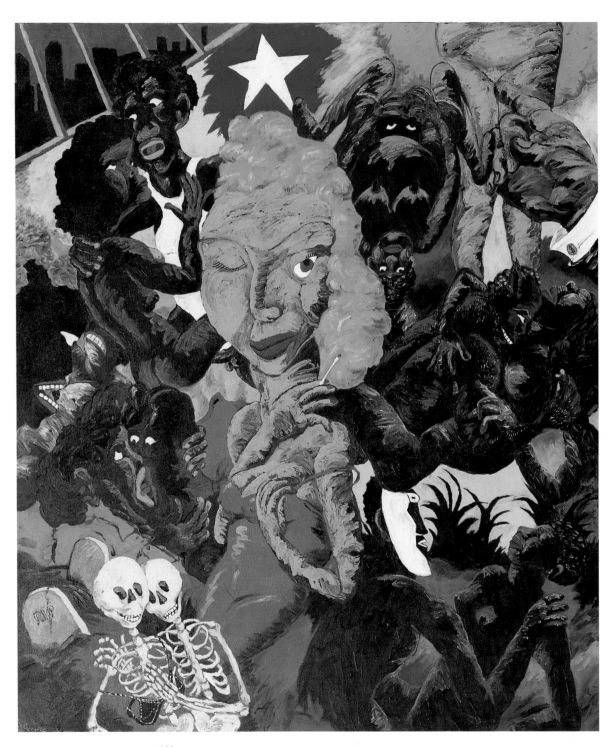

108

Robert Colescott,

Blondes Have More

Fun, 1990

do have cell phones in the afterlife, but they're all in the other place—in cells. After I punched a lot of numbers, pound keys, etc., I finally got a live(?) voice.

"Mr. Voulkos is here, all right," the young (?) woman said, "but he appears to be very busy, busier even than he apparently was on your planet."

"Would you page him anyway, I hafta axe him something?"

The voice on the other end hesitated, then: "Why not? They've been playing that game all nite. It started before I came on."

"Thanks, Angel."

Me & I were put on hold. ME allus puts his tuppence in: "Doesn't Death cancel all debts? Does the young Master feel comfortable dunning so eminent a member of our arts community?"

"Look, ME, I want you to cut the Young Master tripe inmediatamente, instanter, NOW. I am not your young master, I never was. We are the same age, 'til Death do us part."

"The Young Master does not presume to the epithet Old Master, I trust? Given a tendency to antonomasia, I mean?"

"Talk English, ME," I said, reluctantly echoing William the Allan. I am sensitive to sneers about "Old Masters," considering my yearning to "redo them after Nature"—which is the thrust of my performance art, like the *Et in Arcadia Ego*, after Poussin (1971), which I did for Dr. H. W. Janson, Dr. Albert Elsen, the Thiebauds, the Raffaels, the Gordon Cooks (Joan Brown).

"No one is sneering at your Event, sir, but, with permission, this is not the time to go into that storied piece."

"Quite so, ME, very good, ME," saith I (for I am pliant to a fault).

Now a functionary came on to the telephone line. "Mr. Voulkos is in a meeting."

"What, pray, kind of meeting?" asked the ever alert to prevarication Real ME.

"Actually it's more of a GAME than a meeting, strictly."

"Not *the* GAME?" cried ME and I together.

"Yeah, that's correct. Voulkos is just an amateur by the standards here. He's getting his wings beat off t'night. But here he comes! ask away!"

And Pete picked up, his voice was sort of scowly over the phone. "Hiya, John, I know what you want. But I'm in a middle of a bad streak, why'n't we wait on this? God just drew to an inside straight flush."

"Incredible," I said, crestfallen over the plate. Yet why shouldn't God's flush beat Pete's 4 Queens? Those are the rules, people should play by them. But I was crestfallen again at just the thought of how far an art critic would have to travel in order to have the least chance of sitting down to five-card draw with Peter Voulkos. The other guys sat at table that night, beside Pete & "Confidence" Jock Reynolds, were St. Luke the Evangelist-Painter, and God, of course, plus Tony Quinn plus Elvis + Bruce Nauman. I found this out by looking thru the Holy Calendar and the Heavenly Roster faxed to Pilot Hill by that sympathetic angel.

"What's Jock Reynolds doing there?" ME wanted to know. "I thought he was alive."

"He is alive, but Jock will go anywhere to raise money, that's all he has time for."

"Too bad 'cause he's a fine artist."

"Just my sentiments, ME."

"And what's Nauman doing there"

"A few artists are inducted under the Early program. They had to have Bruce, he is everywhere."

"Is Arneson (fig. 109) there?"

"Of course."

"How 'bout Harold Paris?"

"I'm afraid so. There's not a lot of clay."

"Surprise me. How 'bout New York artists?"

"Apparently they don't care for the place. Too clean, there's no criminal activity, too laid back, all those sunny days by the pool, you may as well be in California. . . .

"I see."

"And let's not be miffed that Pete hasn't yet found a way to come thru with the plate. He's a busy man up there."

109

Robert Arneson,

Study for *The Palace*

at 9 a.m., 1966

"You're just going to give the plate to Yale, right?

"To Jock Reynolds."

"The guy who refused to take the fun out of fundraising?"

"Yes. I've started a California Clay Collection there; Yale has very little clay up to now."

"And why d'ya suppose that Voulkos is busier 'n ever up there?"

"One of the penalties of true talent, ME."

"Indeed, sir?"

"Posthumous Fame simply swells & swells until it reaches critical mass, and then . . . what's my word, ME?"

"Apotheosis, sir."

"You enter the Pantheon?"

"I believe so."

"ME, do you recall how Pete so memorably would define Fame?

"At an art opening? Yes."

"Well, let the reader in on it!"

"'Fame,' Peter Voulkos used to say, 'is what keeps you from getting to the bar.'"

■

The whole year I was 10 my ambition was to learn to tie knots. This is hardly an extraordinary interest for a boy of that age & era. What made it different was I was looking to tie the knots not with my fingers but with my toes. This situation came about because one of my neighbors, the Texas oilman Harold Kendrick, was a sort of sponsor or patron of a fraternity at U.S.C. I will explain but first let me inform the reader that each of the sea-verge villas on our street had their own steps that led down to a more or less private beach or tide pool below the house. An appreciable part of my playtime was spent jumping from tide pool to tide pool and not even someone like SpyderMan could have put much more into it. This was eons before I could make a putative connexion between penises & p——s, but like any kid was wowed by the starfish and the purple sea urchins and I enjoyed sticking a curious finger in the maw of sea anemones in order to watch & feel the pretty creature grip hold & suck. Down the street

■

from me the Samuel F. B. Morses had at the end of their steps neither sand nor rocks but a large circular salt-water swimming pool. Concrete it was, and true to that material's nature it was passing ugly. Capitalism is about redundancy, and even at that age I think I got the point about Sammy Morse's ugly pool. A little further on the Bamberger estate had no cliff but terraced gardens leading to the sea at one side and on the other a small sugarloaf hill, not so small that you should safely play on it. Fall offa there, you're a gone little kid. The Bambergers had a Chinese houseman. You went with the older boys way down the beach to harvest abalone and brought three to four back to Mr. & Mrs. Bam's (as they were called) and the houseman kneaded & hammered them until they were ready for the grill and food never tasted better in a boy's mouth.

Mr. Bam was the owner of several European circuses (!) before the war. He'd married Mrs. Bam out of the line at the Folies-Bergères years before. She was not French but East End Cockney. A lively middle-aged woman who could still shake a leg, tho' Mr. Bam could not, since he had the gout. I remember him half reclining in his wicker chair, mufflered against the cool of evening, with this leg extended in front, the foot resting on an ottoman. What stories they had to tell! They were like a chapter out of Robertson Davies, a favorite author of my mother's.

The Bams raced a small stable of thoroughbreds at Hollywood and Del Mar. These were California breds they had raised themselves; strictly local nags that were the bread & jam of Thoroughbred racing in our area. All the Bamberger horses bore names like Mr. Bam, Mrs. Bam, Sea Bam, War Bam, Valdina Bam, Princess Bam, Victory Bam. They made a nice contingent.

There was an entire cast of characters on Victoria Drive. I wasn't at all fond of the Englishman from up past Bambergers. He fished from the shoreline every blessed day. An old Rolls Royce was his life companion. "Ted" told my mother I was too smart for my own good. I returned the favor by enquiring "innocently" if fishing every day didn't get a bit BORING¿¿¿

Mr. Kendrick, however, after the Chinese ladies, was the chief eccentric on our street. His house now belongs to Bette Midler who is in residence about as frequently as Kendrick. It was an event when he came to Laguna for a few days or a month. We kids called him the Question Man. He kept a pocketful of silver, and he was always at the ready to engage in conversation with small boys & girls. You could leave conversations with the Question Man a wealthy little kid, and news of his being in residence spread quickly. Questions were scaled from 5¢ to 50¢, and everything was on a graded-for-age basis. I believe that just about every child came away better'n he started. What's the capital of Idaho? Worth a nickel to a 3rd grader. If you didn't know you could go home or to the library & look it up. I won 25¢, the quarter of a dollar, for knowing right there on my toes what Gestapo meant. "Geheime Staats Polizei." My mother had told me. I don't know what good it does me but I am thankful now & again for my capacity to name the seven wonders of the Ancient World, worth a shiny dime apiece in what was truly a shining yesterday.

Was Mr. Kendrick some kind of pervert, afflicting little children with his soul sickness? Yeah, he was just that—if that's the way you yourself are, reader. Otherwise, Hell no. He was merely a guy who'd made millions in the oil fields and nurtured in this absurdity ended up a wire-rimmed-glasses receding-hairline character who would give you 20¢ if you knew the meaning of Samuel Clemens's nickname. All this in a day when gasoline prices had reached 11¢ a gallon.

Mr. Kendrick's relationship to the U.S.C. frat house was similarly grounded in innocence. He knew nothing about college except what he saw in the movies. College life looked pretty fun in the flicks, a matter of letter sweaters, cheerleader megaphones & light heartbreak. So he wrote to this Greek house volunteering to put the brothers up at Easter break, weekends, all summer if they

wanted it, the whole of this hospitality on offer in return for a little light yardwork and shipshape garden & house duties. Be it noted that in those days you didn't take your date to Laguna Beach & register in a motel. The boys & the girls came separately, the men staying wherever & the women in "respectable" room & board accommodations. All met at the beach for volleyball & tanning & swimming. At night the bonfire & group make-out & liquor-store run.

I was always over at Mr. Kendrick's because he too had a Chinese houseman, who gave you litchi nuts and fixed lemonade & allowed you to take down the swords Mr. Kendrick decorated with above the mantel and to look into but not mess with the suit of armor. And let you play caroms in the walled garden. And above all unlocked the heavy wooden door to the circular castle tower with wrought iron round & down steps that served as the Kendrick-house access to the beach; this tower had slit windows with iron bars and above its conical cap Mr. Kendrick flew the skull & crossbones.

The guest house at the Kendrick property was nothing super fancy but (1) it was right on the cliff and (2) it was designed to accommodate as many as 8 guests, meaning that 15 or so fraternity boys could live there & not know the difference. The boys had fixed up this guest quarters as a secret clubhouse for the society they all belonged to: the Toe-Knot Society. This club was no more & no less than what it claimed to be: an association of Friends who had totally disciplined themselves to the art of tying knots with their toes. At 10 I enjoyed probationary status in this Knotty sodality. This enabled me to play on the beach all day under their tutelage, picking up pointers and refining various surf-art techniques. My recollection is that the governing teaching had to do with learning how to cooperate with the Ocean & let her have her way. These frat-jocks were marvelously kind to a beach-rat like myself; their concern and love were not in question; some of it perhaps had to do with showing off for the girls: what good fathers they were going to make; but some of most

things has to do with showing off for the girls. There were frustrations, of course: I could not enter the clubhouse until my 12th birthday, which seemed an awfully long time ahead. And occasionally I'd be sore over some bit of arbitrariness on the part of the Question Man. What rhymes with month? [Nothing.] And another 50-¢ question, what rhymes with orange? I'm still sore over this one. My answer was syringe; it was disallowed.

Still and all, I had a great time of happy development under the aegis of the Toe-Knot crew. I would wake up early & dangle both legs over the lower berth where my little brother slept. With a length of cord between each big toe & 1st toe I would begin the task of tying a simple square knot or half hitch. I wouldn't get very far and then there would be breakfast and some time to kill before I was authorized to go over to the clubhouse (10 a.m.). I'd be there, too, at 9:59, lolling in the doorway, peering in at the U.S.C. pennants & photos & memorabilia & YES! pinned to the wall great twisted, interlaced knots. Knots from the hands, or rather make that from the toes, of Past Masters, distinguished clubmen of yore. And there! SEE! Sitting on the arm of the sofa, a young man, his feet cat's cradled in cord, is about to demonstrate current Mastery to the world and tie a loop de loop so gorgeous that. . . . But, lo! The Room takes notice of me, there are mutterings, a whistle blows: tweeeeeeeeeeettt. "No knot tying After 10 o'clock." And we all get set for another perfect day at the beach.

At the end of summer we moved away to Berkeley. All Knots/Thots whirled away in the new life. Eventually I would meet Diebenkorn, learn thru work like the *Santa Cruz* (1962) we have here (fig. 110) that a landscape is not a representation of city-sea-sky but of the profound sorrow one friend feels at the loss of his dear colleague & friend, in this case David Park. In due time I became interested in questions of Justice, Power, Freedom, Beauty and so forth. America was said to be beautiful. If this were so then why? In any case how could you enjoy a good Love in a bad

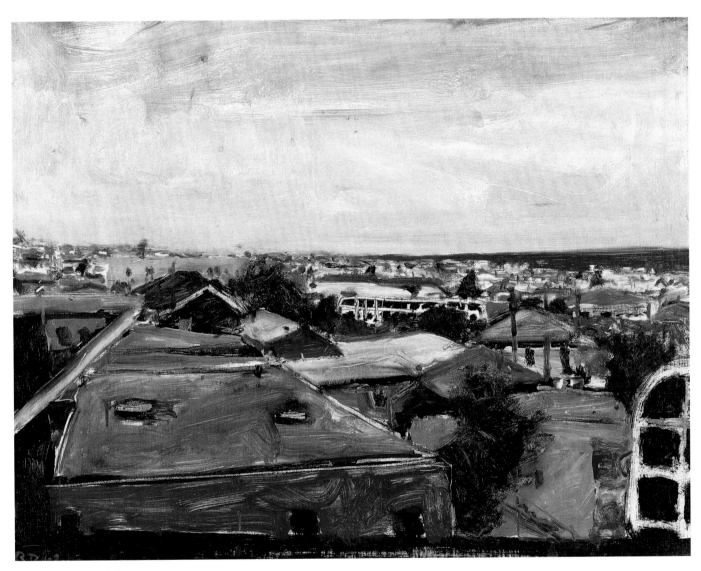

110

Richard Diebenkorn,
Santa Cruz, 1962

Seven Deadly Sins—Lust, 1974: Leon Golub

Society? As I began, professionally, to TALK ART, I started to see that good art criticism is "about" good sentences, not art. I understood further, that one must understand the Painting prior to looking at it. And I was able to teach this concept to America's number-1 Docent, the wife of a schoolmate; I value them both dearly, but I am forever pleased to tease. (There has been a development in the Docent serial case, by the way, with the apprehension—in Switzerland, no less—of one J*S*PH CH*WN*NG, a notorious bad egg.)

There came a time that I saw I would have to BUY ART in order to clarify my critical position beyond any possible misinterpretation. This led to my making more friends among artists (who like to see a critic—or anybody else—put his money where his mouf is). Ultimately, dear readers, from hanging around artists like the painter of the *Achilles & Patroklos* in the present exhibition (fig. 111), I concluded that a major content of art was friendship such as R. D. felt for Park & Bischoff & Hassel Smith. Or Bob Brady for Roy De Forest, or Joan Brown for Jay DeFeo. Or Wiley for Hudson for Allan and Raffael. Or Richbourg

for Carrillo for Hendler for Garabedian. Or John Ford for Roger Herman for Don Hazlitt. Or Carlos Villa for Melchert & so many another. Or Tony King for Hazlitt & Wheeler & Morehouse & the latter for Jack Stuppin. In other words, good readers, a whole Homeric catalog of friendships among artists. In the Southland Larry Bell with darned near everybody. In the north everybody with Manuel & Manuel with everybody. Bob Arneson with Frank Owen, Julia Couzens with Ellen Van Fleet, Bob Colescott with Judy Linhares with Lulu Stanley. Marcus with Suzuki with Ogden with Albertson. McLean with Bechtle with Ramos. VandenBerge with DeStaebler. Stephen J. Kaltenbach with . . . yours truly. And ME with Mike Todd & Todd with Irving Petlin and Irving with Leon Golub and Leon + Michel Gerard—but beware, reader, or we'll be off to New York and Paris and then what?

It wasn't until I recognized I would have to try to MAKE ART myself in order to make still more concrete the view from Pilot Hill, so to speak, that my boyhood experience in Laguna Beach came back into sharp focus. Those college boys who'd set up camp in the guest quarters of Mr. Kendrick's seacliff house had foisted a kindly hoax upon a little boy whose capacity for trust & belief was and is very great. They had made me believe in the existence of a secret club whose purpose was to Defend the Right and To Tie Knots with our Toes. Surely this was a Theatre of Love? I suppose it was shortly after seeing Bill Allan's brief film *Untying the Knots in the Reel* that I said to myself, sez I: Wait just one fine minute! Back there in Laguna! Back in those 10-year-old days, The Club that tied knots with their toes, the guesthouse beside the Pirate Tower. . . .

In that very moment, reader mine, I realized that there could be no such club. For nobody ties knots with his toes, not even you, dear reader, who've walked in my footsteps this long tap tap way. In that very moment I was lost, I felt like the protagonist of Hesse's novel who, tho' he himself had been on it, doubted the existence of The Journey to the East! In the very next moment I got it

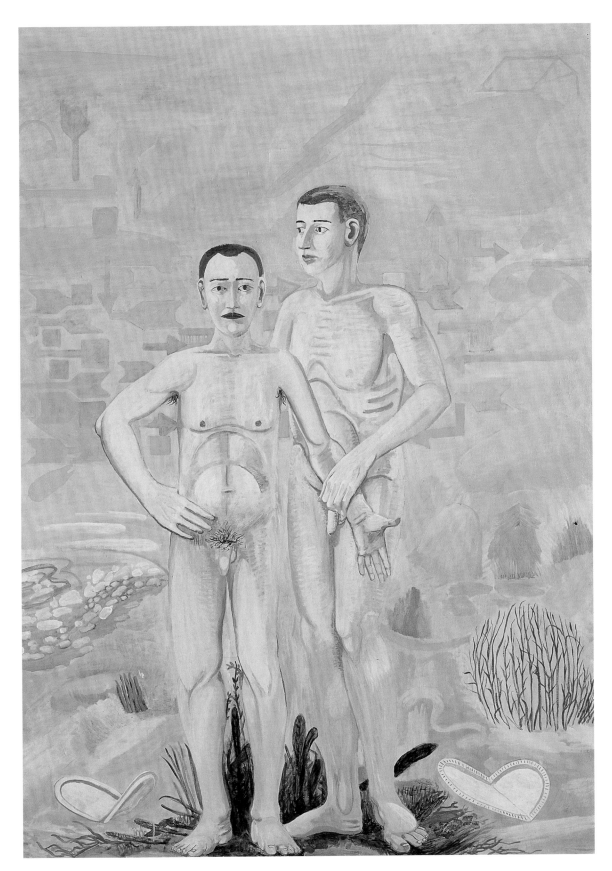

111

Charles Garabedian,
*Achilles and
Patroklos*, 1992

back, it all rushed back to me, at me, over me, the tide of the Imagination, rushing back over me from the place where fancy's bred. Of course there was such a club, *is* such a club, always will be such a club composed of the persons who as a matter of course daily tie knots with their toes. Those persons are named in this book. They are to be found between these covers but at the same time on the walls of the participating museums, where when you encounter each other, please introduce yourselves, as long-suffering readers, & make friends where it looks like it may be appropriate, and ask if they like the installation & their place in it⸮ And just generally send along our well wishes for a safe trip + a warm hello from JANE & JOHN.

NOTES

1. Rosalind E. Krauss, *The Originality of the Avant-Garde and Other Modernist Myths* (Cambridge, Mass.: MIT Press, 1984), 215–16.

2. Please hold all tickets. The reader will recall the extraordinary flap in the Sporting Pages over the 2003 Pilot Hill Biennial (for painters entered in prior interntl' Biennials) & realized @ 1 & $^5/_8$ mi. on the turf. It resulted in an unprecedented quintuple Dead Heat. After reviewing the photo-finish, the Stewards declared themselves unable to discriminate among the 5 noses on the wire: Raffael, Colescott, Garabedian, Diebenkorn & Wiley. Also ran: Linhares, Nutt, Nilsson, Wirsum, Kaltenbach, Yarber, De Forest. Who'd I play⸮ I didn't bet the race I hate to lose friends, dear reader.

3. John Fitz Gibbon, "Frank Owen: The Machine in the Ghost," 1987.

4. Ibid.

5. ———, *California A–Z,* exh. cat. (Youngstown, Ohio: Butler Institute of American Art, 1990).

6. ———, "Frank Owen."

7. ———, *California A–Z,* 69.

8. Ibid., 82.

WHO DID IT AND
WHAT DOES IT MEAN?

■

T. S. ELIOT, ON THE MISUSE OF KNOWLEDGE:

The knowledge imposes a pattern, and falsifies,
For the pattern is new in every moment
And every moment is a new and shocking
Valuation of all that we have been.

To proceed with his or her calling, an art historian needs a number of artists; an artist could use at least one art historian. It makes little difference whether they are in general agreement, or at odds with most everything. I prefer a bit of both; more interesting questions are raised. They must have a genuine love for art that dominates their particular position of authority and the exchange must be more visceral than academic, to allow that position of authority to be put aside. The following is a rough chronology of an exchange that has been going on for more than thirty years.

John and I were teaching in the art department at Sacramento State University in the early seventies. We had been introduced as colleagues, which at best can be a pleasant formality but predicts little for the future. It takes something more personal, something more revealing or confrontational to have a sense of who a person is and what your relationship might be. It didn't take long. John was teaching art history and I was teaching studio classes. One of our mutual students informed me that several slides of my paintings had been shown in John's twentieth-century class. They were from a series of fish watercolors of native trout and salmon. John identified them as surrogate penises and the student asked if that had been my intention.

It was as if my reply had been considered and formed long before and had been lying in wait for a place and time. It needed only a target, and John was it. I said to the student, "Don't you know that art historians' interpretations of artists' work are many times pure illusion and occasionally berserk? This interpretation is especially berserk. They are fish, or they are paintings, or they are paintings of fish. They are not penises. If you want to know what a painting means, ask the artist and protect

yourself when you do it. Furthermore, while the alchemy of transforming a fish into something else is interesting, it is still something akin to a few of Pliny the Elder's descriptions of never-seen creatures and lost primitive tribes."

The speed at which these observations were relayed to John was exceeded only by the appearance of John, hurtling down the hall like an asteroid that was about to graze earth. He was hunched over and had intent, which led me to believe this wasn't going to be the usual arbitrary space collision—he was aimed directly at me. I still prefer not to believe a well-educated graduate of Yale could turn so purple. After some heated huffing and puffing, we fortunately became more interested in the other's ability to get ourselves out of trouble as easily as we'd gotten into it. John departed, less purple than when he came in and I, less pale than when I saw him come in.

John's reaction was understandable, but I felt the real passion was coming from deeper strata. In his outrage were hints of how much he cared about art. Some of these layers would be revealed in time. I soon learned that as a student of art history, John was trained to be a "Voice for the Artist," who is apparently voiceless. Voiceless for a moment, I soon found something to say and was grateful that the news of this service to artists was delivered with more than a grain of salt (I think?). Not being sure how much salt John had, I carried a bag of it every time we got together.

Our occasional meetings in the early days were slightly confrontational, but vital and interesting. We soon developed a kind of Rules of Engagement that allowed us to continue. We worked on who needed to be more right, which included who owned the ranch and who was the hired hand. The conversations were rather one sided and would run in spate till the rain let up, which allowed the other to start raining and the recipient running for shelter to watch the storm. Having no manners, I usually began by spewing idealism with occasional scraps of poetry. John would return by spewing his education with occasional

scraps of wisdom. Being more needful than hungry, I found it a decent trade at the time. When the meetings ended, each knew he was right. It would take some time to realize that if you owned a ranch, you were also the hired hand.

Needing to be right all of the time has a certain shelf life and then it's time to move on. Fortunately many of my students were telling me how much they liked John's classes. He wasn't just dishing out titles and dates, he seemed to love the stuff. I listened. This is seductive and I am as vulnerable to it as the students seemed to be. Unlike the earlier-mentioned child who had turned his outspoken parents over to the commies for subversive thinking, these students were wise enough not to pass along our interpretations about each other's efforts. Any transgressions into each other's territory were done at the hour between sleep and awakening, behind the shed. Placed back on the shelf as fresh bread, we continued.

There was still some poker-playing going on, but not always to win. Often as not it was to make sure whoever did, deserved it. If one of us were prejudiced, shallow, or just plain stupid we would hear about it quickly. Some new skills in communication had been learned, the most important being Do Not Share. I think in earlier times we might have been under the illusion that information was being shared. There was a social phenomenon going on at that time that began with, "I would like to share something with you." This meant that you were going to hear something whether you wanted to or not. It could also imply you might get half of something you desired. No! You were going to get all of something and with a meaningful look at the finish. Not to be culturally left behind we followed suit, without the meaningful look. Our phone calls consisted of filling up the truck with any interesting things you had at the time, taking it to the other guy's place, dumping it, and leaving. It was up to him to go through it and see if there was anything of value.

Having now learned enough to allow our curiosity about each other to dominate any individual

position of authority, matters of impudence as well as matters of importance could be exchanged, often at the same time. At least now we were on the same river at the same time—just on different sides: on river-right John and art history floating on the Royal Barge with Handel and company listening to water music; on river-left me, Huck, and Tom on our homemade raft, looking for giant catfish, blowing on bottles, throwing rocks into the void, and listening to water music. This is not to imply that John spends all of his time in the upper canopy. He is also comfortable in the middle tiers, with the howler monkeys and veins of serious ants. He can even get down into the lower level in rainy season, where glistening eyes protrude and odd sounds can be heard. This is unusual and worth paying attention too.

Although the owner of the ranch still lurks in the background, listening eventually became as important as stating, which made the conversations seem as if they might be following a particular course, instead of arbitrarily spraying the landscape with disparate thoughts. There were still some efforts to convert, mostly on my part—rants about art historians' continual need to legitimize artists by placing them somewhere in art history. "Yes there is precedence and here it is." This might be fine for the dead, but it robs the living artist and the living viewer of their individual scent. Once the doors of art history have been opened and the artist engulfed, the living scent is no longer as mysterious or even necessary. When you know what it is—you know what it does. This makes things easier and you don't have to go into the woods alone, or go into the woods at all. John has been a patient sounding board for this kind of outburst. In return, I have learned to be patient with his elaborate words and phrases, French, Italian, Latin, and sources unknown, which always sent me to the verbal ballistics lab to identify the source. I now see them as nouvelle cuisine's dribbling and spattering around

the entrée, not much nutrient, but quite decorative. I teased John about this and his reply was, "I like them." Good enough for me, the learned must use their muscles.

■

Recent Times: Exchanges are easier and fuller now. We don't see each other often, but the phone calls, letters, and stories are more frequent. John is a great reference library. The wait for a reply to a question or opinion, if not immediately at hand, takes less than a minute. I don't know how he does this—a bit of muttering, the flipping of pages, and there is the answer. Is it possible the same questions are being asked? There is more humor and the course of the conversation sets itself, rather that being predetermined. I now look forward to his missives the same way, as a kid, I waited for the next how-to-catch-a-bluegill article in *Field and Stream*. A few weeks ago, we were going over the status of artists today. One of my favorites from the past was "Artists are the elite of the servant class." I thought about this and told John I believed artists had slipped a notch or two since that statement was made. I think they are now viewed more like free-range chickens and the artist should not question how large the free range is. John would make it larger than most.

John is relentless. It may appear that after all these years some kind of peace and fulfillment may have been reached. It matters little. The great whale is still pursued each day with the energy of youth, at the latitudes and longitudes of choice. Harpoons are no longer necessary. The doubloon once nailed to the mast is no longer there and the quadrant went overboard years ago. We pass each other at sea now and then, often in different directions, each having an idea of where the leviathan will be. There is usually a greeting, sometimes not. On a great day a glass or four will be shared. This may have a ring of heroic romanticism, which indeed would be true. That is how I view my friends.

—*William Allan*

11. Larry Bell, *Untitled,* 2001. Oil on canvas, 42 × 42 inches. Collection of John and Jane Fitz Gibbon. Figure no. 20

12. Elmer Bischoff, *Woman Resting,* 1958. Oil on canvas, 23¾ × 19¾ inches. Collection of John and Jane Fitz Gibbon. Figure no. 16

13. Robert Brady, *Rage (Self Portrait),* 1980. Ceramic, 27 × 21 × 20 inches. Collection of John and Jane Fitz Gibbon. Figure no. 33

14. Robert Brady, *Self Portrait (Mouse),* ca. 1980s. Ceramic, 15 × 27 × 24 inches. Collection of John and Jane Fitz Gibbon. Figure no. 26

15. Joan Brown, *Sara as Eve with Fish and Bird,* 1970. Enamel on panel, 96 × 48 inches. Collection of John and Jane Fitz Gibbon. Figure no. 99

16. William H. Brown, *Chair,* ca. 1960s. Encaustic on canvas, 20 × 24 inches. Collection of John and Jane Fitz Gibbon. Figure no. 15

17. Eduardo Carrillo, *Down the Lane,* 1991–1992. Oil on canvas, 71 × 52 inches. Collection of John and Jane Fitz Gibbon. Figure no. 92

18. Eduardo Carrillo, *Woman with the Snake,* 1975. Oil on panel, 55 × 33 inches. Collection of John and Jane Fitz Gibbon. Figure no. 93

19. Victor Cicansky, *Cabbage,* 1996. Ceramic, 12½ × 12½ × 12½ inches. Collection of John and Jane Fitz Gibbon. Figure no. 18

20. Victor Cicansky, *Jar of Corn* (1981); *Jar of Prunes* (1981); and *Jar of Trilobites* (1980). Ceramic. Collection of John and Jane Fitz Gibbon. Figure no. 19

21. Robert Colescott, *Another Breakthrough for the Colonel,* 1972. Acrylic on canvas, 79 × 58 inches. Collection of John and Jane Fitz Gibbon. Figure no. 22

22. Robert Colescott, *Blondes Have More Fun,* 1990. Acrylic on canvas, 84 × 72 inches. Collection of John and Jane Fitz Gibbon. Figure no. 108

23. Robert Colescott, *Life Class,* 1987. Acrylic on canvas, 84 × 74 inches. Collection of Dr. John Fitz Gibbon Jr. and Linda Fitz Gibbon. Figure no. 53

24. Robert Colescott, *The Scream (Georgia O'Keeffe in Los Angeles),* 1992. Acrylic on canvas, 84 × 72 inches. Collection of John and Jane Fitz Gibbon. Figure no. 91

25. Julia Couzens, *Mortal Lessons,* 1990. Charcoal on paper, 44 × 30 inches. Collection of John and Jane Fitz Gibbon. Figure no. 96

26. Roy De Forest, *Bigfoot Series (Dog in the Woods),* 1988. Pastel and gouache on black paper, 31 × 42 inches. Collection of John and Jane Fitz Gibbon. Figure no. 7

27. Roy De Forest, *Events in the Rabbit Quarter,* 1977. Acrylic on canvas, 66 × 66 inches. Collection of John and Jane Fitz Gibbon. Figure no. 78

28. Stephen DeStaebler, *Pale Red Leg,* 1996–1998. Stoneware, 34¾ × 7¼ × 7¼ inches. Collection of Dr. John Fitz Gibbon Jr. and Linda Fitz Gibbon. Figure no. 100

29. Richard Diebenkorn, *Portrait of Jane,* 1961. Oil on canvas, 17 × 14 inches. Collection of John and Jane Fitz Gibbon. Figure no. 94

30. Richard Diebenkorn, *Santa Cruz,* 1962. Oil on canvas, 25 × 32 inches. Collection of John and Jane Fitz Gibbon. Figure no. 110

31. Richard Diebenkorn, *View Toward Oakland,* 1960. Ink and pencil on paper, 17½ × 11 inches. Collection of John and Jane Fitz Gibbon. Figure no. 12

32. Linda S. Fitz Gibbon, *Do You Like My Hat? Autumn,* 2000. Ceramic, 21½ × 16 × 14½ inches. Collection of Dr. John Fitz Gibbon Jr. and Linda Fitz Gibbon. Figure no. 102

33. John Ford, *"High Velocity #15"* from the Explosion Series (detail), 1978. Acrylic on canvas, 96 × 120 inches. Collection of John and Jane Fitz Gibbon. Figure no. 64

34. John Ford, *Requiem for Phil Ochs,* 1976. Oil on canvas, 80 × 120 inches. Collection of John and Jane Fitz Gibbon. Figure no. 61

35. Viola Frey, *Plate,* 1992. Ceramic, 25 × 25 × 4 inches. Collection of Dr. John Fitz Gibbon Jr. and Linda Fitz Gibbon. Figure no. 98

36. Charles Garabedian, *Achilles and Patroklos,* 1992. Acrylic on canvas, 84½ × 60 inches. Collection of John and Jane Fitz Gibbon. Figure no. 111

37. William Geis, *Plato's Harp,* 1969. Mixed media, 6½ × 16 × 6 inches. Collection of John and Jane Fitz Gibbon. Figure no. 2

38. William Geis, *Untitled (Kill),* ca. 1969. Watercolor on paper, 34 × 20 inches. Collection of John and Jane Fitz Gibbon. Figure no. 1

39. Michel Gerard, *Genetic Fingerprint—Data 25,* 1992. Mixed media on paper, 39½ × 51½ inches. Collection of John and Jane Fitz Gibbon. Figure no. 38

40. David Gilhooly, *Dagwood Sandwich,* ca. 1980. Stoneware, 23 × 13 × 12 inches. Collection of John and Jane Fitz Gibbon. Figure no. 46

41. Arthur Gonzalez, *Untitled,* ca. 1993. Ceramic, 28 × 18 × 12 inches. Collection of John and Jane Fitz Gibbon. Figure no. 34

42. Don Hazlitt, *Sinking Ship,* 1984. Wood, wire, and acrylic, 24½ × 22¼ × 2 inches. Collection of John and Jane Fitz Gibbon. Figure no. 63

43. Don Hazlitt, *Untitled* (detail), 1974. Sewn paper and acrylic, 75 × 114½ inches. Collection of John and Jane Fitz Gibbon. Figure no. 62

44. Max Hendler, *Yellow Brick Wall,* 1985. Styrofoam and paint, 79 × 99 inches. Collection of John and Jane Fitz Gibbon. Figure no. 21

45. Roger Herman, *Staircase for W.,* 1983. Oil on canvas, 120 × 72 inches. Collection of John and Jane Fitz Gibbon. Figure no. 60

46. Roger Herman, *Untitled (Study for Auditorium),* 1984. Oil on canvas, 19 × 15 inches. Collection of John and Jane Fitz Gibbon. Figure no. 49

47. Robert Hudson, *Teapot,* 1999. Porcelain, 12 × 5 × 14 inches. Collection of John and Jane Fitz Gibbon. Figure no. 31

48. Stephen Kaltenbach, *Expose Your Self.,* April 1970. Ink on paper, 21 × 18 inches. Collection of John and Jane Fitz Gibbon. Figure no. 43

49. Stephen Kaltenbach, *Model for a Blastproof Peace Monument,* 1992. Concrete, 15 × 22 inches. Collection of John and Jane Fitz Gibbon. Figure no. 3

50. Tony King, *Cape Arago, Oregon Coast,* 2001. Oil on canvas, 44 × 36 inches. Collection of John and Jane Fitz Gibbon. Figure no. 10

51. Marilyn Levine, *Bag,* late 1980s. Ceramic and mixed media, 12 × 5 × 6 inches. Collection of John and Jane Fitz Gibbon. Figure no. 97

52. Judith Linhares, *Death and the Maiden,* 1980. Gouache on paper, 5 × 8½ inches. Collection of John and Jane Fitz Gibbon. Figure no. 50

53. Judith Linhares, *Eve's Dream,* 1984. Oil on canvas, 96 × 77¾ inches. Collection of John and Jane Fitz Gibbon. Figure no. 48

54. Judith Linhares, *Red Planet,* 1984. Oil on canvas, 96 × 78 inches. Collection of John and Jane Fitz Gibbon. Figure no. 47

55. Ken D. Little, *Bore,* 1982. Shoes and leather, 21 × 17 × 23 inches. Collection of John and Jane Fitz Gibbon. Figure no. 67

56. Irving Marcus, *House Search,* 1969. Oil on canvas, 62½ × 75 inches. Collection of John and Jane Fitz Gibbon. Figure no. 89

57. Joe Mariscal, *Inmate,* 1984. Ceramic, 21 × 21 × 18 inches. Collection of John and Jane Fitz Gibbon. Figure no. 101

58. James Melchert, *NCHO,* 1966. Porcelain, 11½ × 13½ × 4 inches. Collection of John and Jane Fitz Gibbon. Figure no. 86

59. William Morehouse, *From John's Aerie,* 15 August 1991. Acrylic on canvas, 48 × 24 inches. Collection of John and Jane Fitz Gibbon. Figure no. 35

60. Miriam Morris, *Bull Eyeing Europa,* 1999. Ceramic, 12 × 14 × 9 inches. Collection of John and Jane Fitz Gibbon. Figure no. 104

61. Philip Morsberger, *A Guiding Hand,* 1978–1993. Oil on canvas, 20 × 26 inches. Collection of John and Jane Fitz Gibbon. Figure no. 68

62. Manuel Neri, *Nude,* 1988. Charcoal and pastel on paper, 41½ × 29½ inches. Collection of John and Jane Fitz Gibbon. Figure no. 54

63. Gladys Nilsson, *Pynk Rabbit,* 1970. Acrylic on canvas, 29½ × 30 ¾ inches. Collection of John and Jane Fitz Gibbon. Figure no. 56

64. Richard Notkin, *Dice Teapot (Variation #5,* Yixing Series), 1988. Ceramic, 9½ × 3 × 3 inches. Collection of Erle and Pinkerton F. G. Flad. Figure no. 30

65. Jim Nutt, *G. G.,* 1968. Acrylic on canvas, 30 × 24 inches. Collection of John and Jane Fitz Gibbon. Figure no. 52

66. Jim Nutt, *Peanut Head,* 1967. Acrylic on glass and steel, 24 × 18 inches. Collection of John and Jane Fitz Gibbon. Figure no. 55

67. Jack Ogden, *Riverbank Lovers,* 1984. Oil on canvas, 60 × 80 inches. Collection of John and Jane Fitz Gibbon. Figure no. 88

68. Nathan Oliviera, *Couple,* 1968. Oil on canvas, 14 × 10 inches. Collection of John and Jane Fitz Gibbon. Figure no. 107

69. Nathan Oliviera, *Standing Nude,* 1982. Charcoal on paper, 25 × 17 inches. Collection of John and Jane Fitz Gibbon. Figure no. 106

70. Frank Owen, *Untitled,* 1988–1989. Acrylic and mixed media on canvas, 90 × 69 inches. Collection of John and Jane Fitz Gibbon. Figure no. 87

71. Harold Paris, *Et in Arcadia Ego,* ca. 1970s. Ink and mixed media on paper, 19 × 13¼ inches. Collection of John and Jane Fitz Gibbon. Figure no. 13

72. David Park, *Portrait of a Young Man,* 1960. Gouache on paper, 15 × 12 inches. Collection of John and Jane Fitz Gibbon. Figure no. 51

73. Philip Pearlstein, *John Fitz Gibbon,* 1986. Oil on canvas, 24 × 29 inches. Collection of John and Jane Fitz Gibbon. Figure no. 79

74. Philip Pearlstein, *Kate Fitz Gibbon,* 2000. Oil on canvas, approx. 20 × 30 inches, Collection of John and Jane Fitz Gibbon. Figure no. 82

75. Philip Pearlstein, *Linda Fitz Gibbon,* 1985. Oil on canvas, 26 × 22 inches. Collection of Dr. John Fitz Gibbon Jr. and Linda Fitz Gibbon. Figure no. 80

76. Philip Pearlstein, *Pinkerton F. G. Flad,* 1988. Oil on canvas, 17¾ × 12½ inches. Collection of Erle and Pinkerton F. G. Flad. Figure no. 81

77. Roland Petersen, *Picnic,* 1962. Oil on canvas, 44 × 36½ inches. Collection of John and Jane Fitz Gibbon. Figure no. 37

78. Irving Petlin, *Soldier's Dream,* 1990. Charcoal and chalk on paper, 25½ × 19¾ inches. Collection of John and Jane Fitz Gibbon. Figure no. 59

79. Joseph Raffael, *Water Painting* #3, ca. 1973. Oil on canvas, 78⅓ × 114½ inches. Collection of John and Jane Fitz Gibbon. Figure no. 75

80. Mel Ramos, *I Still Get a Thrill When I See Bill,* 1977. Graphite on paper, 30 × 22 inches. Collection of John and Jane Fitz Gibbon. Figure no. 28

81. Mel Ramos, *Untitled,* 1979. Lithograph, 23 × 16 inches . Collection of Dr. John Fitz Gibbon Jr. and Linda Fitz Gibbon. Figure no. 29

82. Lance Richbourg, *Bat Boys,* 1984. Oil on paper, 56¼ × 40 inches. Collection of John and Jane Fitz Gibbon. Figure no. 25

83. Lance Richbourg, Study for *New Material,* 1994. Oil on board, 11 × 9¼ inches. Collection of John and Jane Fitz Gibbon. Figure no. 23

84. Tom Rippon, *Olée,* 1993. Porcelain, 31 × 7 × 7 inches. Collection of Dr. John Fitz Gibbon Jr. and Linda Fitz Gibbon. Figure no. 77

85. Peter Saul, *"Texis,"* 1985. Hand-colored lithograph, 29 × 29 inches. Collection of Dr. John Fitz Gibbon Jr. and Linda Fitz Gibbon. Figure no. 58

86. Richard Shaw, *Baseball Player,* 1982. Porcelain, 21 × 24 × 13 inches. Collection of John and Jane Fitz Gibbon. Figure no. 27

87. Patrick Siler, *Ceramist with Birds,* n. d. Graphite on paper, 15 × 19 inches. Collection of John and Jane Fitz Gibbon. Figure no. 17

88. Hassel Smith, *Bop City,* 1978. Acrylic on canvas, 68 × 68 inches, Collection of Erle and Pinkerton F. G. Flad. Figure no. 71

89. Hassel Smith, *Rape of Lucretia,* 1963. Oil on canvas, 67¾ × 67½ inches. Collection of John and Jane Fitz Gibbon. Figure no. 70

90. M. Louise Stanley, *Orpheus,* 1981. Watercolor on paper, 22½ × 29½ inches. Collection of John and Jane Fitz Gibbon. Figure no. 95

91. Jack Stuppin, *Farallon Islands, 25 September 1995,* 1995. Oil on canvas, 25½ × 35 inches. Collection of John and Jane Fitz Gibbon. Figure no. 9

92. Jimi Suzuki, *Friday 13th at Fitz Gibbon's,* 1974. Oil on canvas, 30½ × 30 inches. Collection of John and Jane Fitz Gibbon. Figure no. 65

93. Jimi Suzuki, *Untitled (Abstract),* 1964. Oil on canvas, 71¾ × 70 inches. Collection of John and Jane Fitz Gibbon. Figure no. 66

94. Wayne Thiebaud, *Lunch,* 1964. Etching, 5 × 6¾ inches. Collection of John and Jane Fitz Gibbon. Figure no. 36

95. Michael Todd, *Black Iris,* 1991. Charcoal on paper, 25 × 19½ inches. Collection of Erle and Pinkerton F. G. Flad. Figure no. 39

96. Leo Valledor, *Untitled (Round Canvas),* ca. 1987. Acrylic on canvas, 42 × 47 inches. Collection of John and Jane Fitz Gibbon. Figure no. 85

97. Leo Valledor, *Untitled (Trapezoid Canvas),* 1981. Acrylic on canvas, 72 × 48 inches. Collection of John and Jane Fitz Gibbon. Figure no. 84

98. Peter VandenBerge, *Figure,* 1982. Ceramic, 44 × 16 × 21 inches. Collection of John and Jane Fitz Gibbon. Figure no. 41

99. Peter VandenBerge, *Leger,* 1982. Ceramic, 36½ × 19½ × 12 inches. Collection of John and Jane Fitz Gibbon. Figure no. 40

100. Peter VandenBerge, *Pregnant Woman,* 1982. Ceramic, 71 × 24 × 18 inches. Collection of John and Jane Fitz Gibbon. Figure no. 45

101. Peter VandenBerge, *Radish,* ca. 1970s. Ceramic, 42 × 10 × 4 inches. Collection of John and Jane Fitz Gibbon. Figure no. 44

102. Carlos Villa, *Abstract* (detail), 1963. Oil and enamel on canvas, 101 × 84 inches. Collection of John and Jane Fitz Gibbon. Figure no. 83

103. Peter Voulkos, *Plate,* 1981. Ceramic, 20½ (diameter) × 5 inches. Collection of Erle and Pinkerton F. G. Flad. Figure no. 32

104. Ken Waterstreet, *Luni Zuni,* 1986. Acrylic on canvas, 36 × 48 inches. Collection of John and Jane Fitz Gibbon. Figure no. 90

105. William Wheeler, *Cape Arago, Oregon Coast,* 2001. Oil on canvas, 43½ × 36 inches. Collection of John and Jane Fitz Gibbon. Figure no. 11

106. William Wiley, *Delta Ledge End,* 1972. Lithograph and hand-painting on chamois, 25 × 31 inches. Collection of John and Jane Fitz Gibbon. Figure no. 4

107. William Wiley, *Diamonds in the Rough,* 1972. Acrylic on canvas, 68 × 129 inches. Collection of John and Jane Fitz Gibbon. Figure no. 8

108. William Wiley, Study for *Sacramento 2000* (recto), 1997. Oil on canvas, 36 × 37 inches. Collection of John and Jane Fitz Gibbon. Figure no. 5

109. William Wiley, Study for *Sacramento 2000* (verso), 1997. Oil on canvas, 36 × 37 inches. Collection of John and Jane Fitz Gibbon. Figure no. 6

110. Karl Wirsum, *Beer Did Lay Dee,* ca. 1970. Crayon and ink on cardboard, 26½ × 24 inches. Collection of John and Jane Fitz Gibbon. Figure no. 57

111. Robert Yarber, Study for *Bad Bell Boy,* 1981–1991. Conté on paper, 26 × 35½ inches. Collection of John and Jane Fitz Gibbon. Figure no. 69

INDEX

■

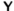

DESIGN AND PRODUCTION BY SEVENTEENTH STREET STUDIOS

PRINTING AND BINDING BY FRIESENS, INC.